RUSSIAN CRIMINAL TATTOO
ENCYCLOPAEDIA

VOLUME III

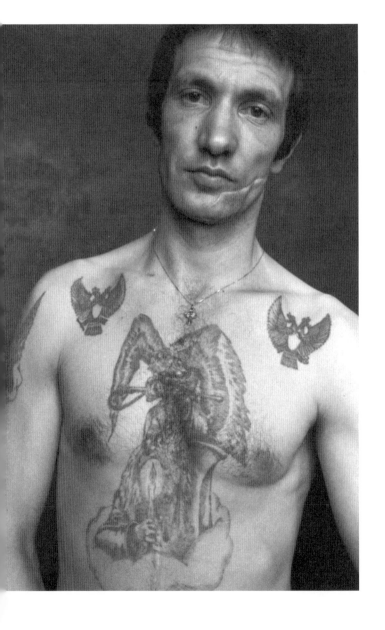

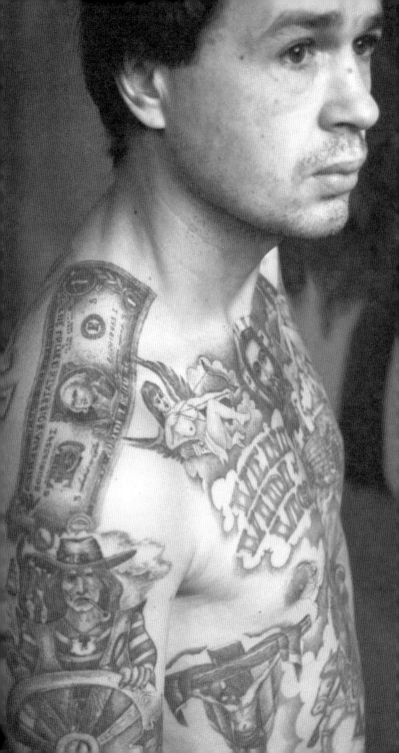

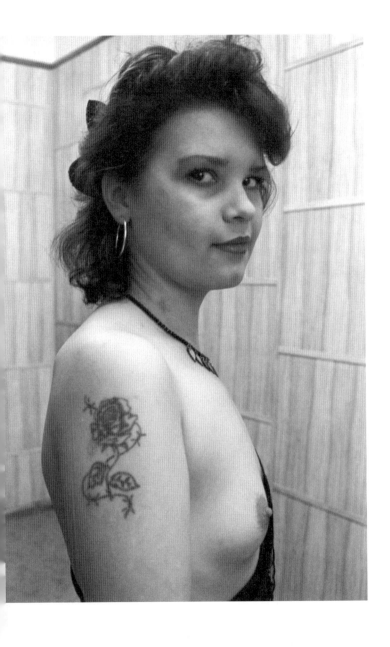

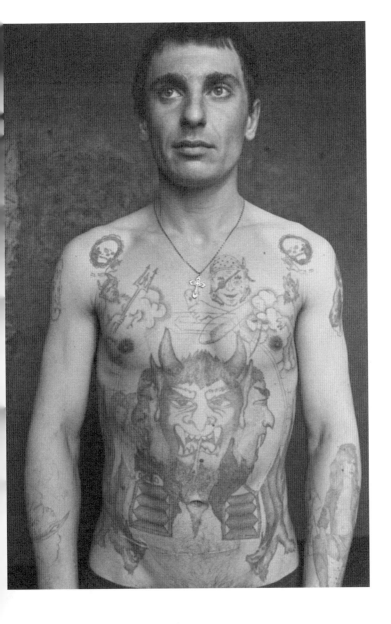

DRAWINGS Danzig Baldaev
PHOTOGRAPHY Sergei Vasiliev
ESSAY Alexander Sidorov

DESIGN AND EDIT Murray & Sorrell FUEL
TRANSLATORS Polly Gannon and Ast A. Moore
CO-ORDINATOR Julia Goumen

Russian Criminal Tattoo Encyclopaedia

Volume III

FUEL

Contents

The Russian Criminal Tattoo: Past and Present

Alexander Sidorov

An English Trace on a Russian Body

The art of the tattoo arrived in the Old World from the South Seas during the Age of Exploration. Imitating indigenous peoples, sailors and pirates were eager to have similar drawings on their bodies: James Cook's crew were known to have practised the art of tattooing during their first voyage around the world.

Not only did the numerous tattoos worn by sailors serve to mark their occupation, but they also symbolised the bearer's initiation into the realm of perils and fabled riches encountered in distant lands. The officers of the expeditions, who were from the highest ranks of nobility, did not neglect the opportunity to display their exotic tattoos either. In the salons of the beau monde, such tattoos gave them an air of valour and boldness. They were a permanent mark of the bearer's thirst for adventure and demonic bravado. Travels, battles with pirates and savages, and the hardships of maritime life tested the mettle of these sea dogs. The criminal world appropriated these qualities from sailors.

The tattoo covered nobleman-adventurer Feodor Tolstoy (1782–1846), was given the nickname 'the American', after his journey as part of the expedition of Admiral Adam Johann Ritter von Krusenstern. His contemporaries characterised him as a man of courage, a card-sharp and an adventurous bully; he killed eleven men in duels. One of his descendants wrote that Tolstoy was 'A brave man who flew in the face of danger, defied commonly accepted mores, and even the criminal underworld.' Tolstoy 'the American' embodied all the traits of an adventurer, which later would define the qualities of the professional criminal elite – the *vor v zakone* (legitimate thieves), *blatnye* (cons), and *avtoritety* (authoritative thieves). Tolstoy's escapades drove Captain Krusenstern into a frenzy, and he finally commanded that Tolstoy be marooned on Baranof (or Sitka) Island, east of the Aleutian Islands of North America. He was later rescued and returned to Russia (in 1905), where he proudly displayed to high society the tattoos that the Aleuts had

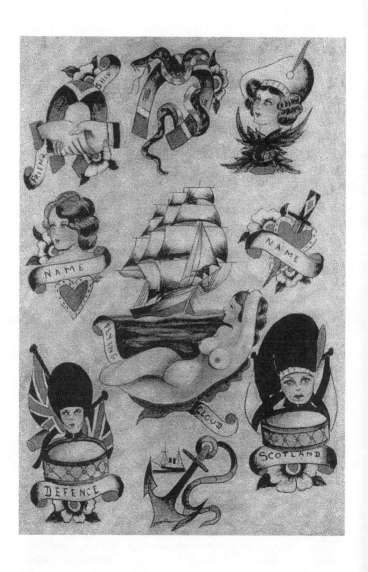

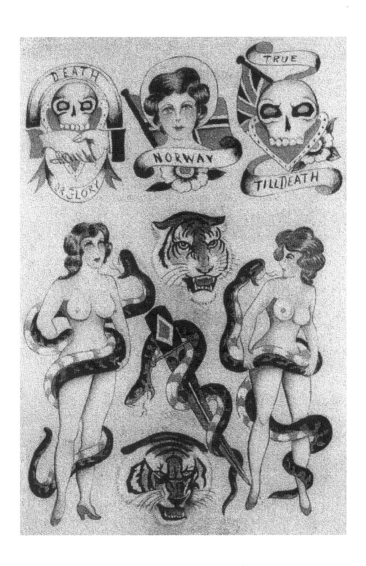

etched on his body – he was covered from head to toe.

In Russia, sailors' tattoos were the original source for their criminal counterparts. This is evident from the standard motifs that English tattoo artists used in the period between the two World Wars.

There is a striking similarity between these motifs and those of Russian criminal tattoos – a handshake, a skull, a tiger baring his teeth, a serpent-entwined dagger, flying tall ships, anchors, a heart pierced by a dagger – these symbols found their way into the Russian criminal tattoo from England, suggesting that vagrants and criminals learned their tattooing skills from sailors. There was never a clear distinction between these groups – captains didn't exercise much discrimination when recruiting, often hiring individuals with a shady past. For the most part these recruits were representatives of the lower social classes – criminals, the homeless, and peasants whose fortunes had been ruined – all looking to make an easy gain in distant parts. In a sense, tattoos functioned as invitations to a wonderful new life.

Sailors themselves often ended up behind bars due to their quick tempers and proclivity for danger and adventure, making an indisputable connection between the Russian criminal tattoo and English sailors' tattoos.

Branding: Cons, Thieves, and Escapees

The branding of criminals, practised in Russia since ancient times, can be considered another prototype of the modern criminal tattoo. Up until 1846, criminals condemned to hard labour were branded *VOR* (THIEF). The letters on the cheeks and forehead allowed any law abiding citizen to recognise a convict, even after they had served their term. Brands were also often applied to the shoulder blades and the right forearm. These were of three types: the letters *SK*: *SsylnoKatorzhny* (hard labour convict); *SP*: *SsylnoPoselenets* (hard labour deportee); and *B*: *Begly* (escapee). The letters were tattooed using metal needles attached to a special device which made deep wounds, these were then covered with dye. Escapees were branded on their forearms. If they were repeat offenders, a new brand was applied below the previous one.

In 1846, when the Decree on Punishments came into effect, the brand *VOR* was replaced with *KAT*, the three first letters of the word for hard labour convict – *katorzhnik*. The letter *K* was applied to the right cheek, *A* to the forehead, and *T* to the left cheek. Since that date, the word *kat* has come to mean a scoundrel for whom nothing is sacred.

The decree remained in effect up until 1863. These lifelong marks on the body and face of hard labour convicts can be considered the earliest symbols of membership in the world of outcasts: the first criminal tattoos. Though forcibly applied, they nevertheless began to function as caste markings. However, prisoners and hard labour convicts did not yet apply their own tattoos to distinguish status among themselves, perhaps

the practice of branding quelled any desire they might have had to decorate their bodies. Tattoos are not mentioned in the memoirs of convicts from this time, they are also absent from the reports of renowned Russian journalists who visited the hard labour camps on Sakhalin Island. In all likelihood, the custom of tattooing appeared among criminals in czarist Russia towards the end of the 19th and the beginning of the 20th centuries, when the country was gripped by a tattoo mania.

Some scholars argue, however, that this practice had already taken hold in the middle of the 19th century, becoming widespread over the next fifty years as convicts in Amur and Sakhalin interacted with the Chinese and Koreans. But it could also be claimed that this interaction was minimal – if it took place at all – as convicts were strictly isolated. It may have occurred among escapees, but their encounters with the Asian population were sporadic at best. Another counter-argument is the fact that there are no oriental motifs in the Russian criminal tattoo.

The indirect influence of branding is evident in the custom of Russian criminals and convicts to tattoo inscriptions on their foreheads, eyelids, and, at one time, images on their cheeks as well (for example, the depiction of a butterfly as the symbol of membership in a caste of inveterate thieves or *blatnye*).

More Than Skin Deep

The tattoo had become widespread among Russian criminals by the beginning of the 20th century. It is difficult to precisely what they looked like during this period, as there are no specific pre-revolutionary studies of this phenomenon. There is, however, a detailed description of prison tattoos in a remarkable work by Mikhail Gernet: *Tattoos in Places of Incarceration in the City of Moscow* (1924).[1]

> Most often we saw tattoos of unclothed ladies, usually rendered with a great deal of refinement. Upon comparing the tattoos of foreign criminals we have seen in books with those of Russian convicts, we conclude that the latter are more compelling. We believe that the world record in this regard has been set by the depiction on the chest of one of the inmates of a Moscow prison: a copy of *Bogatyrs*, the painting by Vasnetsov. As far as we know, foreign criminals have yet to come up with the idea of copying great works of art on their bodies. Muscovites have also broken the record in the genre of the so-called political tattoo: one of our students observed on the chest of a dosshouse dweller an entire gallery of portraits of the Romanov royal family. We have also observed a convict with tattoos of the King and Queen of England rendered in two dyes... Another noteworthy example was the tattoo of one criminal who had a cross on his chest with a skull at its base and kneeling angels on each side. There were also religious depictions above both nipples. On his left leg was a picture of a Turkish woman in a veil and roomy harem trousers. On his right arm he had a garland of leaves and other floral motifs... We saw another interesting tattoo on a convict's back

depicting an eagle in flight carrying a serpent in its claws... We subsequently observed the same subject numerous times. Yet the most frequent tattoos among Moscow detainees are anchors and hearts, crosses and other religious tattoos, female figures and heads, and birds and butterflies.

At the time of Gernet's study, the subject matter of Russian criminal tattoos appeared random to him, containing no secret symbolism. According to Gernet, most tattoos were applied 'out of boredom or in emulation of other inmates.' However, we could also conclude from his work that their tattoos signalled membership of the criminal world, and that this visual manifestation of the closed criminal society had not yet been recognised by the authorities.

Gernet's document also demonstrates that in the first decade of Soviet power, tattoos were not especially common among prisoners, only twenty-five percent wore them. These were, as Gernet makes clear, thieves, robbers, murderers, and swindlers. A high percentage of tattoos were found among socially dangerous elements 'with multiple sentences and no right to reside in Moscow' – referred to as extremely dangerous criminal recidivists. Thus, it was superfluous to attach special symbolism to a tattoo: merely having one was proof of a criminal past.

Stalin's Profile Tattooed on His Chest

In the early 1930s, the Russian criminal caste system emerged: the *masti* (suits, as in cards), and the *vory v zakone* or *blatnye* (authoritative or legitimate thieves, the elite criminal caste). The tattoo developed a special status, and virtually all professional criminals were tattooed.

Prison officials took advantage of this. In Stalin's Gulags former convicts were recognised by their tattoos. For a long time, they functioned as a system for sorting out newcomers from veteran prisoners before they were assigned to cells: the latter went to 'Abyssinia', the former to 'India'. These exotic names for prison cells derived from the heat and lack of fresh air in the overpopulated, cramped quarters. In his autobiographical novel *Convict*,[2] Mikhail Demin, himself a prisoner from the 1930s to the 1950s, describes the process of assigning newcomers to cells:

> The selection began immediately with the arrival of a fresh bunch of prisoners. They are lined up in the corridor and ordered to take off their shirts. Then the prison officials scrutinise each of them, one by one, for traces of tattoos.
> Cons are immediately recognised by their tattoos – all criminals wear them. A tattoo is a unique caste marking, a sign of knighthood or dandyism. 'You with the ink job,' says the guard after singling out another dandy from the silent ranks. 'Step out and join your sisters.'
> The jail argot refers to this procedure as 'Roosters with Roosters, and Lobster Necks with Lobster Necks.' As soon as I took off my shirt and the warden saw the ace of clubs on my shoulder, I was with the Lobster Necks. My partners were luckier. Gypsy had no tattoos at all, and Scar had pictures

of anchors and mermaids on his arms – sure signs that he had been a sailor. Besides, he wore a striped sailor's jersey and bell-bottoms (typical attire of the Odessa street gangs).

The names 'Roosters' and 'Lobster Necks' were taken from popular brands of sweets.

In general the tattoos of the 1930s and 1940s had no secret meanings. Portraits of the Bolshevik leaders Lenin and Stalin were an exception. They signalled the loyalty and affinity of the criminal world to Soviet power, professional criminals were considered to have a 'social kinship' with the Soviets and were often given lighter sentences. But there were other motives behind these tattoos. According to prison legend, they were believed to protect the wearer from execution, as officials wouldn't dare shoot at an image of a Soviet leader. For this reason the portraits were tattooed either on the left of the chest – by the heart – or one on each side. The authorities solved this problem by shooting the convict in the back of the head.

Even after the demise of Stalin's cult of personality, legitimate thieves continued to tattoo pictures of Lenin on themselves. Emphasising the 'social kinship' of the leader with the criminal world, they gave a new meaning to the word *vor* (thief) with their characteristic mordant humour. They held that Lenin was, indeed, the chief *VOR*: *Vozhd Oktyabrskoy Revolyutsii* (Chief of the October Revolution).

Penal Units Marching into Battle

Up until the Great Patriotic War (Second World War), any tattoo signified membership in a professional criminal brotherhood. The only exceptions were sailors, whose tattoos were considered to be professional insignia. All convicts were held accountable for every tattoo on their body, and had to explain how they were acquired.

Apart from the tattoos of criminals and sailors, Russians had virtually no other body decorations. One exception was the forced branding of the red star, applied to many soldiers of the Red Army after the fall of 1919. Officially, this was explained by the necessity to prevent these troops deserting or siding with the enemy. But branding of this kind, was commonly perceived as the 'sign of the antichrist', particularly as the procedure itself was so humiliating.

After the Great Patriotic War drawings on the body acquired secret symbolism. This was connected with a schism in the criminal world. Tens of thousands of Gulag convicts fought against the Nazis as part of penal military units. These battalions and companies were created on 28th July 1942 by Order Number 227 of the People's Defense Committee. Initially, only soldiers who were 'guilty of disrupting discipline through cowardice and lack of rigour' were sent to penal units. Later, after the fortunes of war had shifted, and the number of 'deserters, cowards, saboteurs, and

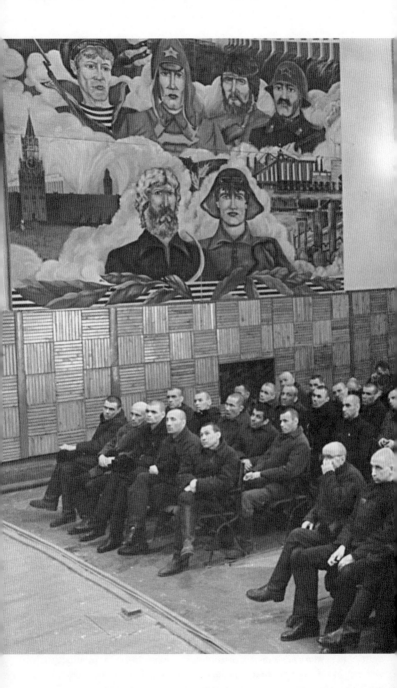

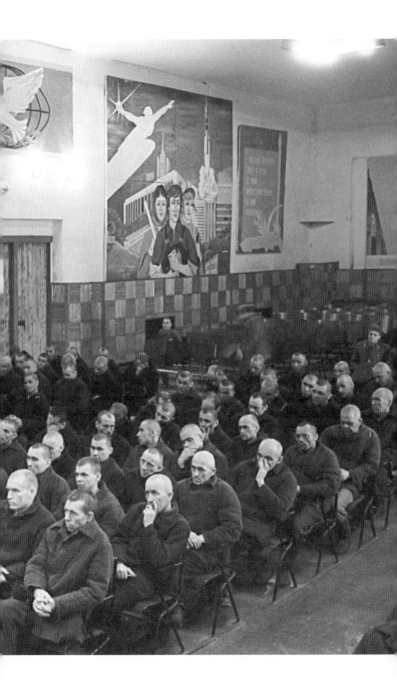

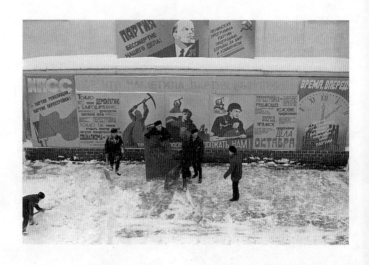

weak-willed' dwindled, Stalin used convicts to replenish these penal units. Most of these were professional recidivists who preferred death from a bullet to death from starvation.

However, according to the thieves' code, an 'honest swindler' was not permitted to serve in the military. It was considered shameful treason, even though it was a matter of defending the motherland. A thief who tarnished his honour in this way became demoted to an uninitiated *frayer* (outsider), or a *muzhik* (male peasant). In other words, he became an ordinary, unprivileged convict who was forced to do drudgery for the legitimate thieves.

Meanwhile, former legitimate thieves who had fought on the front line were unable to make an honest living in civilian life. Having lived a profligate lifestyle, they were unaccustomed to working hard for meagre wages. After demobilisation, most of them resumed their usual civilian professions: robbery, theft, and murder. Many ended up back in prison, expecting to receive honour and respect from the other inmates. They knew they had breached the thieves' code, but consoled themselves that somehow this could be resolved: they had left their partners in crime behind in the prison camps, with whom they had conferred on important issues during their 'conferences'. Together, they had made decisions about their codes and created their rules. In addition they had 'defended the motherland from the foe'.

Winner Takes Nothing

The heroic past of the frontline veterans did not impress the criminal brotherhood. If a thief accepts a weapon from the hands of the government he loses his calling permanently. He becomes a *suka* (a traitor, a bitch).

A veiled struggle for power in the criminal world lurked behind this stigmatisation. In theory, the thieves who were former frontline combatants were in a position to overpower the 'legitimate' criminal elite, who had waited out the war in prison camps. Their military past, combat experience and exploits, could potentially privilege them in the eyes of other prisoners. For the 'legitimate' thieves the scarcity of food during the post-war years also played a role. Accepting the returning thieves back into the brotherhood would mean extra mouths to feed – they would have to tighten their belts and share – it would be easier simply to increase the numbers of drudges with the new 'outlaws'.

Initially the legitimate thieves wanted no confrontation with the traitors – merely to put them in their place. Their fate behind the barbed wire was to work like all the *muzhiks* (peasants) in the camp. Their former mates, who had remained loyal to the code, would live off their labour. But the traitors could not accept this role.

They decided to stand up to their former brothers and form their own criminal elite. They turned to the Gulag officials, and offered their help

in keeping the legitimate thieves under control. This role was not dissimilar to that of the *polizei* of local populations in territories occupied by the Nazis.

The officials immediately accepted the offer of the 'bitch caste', and wars between 'thieves' and 'bitches' broke out. They were so brutal that the officials had to intervene to clear up the bodies. To keep the factions apart the Gulag administration ordered the creation of separate prison camps for bitches and thieves. Using the principle of divide and rule, the authorities often threw bitches to the thieves, or vice versa.

The bitches used tattoos to spot their ideological enemies and retaliate against them. In special 'bitch zones', under the approval of the officials, they conducted searches among the thieves, forcing them to publicly renounce their criminal past and adopt the 'bitches' faith'. Those who refused were killed. Writer Varlam Shalamov,[3] a former labour camp prisoner, describes the procedure:

> The wardens' new servant didn't waste any time. King strolled back and forth in front of the detainees, stared intently at each one in turn, and shouted:
> 'Step out! You, you, and you!'
> King's finger moved, pausing frequently and always on target.
> 'Take off your shirt. Now!'
> The tattoo, this insignia of the order, played its destructive role. Tattooing yourself is a mistake that young convicts make. The permanent drawings make it easier for the criminal investigator. But the tattoo's fatal significance only now becomes clear to them.
> The retaliation began. With feet, clubs, brass knuckles, stones, and a 'legal mandate' from the wardens, King's gang massacred the followers of the old thieves' code.

The New Elite

Before the war, most bitches were legitimate thieves, they spoke the same argot, wore the same tattoos. During periods of carnage, bitches who ended up in the 'thief zone' might pretend to be 'honest thieves' in order to survive. The Gulag was vast, rumours travelled slowly, many bitches had connections among the legitimates, and many legitimates had friends among the bitches: often it was impossible to tell a bitch from a thief.

The secret symbolism of tattoos became a method for uncovering impostors. The tattoos unmistakably displayed the status of the bearer within the hierarchy of the criminal world – his 'honours', his trade (pickpocket, burglar, etc.), biographical details, character traits, and more. Tattoos had to be accounted for, and the wearer could be made to pay with his blood for any that flouted custom or were undeserved.

Because bitches and thieves wore the same tattoos, only a failure to explain their meaning exposed the traitor to the thieves' code. A frequent image before the 'bitch war' was a dagger piercing the heart. The legitimates imparted a secret message to a modified version of this

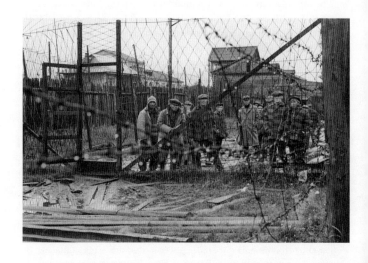

image, adding an arrow to the dagger – indicating the desire to seek vengeance against those who had violated the thieves' code. The compass rose expressed aggression to the prison officials. Tattooed on the shoulders it corresponded to the vow 'I will never wear epaulets' (an expression of hatred toward the bitches who had served in the Soviet Army). If tattooed on the knees, the compass rose came to mean, 'I will not kneel before the police.' Images of compass roses (usually in pairs) were called 'thieves' stars' and were initially tattooed only on thieves.

The bitches, unaware of these telling details that had developed within the tattoos, gave themselves away. In the early 1950s, it became customary for thieves to tattoo dots or small crosses on the knuckles, the number of dots indicating the number of terms. Other new symbols, such as images of insects, began to appear. An ant, beetle, cockroach, and bumblebee became pickpocket's emblems.

Acronyms and abbreviations were a manifestation of the wit of the thieves' brotherhood. The legitimates tattooed short words that by themselves looked ordinary or innocent: *KOT* (tomcat), *LORD* (nobleman), *SLON* (elephant), *BOG* (god), and many others. Any 'honest thief' had to learn what each acronym stood for: *KOT – Korennoy Obitatel Tyurmy* (Native prison inhabitant), *LORD – Legavym Otomstyat Rodnye Deti* (Coppers beware, our children will avenge us), *SLON – Suki Lyubyat Ostry Nozh* (Bitches love a sharp knife), *BOG – Byl Osuzhden Gosudarstvom* (Sentenced by the state), and so on.

Such wordplay only worked for a short time. Ultimately, these secret messages became part of the prison tradition and lost their power as weapons against the bitches.

Religious Tattoos

The rite of initiation of a convict to the thieves' caste is known as a coronation or baptism. The origin of the former is easy to explain – upon initiation, the *urka* (slang for criminal) who has successfully completed the trials is tattooed with a crown, a symbol of power. Baptism is not as straightforward, the complex historical relationship between religion and criminal society warrants a more detailed explanation.

Piety cannot be considered a tradition among the legitimate thieves. In the criminal world of czarist Russia there was no respect for religion or the church: according to the 19th century Russian populist Peter Yakubovich,[4] all convicts despised the clergy. This hatred stemmed from the unconditional support given by the government to the church. At the same time the clergy preached resignation, patience, and non-resistance on the part of the people. This especially outraged the rebellious and refractory outlaws.

When the Bolsheviks declared the clergy among their greatest enemies, convicts immediately voiced sympathy for this view. Mockery

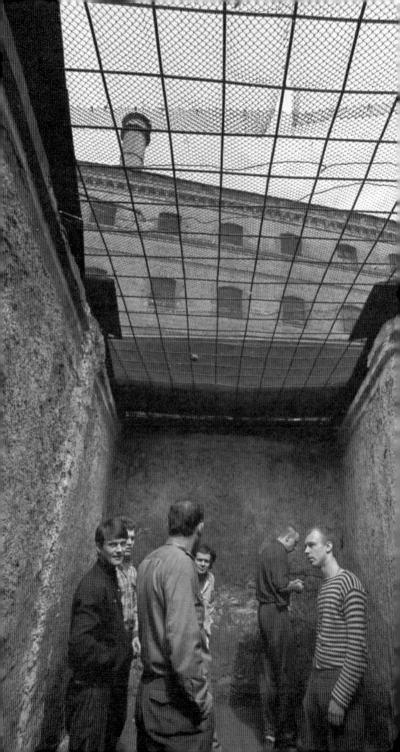

and denigration of both church and faith, as well as the humiliation and persecution of priests, was the typical conduct of the Soviet state towards the church. The criminal world and the prison community acted in a similar fashion.

In the late 1930s, however, the authorities' attitude changed. Traditional religion played a necessary role in consolidating the cult of personality and the totalitarian state. Another important factor in this ideological shift was the preparation for war with Germany. The Germans were determined to destroy both Russia and its political regime. Patriotism and national pride had to be awakened, and the Russian Orthodox Church was indispensable for this purpose. Anti-religious propaganda was curtailed as party leaders referred to the positive role of Orthodoxy in Russian history, and the authorities tried to win the support of the religious sector of the population.

The criminal world immediately adapted to these changes in attitude. From the mid-1930s the legitimates proclaimed themselves to the 'keepers of the true Orthodox faith', and changed the name of the thieves' initiation ceremony to 'baptism'. In reality, the two were not dissimilar. First, the newcomers were converted to a new faith – the thieves' faith. They were then given new names: a *klikukha* (alias), or *pogonyalo* (nickname). From then on, they were only addressed by this moniker. Lastly, each new convert was given a 'thieves' cross', either worn around the neck on a string, or tattooed on the chest. This was similar to the Orthodox cross in appearance, but often bore additional distinctive features. The cross was usually embellished with the wearer's favourite image: a heart, playing cards, perhaps a naked lady. In this way thieves' crosses were distinguishable from those worn by other prisoners, especially *kulaks* (convicted rich peasants).

In addition to crosses, other religious tattoos included the Madonna and Child, churches, angels, and so on. Later, during the 'bitch wars', these tattoos acquired more defined meanings. The crucifix and the Madonna and Child, depicted in the Orthodox tradition of icon painting, meant 'my conscience is clean before my friends', 'I will not betray'. The Madonna signified 'prison is my home' – that the wearer was a multiple offender and recidivist. The number of domes on the tattoo of a church indicated the number of convictions. If a dome was adorned with a cross, it meant that the sentence had been served in full – *do zvonka* (until the sound of the bell). Orthodox religious tattoos are still among the most popular among criminals today.

Nikita the Corn King Declares War

In the 1950s, the situation in Russian prisons and labour camps changed, and this affected the criminal tattoo. After a series of amnesties (beginning with the famous Beria amnesty of 1953), a romanticism

developed around the 'noble world of thieves'. Hordes of pardoned convicts poured from the prisons and, like the sailors and adventurers before them, they spread their colourful tales. With their exotic tattoos, heartbreaking 'rogues'' songs and jaunty, cruel argot, these people quickly became heroes for street adolescents.

The intelligentsia who were pardoned after the 20th Congress of the Communist Party cultivated these myths. Members of the creative elite promoted the poetics of this subculture far more successfully than any mere criminal could. Inspired youths tattooed themselves in an attempt to emulate their new criminal idols. Just like real criminals, they wanted to distinguish their 'brothers' from the 'others', and the symbolism of the tattoo played its familiar role.

In the latter half of the 1950s, Nikita Khrushchev declared a policy for the complete eradication of criminality in Soviet society. He promised that soon he would display the very last Russian criminal. A succession of films was released following this pronouncement – *The Rumyantsev Case* (1955); *Case No. 306* (1956); *Believe Me, People* (1964) – all portrayed a dark criminal world, and thieves who had turned their backs on a life of crime. In *Night Patrol* (1957), the role of Ogonek, a criminal who severed his ties with the underworld, was played by Mark Bernes, a famous Russian singer and actor. As a direct result of this film, many prisoners openly denounced professional criminals, and numerous ex-cons followed the example of Bernes's character. Rumours circulated that criminal bosses had ordered his murder. This propaganda culminated in an unprecedented act when in 1959, Khrushchev personally met with an ex-'legitimate thief' and helped him start a new life. News of this meeting was promptly circulated through national media.

Simultaneously, the government mounted an attack on professional criminals. Sentences for severe offenses committed by recidivists and 'other dangerous asocial elements' increased. The Central Prison Authority (formerly known as the Gulag) adopted new measures, depriving convicted criminals of basic rights. Packages, letters, and visitation hours were reduced, while punishments intensified.

A special prison camp for legitimate thieves was created near Sverdlovsk. All those calling themselves 'legitimates' were sent here in stages. The main goal of the facility was to make 'honest thieves' renounce their codes and traditions. Cruel methods were applied to this end, including beatings and torture. The thieves retaliated against these excesses by intensifying their own codes and laws. Before the Great Patriotic War honest thieves numbered in the thousands – now only the most deserving were crowned. Their ranks dwindled from tens of thousands to a few hundred. The punishment for the slightest attempt to position oneself as a legitimate or to wear an undeserved tattoo was severe. At best, the tattoo would be removed with sandpaper or a razor,

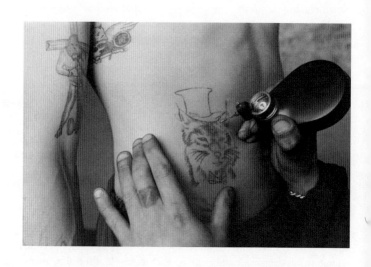

but it was not uncommon for the offender to be raped or killed. Convicts were even punished for tattooing more dots on their hands than sentences they had served, or for wearing a ring tattoo with the symbol of a crime they hadn't committed. There was no alternative – the legitimate thieves were suspicious of anyone attempting to pass themselves off as one of their own. In these hard times, the status of the legitimate thieves increased.

During this period shaming or forcible tattooing became commonplace, and was applied to those who were 'lowered' to the shamed caste – those who were made passive homosexuals. They were tattooed with dots 'beauty marks', on the forehead, the cheeks or above the upper lip; or with an image of a woman and a snake entwined, on the back. They were also marked out by special ring tattoos on their fingers.

Easing of Tension

At the end of the 1970s, there was an easing of tension behind the barbed wire. This was a reaction to the excessive bullying practices of the criminal world. When the thieves made their codes more stringent in the 1950s any new arrival to a cell would be subjected to a barrage of trick questions, trials and rituals. Inmates who failed these tests underwent severe forms of humiliation, beating and torture. Sexual violation of those who transgressed the thieves' code was frequent at the end of the 1950s, until this time, these type of excesses were rare.

By the late 1960s, this cruelty had turned against the legitimates. There were so many shamed prisoners (passive homosexuals) that the administration started to use them as a weapon against the authoritative thieves – they were thrown into cells with those who had been raped by their fellow thieves. The shamed revolted against the legitimates in many prisons, and bloodshed ensued. The leaders of the criminal world demanded an immediate end to the excesses. Rites of passage were outlawed. Eventually, during one of the thieves' councils, a new rule was established: 'no punishment with the penis'. It was strictly prohibited to rape prisoners under any circumstances. Those who broke the rule were themselves shamed in this way. The 'house accounts for blood' rule appeared: physical violence, beatings, and fights between inmates were outlawed, conflicts were resolved by the cell's supervisor (an inmate), who, if need be, could appeal to the warden. A natural consequence of this 'humane' policy was the gradual disappearance of punishments for wearing illegitimately acquired tattoos.

The fashion for tattooing had swept through the juvenile prisons. They tattooed themselves with every design and inscription, including the trademark thieves' tattoos. This put the authoritative thieves in an impossible position. Realising they were unable to enforce their laws on the youth who were so in awe of them, they eventually gave up – allowing them the freedom to tattoo whatever they liked.

Flowers and Dragons Versus Thieves' Stars

In 1985, perestroika dealt the final blow to the secret symbolism of the Russian criminal tattoo. The numerous reforms in Russia resulted in a plethora of tattoo parlours and made piercing and tattooing fashionable. Newcomers with flowers, dragons, and snakes flooded the prisons. The total number of tattooed convicts increased.

According to prison figures at the beginning of the 1980s, fifty-six percent of adult prisoners wore tattoos, today seventy-one percent have tattoos. Of these, sixty-five percent have both decorative and criminal tattoos. In addition to the characteristic prison motifs, prison tattoo artists now also specialise in purely decorative tattoos. This has changed the function of the criminal tattoo as a signifier of status. In his book *The Criminal Subculture*,[5] author Daniil Koretsky states:

> Currently, in places of detention, tattoos do not reflect internal hierarchies. Violence is no longer used against criminals who bear unsanctioned tattoos. Tattoos are no longer applied forcibly, and the criminal tattoo is giving way to ordinary decorative tattoos.

But it would be wrong to assume that the criminal tattoo has completely lost its symbolic significance. Although it has ceased to be the mark of a criminal hierarchy, they continue to adorn their bodies with their personal history, character traits, criminal trades and political outlooks. Tattoos are still the trademark of the professional criminal.

1. Mikhail Gernet, 'Tattoos in Places of Incarceration in the City of Moscow' (*Tatuirovki v mestakh zaklyucheniya g. Moskvy*) (Moscow, 1924).

2. Mikhail Demin, 'Convict' (*Blatnye*) (Moscow: Panorama, 1991).

3. Varlam Shalamov, 'Kolyma Stories' (*Kolymskie rasskazy*). (Moscow: Sovetskaya Rossiya, 1992).

4. P. Yakubovich, 'In the World of the Outcast. Notes of a Former Labour Camp Convict' (*V mire otverzhennykh. Zapiski byvshego katorzhnika*). (Moscow – Leningrad: Khudozhestvennaya Literatura, 1964).

5. D. Koretsky, V. Tulegenov, 'Criminal Subculture and Its Criminological Significance' (*Kriminalnaya subkultura i ee kriminologicheskoye znachenie*) (St. Petersburg: R. Aslanov Publishing House, Yuridichesky tsentr Press, 2006).

Photographs. Section One

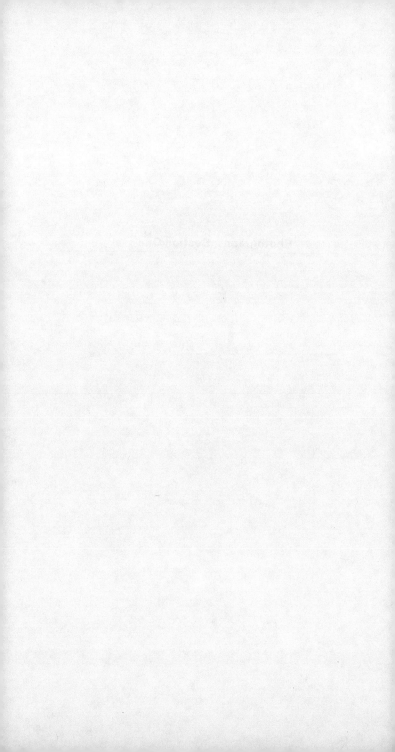

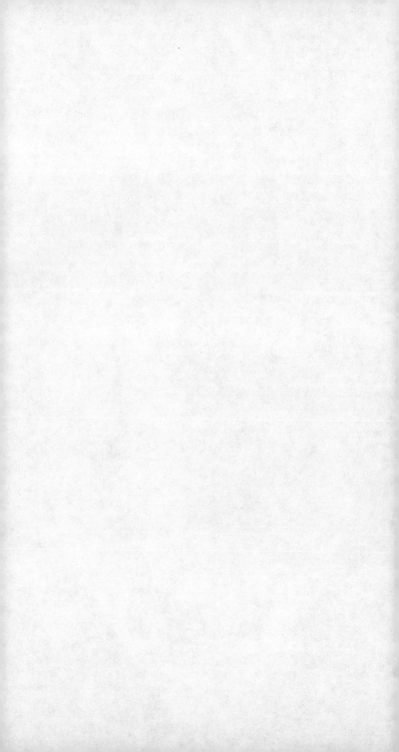

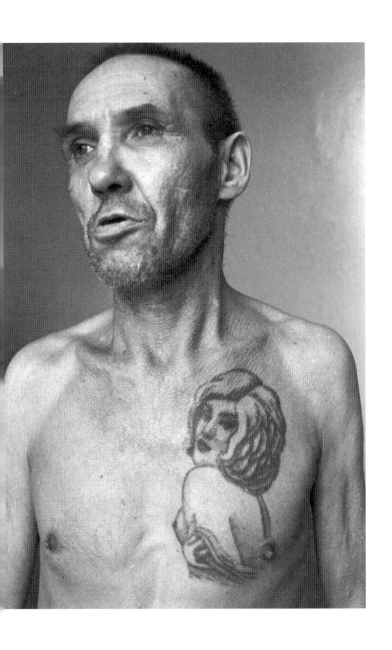

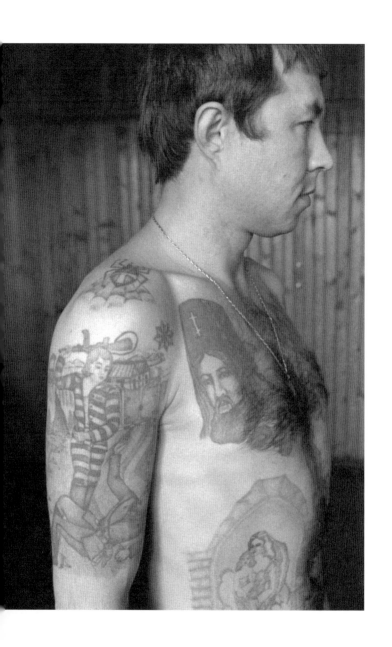

53

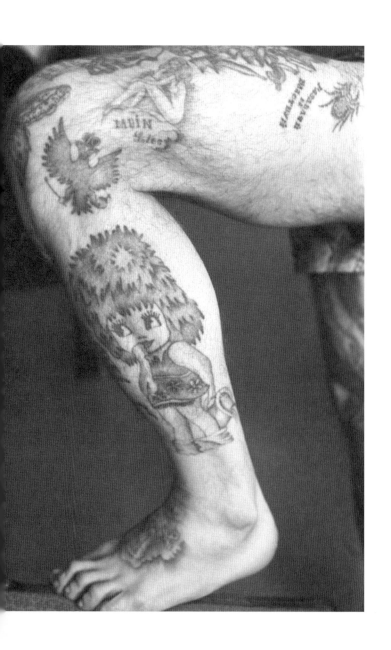

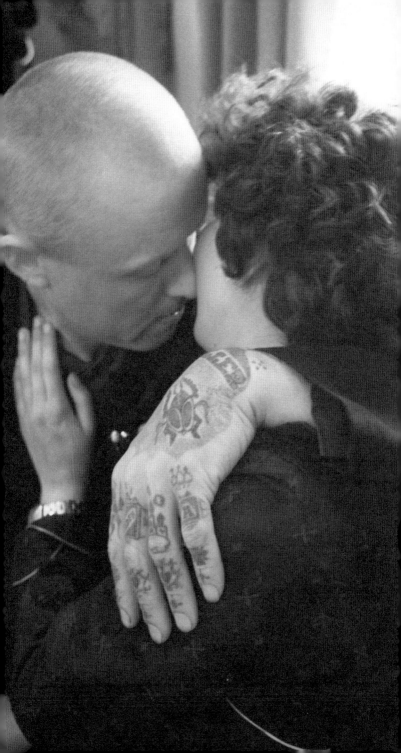

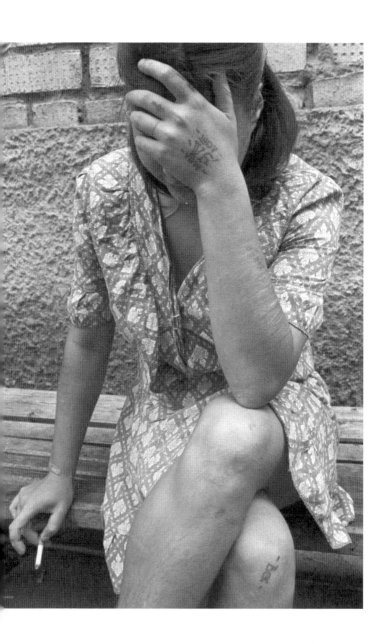

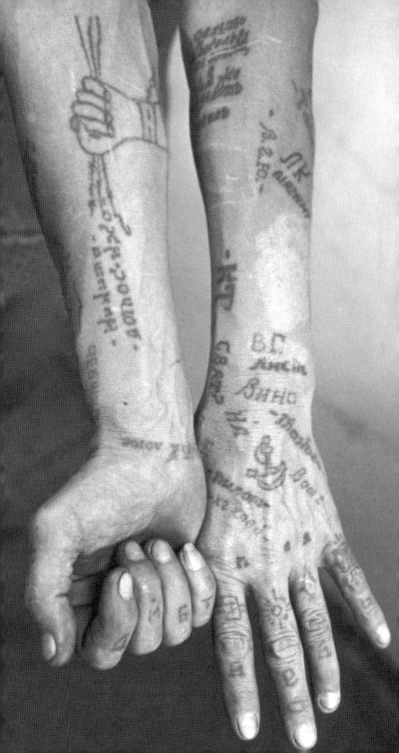

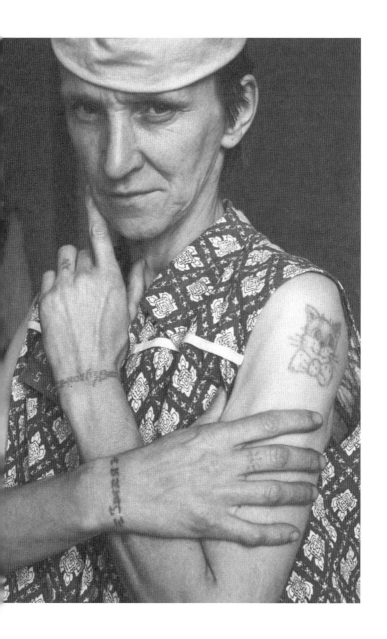

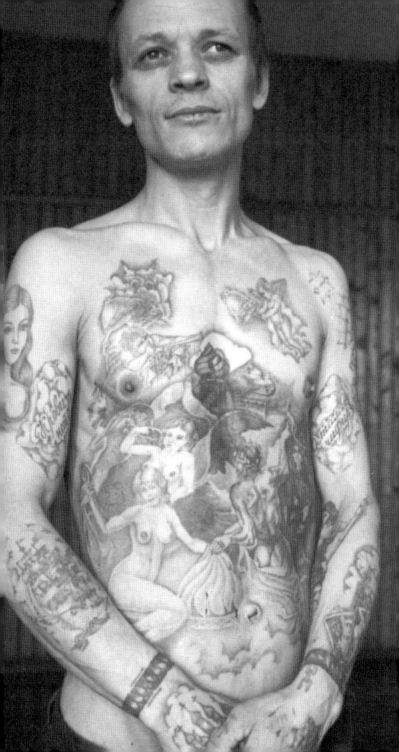

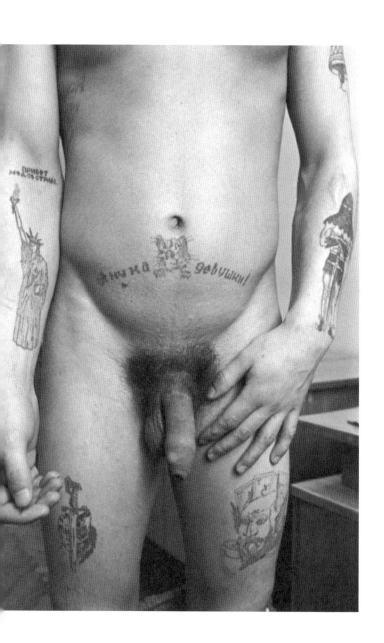

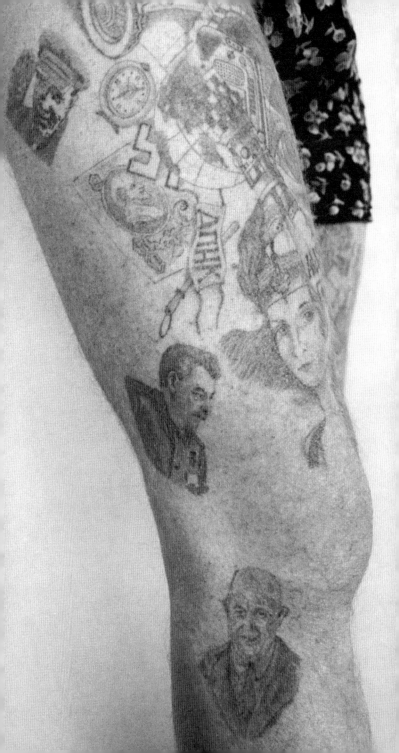

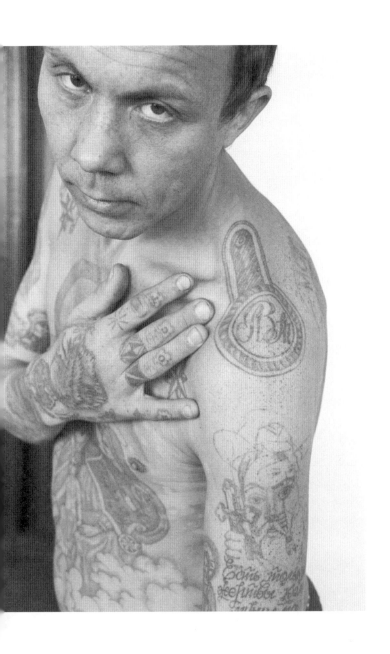

71

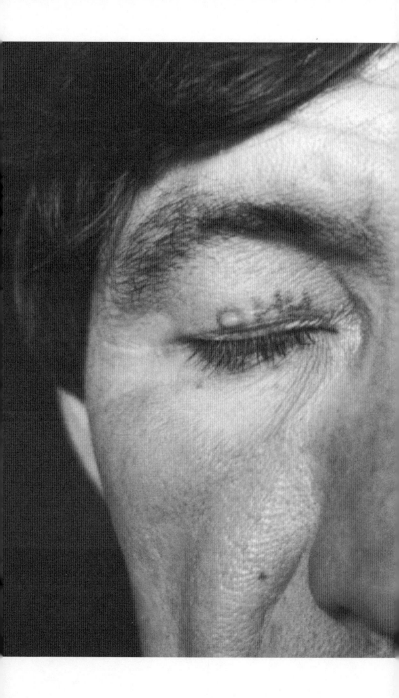

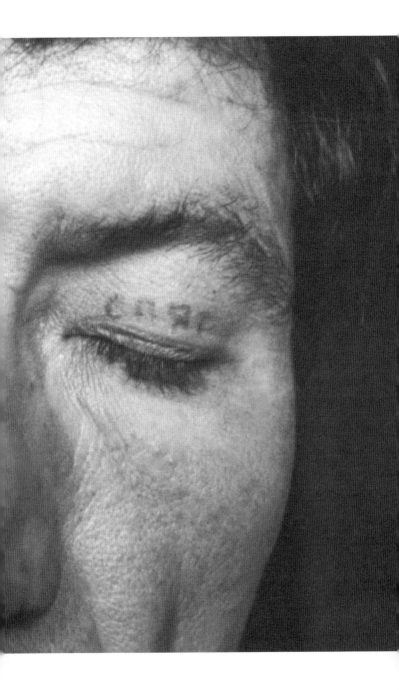

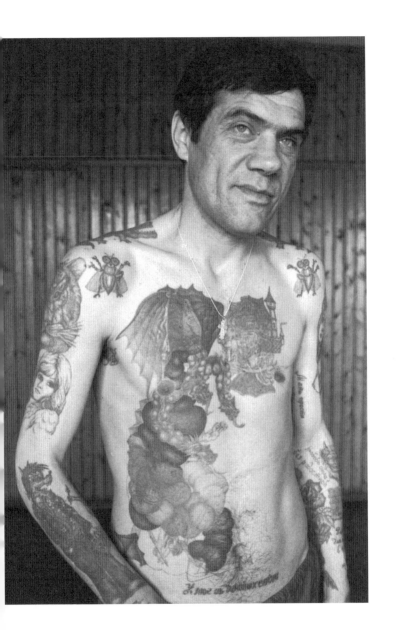

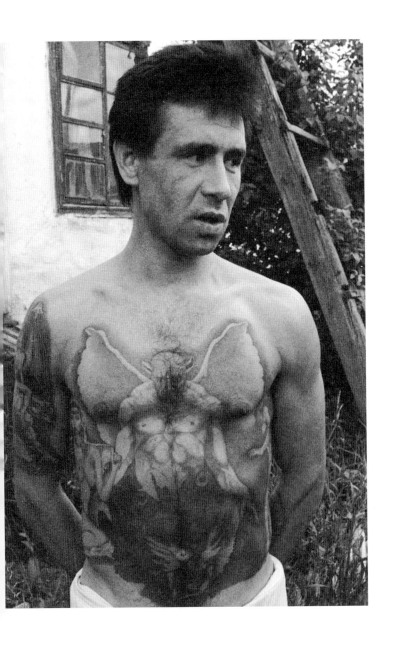

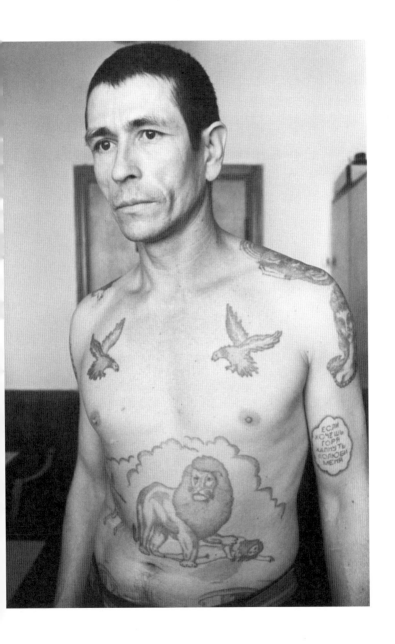

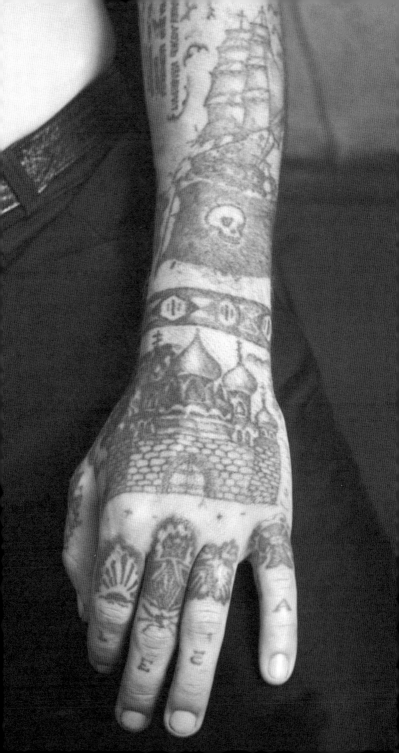

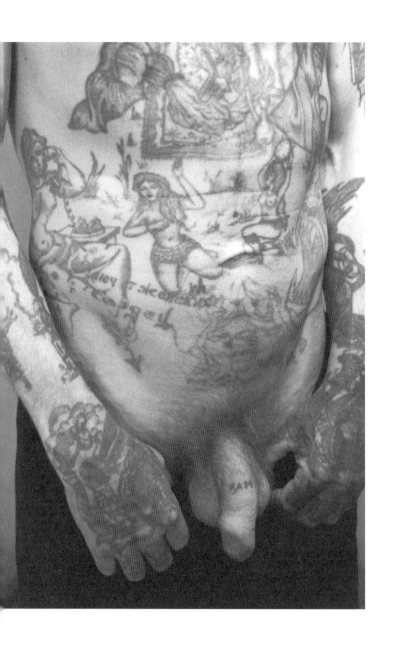

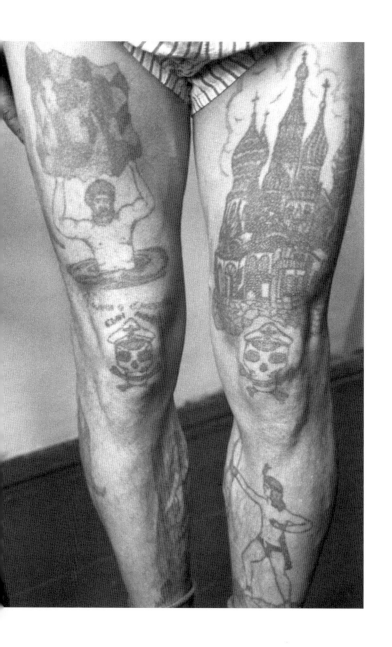

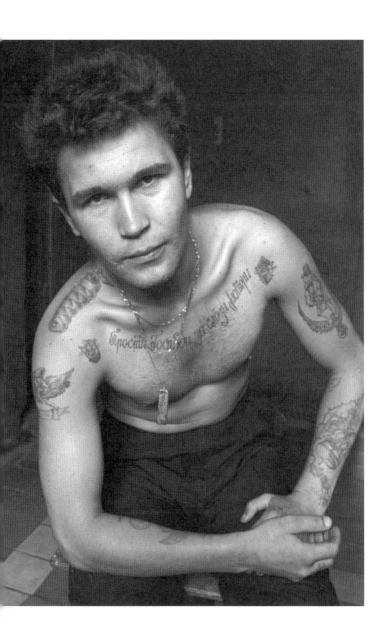

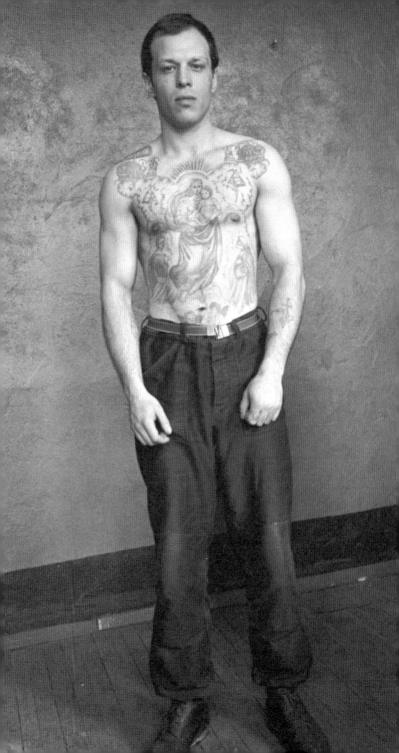

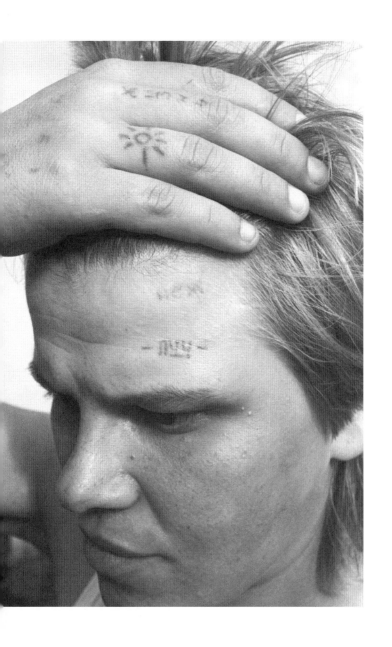

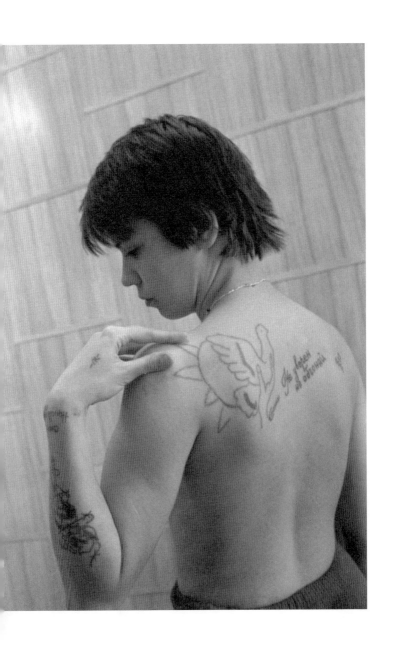

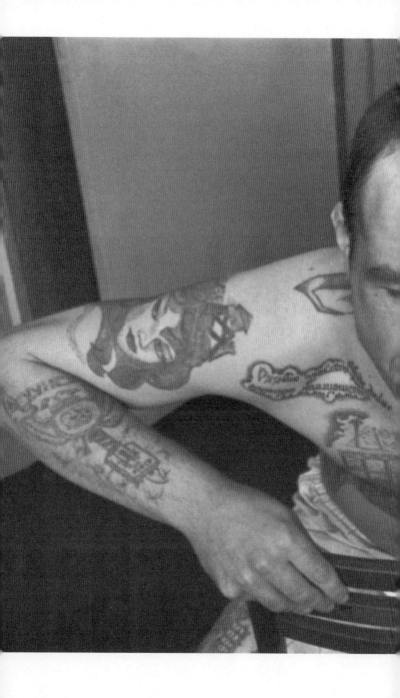

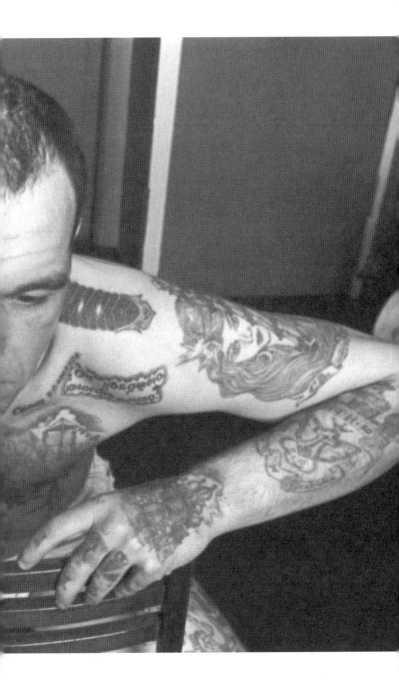

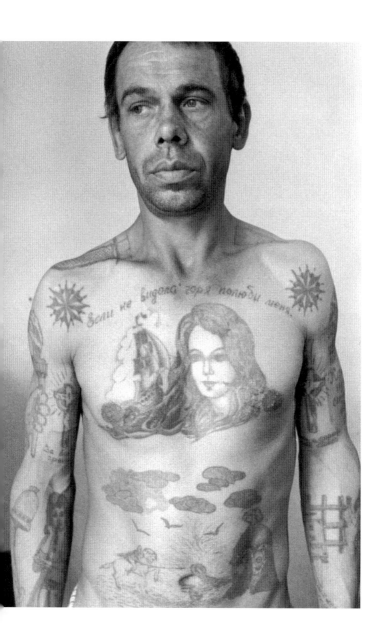

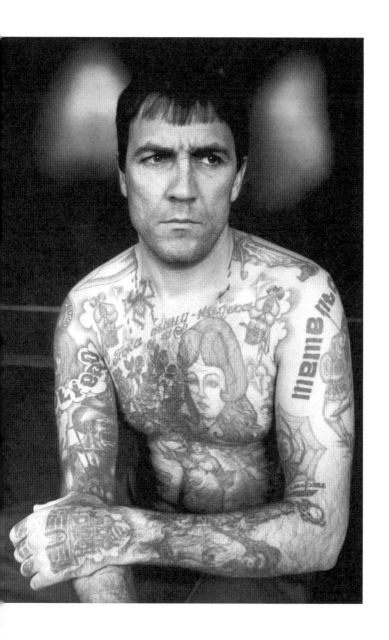

Drawings. Male Tattoos

Text at the top reads **'With Karl Marx's "Capital" and a happy smile to the Jewish Gulag'**. Text on the book reads **'K. Marx. Capital'**. Text on the woman's bottom reads **'Belorussia'**. Text in the fart cloud reads **'Lenin's bullshit and baloney'**. Text underneath reads **'Forward, towards communism!'**.

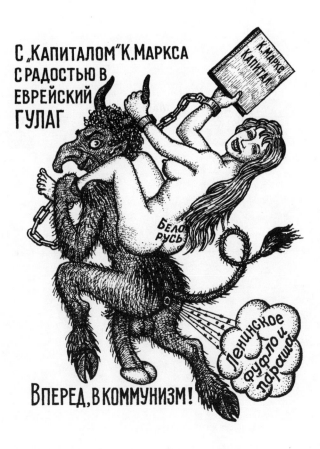

Detention Centre No.1. 1965.

A Belorussian nationalist tattoo belonging to a man sentenced for arson. He had burnt down the home of a Jewish store manager who had previously worked in a prison. The tattoo was made in Bobruisk Corrective Labour Camp.

Lenin shouts **'Shoot!** [them]'. Text on the coffin **'Communist Party'**. Text underneath reads **'Forward, towards communism!'**.

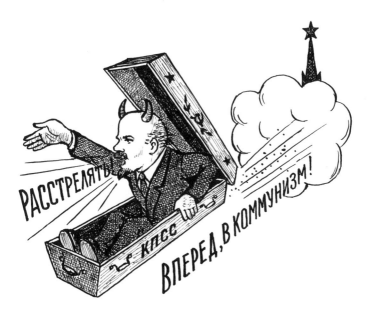

Corrective Labour Camp No.5, Metallostroy Settlement, Leningrad. 1980s. Right side of stomach.

This tattoo was copied from a prisoner sentenced under Articles 206 and 108 of the Criminal Code of the RSFSR of 1960 for hooliganism and causing severe injuries. The prisoner named Stepan, assaulted a car mechanic who had asked him for a bribe for a new truck. Full of indignation, Stepan said that life was unbearable because of communists. His grandparents were dekulakised. In 1947, his father was arrested for praising Studebaker, Dodge, Chevrolet, Ford, and other American vehicles. His father was shot in a prison camp in Norilsk. His mother was left with three young children, they lived in poverty.

Text above the drum reads **'101 km. 1952'**. Text on the drum skin reads **'Decree of the Presidium of the Supreme Council of 4th June 1947'**. Text on the side of the drum reads **'Luga'** (a town south of St. Petersburg).

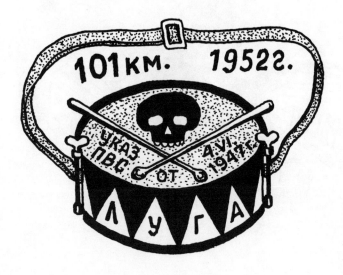

The tattoo of a prisoner sentenced under the Decree of the Presidium of the Supreme Council of the USSR of 4th June 1947 and exiled to '101 km' (a generic term denoting the distance in kilometres from a larger city) after he served his term. In the 1940s and 1950s former convicts were not permitted to live in cities. Convicts caught outside their assigned dwelling area were detained. After three consecutive detentions the convict would be sentenced for violating the residence law.

Latin text reads **'Said and Done!'**. Text on the dagger reads **'Article 102'** [of the Criminal Code].

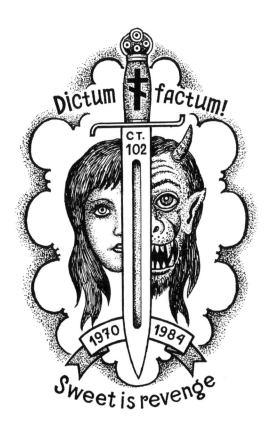

Ministry of Internal Affairs Regional Hospital. 1970s.

This type of tattoo, known as 'bared teeth' or 'werewolf', is very common. The bearer was sentenced to fourteen years for murder.

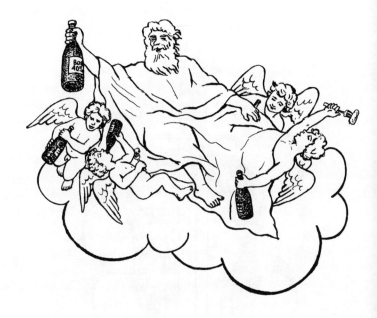

Prison No.1, Leningrad. 1950s.

This picture of Bacchus, the god of wine and merriment, was tattooed on the stomach of a prisoner sentenced under Article 74 of the Criminal Code of the RSFSR for hooliganism. He and his three friends took two drunk prostitutes behind wooden sheds in one of the courtyards on Maly Prospekt, Leningrad. They pushed a crumpled cigarette packet filled with cigarette butts, a matchbox, wine bottle corks, and food remains wrapped in a piece of Pravda newspaper into the vagina of one of the prostitutes. Then they pushed an empty quarter of a litre vodka bottle into the vagina of the other prostitute, an alcoholic and homeless woman. They finished the humiliation by urinating on them. All four were detained, sentenced, and imprisoned. It was the second imprisonment for the bearer of this tattoo. It was made during his first term in Corrective Labour Camp No.5, Metallostroy Settlement.

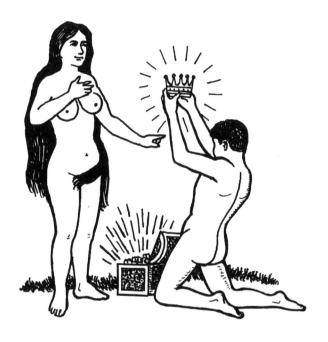

Stomach.

The symbolic meaning of this tattoo is: 'I had everything but now I'm in captivity', or 'I'll get around the law; it's not for me.'

'I can see my fate'

Prison No.1 (Kresty), 7 Arsenal Embankment, Leningrad. 1949. Lower stomach.

Men's thieves' tattoo.

Detention Centre, 39 Lebedeva Street, Leningrad. 1994. Left shoulder blade.

Youth tattoo.

The owner of this tattoo described Brezhnev's doctrine as a tank, 'Crushing socialism through Chechnya and Dagestan, and probably in Azerbaijan, Tatarstan, Bashkorostan, Kazakhstan, and Kirgizstan... He will regret it when the merciless imperial Russian sword crosses with the Muslims' yataghan.'

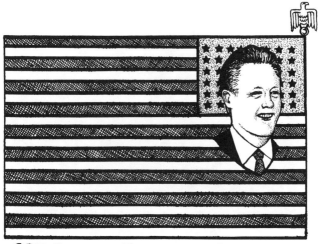

CША - Ум, Богатство, Сила!

Public swimming pool, 30 Zvenigorodskaya Street, St. Petersburg. 1997. Right side of chest.

The tattoo of a sailor, who had been to the United States.

German text reads **'Don't wait for them to hit you'**.

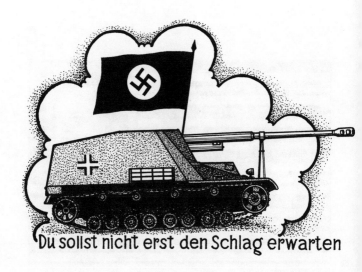

Leningrad. 1949. Chest.

This German nationalist tattoo was explained by its owner: 'I fought in the battle near Moscow. It was a slaughterhouse for us, but even more so for the Russians. The German troops were drowning in the blood and bodies of dead Russian soldiers and officers. The Kremlin Marxist government and command, defending their Jewish Communism, had no mercy on the Russian people who were alien to them. They forced them to die on the battlefield in their millions.'

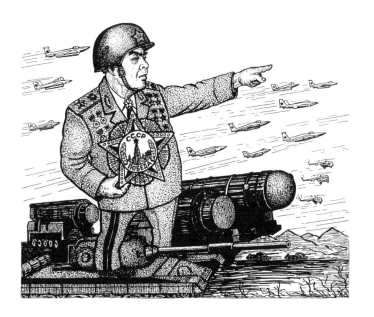

This tattoo is known as 'The most ingenious commander of all time and all peoples, Generalissimo Brezhnev.' He is wearing the Order of Victory – one of the rarest military decorations, it is only awarded to generals and marshals.

I first encountered satanic tattoos in the 1950s, when I was collecting material (criminal subculture, slang, and lore) across the specialised prison camps, corrective labour camps, and corrective prisons of the Gulag. According to the administrations and operatives of these institutions, satanist prisoners systematically violate prison rules, refuse to do labour, and are extremely antagonistic toward the prison authorities and the law enforcement system. As a rule, they are asocial and can be characterised by their bullying and violence towards physically weaker inmates. These insults, intimidation, and atrocities against other prisoners bring them sadistic pleasure. They believe that Satan rules the world – not God, and that kindness is a flaw of the weak. That strong and brutal people are the true masters, and those who are weak in body and spirit must succumb to their will, and blindly follow their orders.

Because such prisoners are so anti-social it was very difficult to copy their tattoos, over a decade I collected no more than three or four. I had a strong feeling that the so-called satanists were mentally divergent people, whose souls were full of venom and fanaticism against those around them. Virtually every punishment for violating prison rules – including punishment cells and solitary confinement – was ineffectual against them. Satanists respected only force and savage brutality.

It was only half a century later that I read *The Mysterious World of Satanists* by Yury Sandulov – an exhaustive study of the reasons behind the appearance of satanic cults. The book contains many unique historical documents, and a meticulous investigation into the development of such sects from ancient times to the present day.

It was only after I'd read this book that I began to understand the mystery of the satanists' symbols, which they had kept concealed from me when I was collecting material across the prisons of the USSR. I have come to believe that this occult sect has a profoundly negative impact on Russia and Russian society. We must fight it using all available methods and not allow it to develop. We need to use powerful counter-propaganda in the mass media. We must fully explain to the public at large the dangers of satanism using these concrete examples.

Many of these symbols are tattooed on a satanist's hand between the thumb and the index finger. They may also be found on the forearm and the shoulder (very rarely on other parts of the body). I believe that many 'baring teeth at the authorities' tattoos stem from these satanic tattoos. They are an attempt to imitate them and the 'romanticism' of *otritsaly* (prisoners who refuse to submit to the prison rules).

i 'Drug dealer'. The stylised sailboat stands for *uplyt* (literally 'to sail or float away'), a Russian slang term for the state of euphoric ecstasy reached when using drugs.

ii 'Mixed cross'. This symbol comes from ancient Rome. It calls into question the existence of Jesus Christ and by extension, Christianity itself.

iii This symbol is from the Nine Satanic Commandments chapter of *The Satanic Bible*.

iv A 'guiding' sign. Used to point in the direction of a meeting place.

v A variation on the 'guiding' sign.

vi A symbol of strength and power.

vii A triangle is often found drawn on the ground in places where rituals take place. It is thought that the Devil can be contained inside it.

viii Signifies a 'trader of arms' and 'equipment'.

ix 'Anti-Law' or 'Lawlessness'. A double-bladed axe, an ancient symbol of justice. Used in the sense of the dual interpretation of the law.

x This sign originally meant 'stealing children'. Today it has the broader meaning of kidnapping to obtain a ransom.

xi 'Theft' or 'Robbery'. This symbol may also be used to mark a convenient place for a robbery.

xii 'Traitor of Satan'. Symbolises a person who betrayed the Code of Satan. Used for vendettas, this mark is often found on dead bodies.

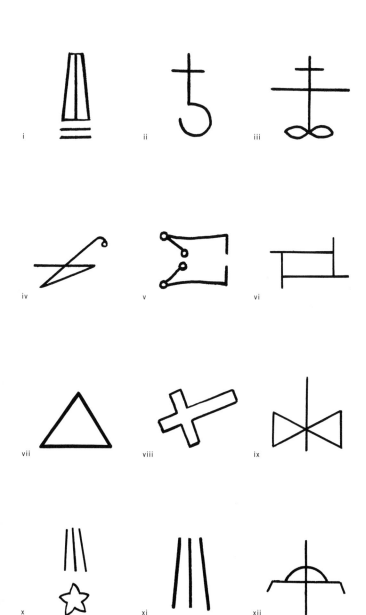

i ii iii

iv v vi

vii viii ix

x xi xii

xiii The meaning of this sign is 'compulsion', or 'violence'. The bearer will use violent methods to force a person to do something.

xiv 'Sex is a magic zone'. Denotes that the area will be used for sexual rituals.

xv A sign designating an area for a 'Blood Ritual'.

xvi A sign prohibiting Christian services in the area.

xvii Symbol of Baphomet (or 'The Sabbatic Goat'). The head of a horned creature inside an upside down pentagram, contained within a double circle.

xviii A sign for 'The Black Mass'.

xiv Variations on 'The Number of the Beast'.

xv Satanists often spell words backwards. The most common of these are the words 'Satan', 'Amen', and 'Murder'.

xvi The symbol of Astaroth, a 'Prince of Hell', keeper of Hell's treasures.

xvii The symbol of Belial, the demon of perfidy and lies.

xviii The symbol of Baal, the demon of destruction.

xix The symbol of Asmodai, the demon of lust and family conflicts.

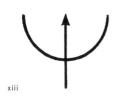

xiii

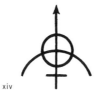

xiv

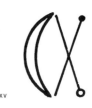

xv

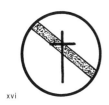

xvi

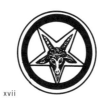

xvii

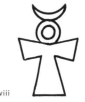

xviii

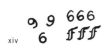

xiv

xv

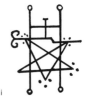

xvi

xvii

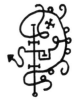

xviii

xix

xx The seal and symbols of Lucifer from *Grimorium Verum* (*The Grimoire of Truth*), a book of black magic from the 16th century. To be effective these symbols must be drawn in the magician's blood on a piece of parchment that is kept on his person throughout the ritual service.

xxi A variation on a symbol of Lucifer from *Grimorium Verum*.

xxii A variation on a symbol of Lucifer from *Grimorium Verum*.

xxiii A variation on the seal of Lucifer from *Grimorium Verum*.

xxiv The book of black magic by Pope Honorius contains figures and spells addressed to Satan. All the black magic rituals have to do with Satan, but those described in *The Grimoire of Truth* are by far the most vivid and numerous.

xxv A sign meaning 'Anarchy'.

xxvi This symbol meant 'peace' in the anti-war movement of the 1960s. In occultism it is called a Neronic Cross, or The Broken Cross, and signifies the defeat of Christianity.

xxvii A symbol of the Black Mass.

xxviii The upside-down pentagram can be interpreted as marking a gathering place for homosexual satanists.

xx

xxi

xxii

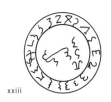

xxiii

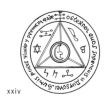

xxiv

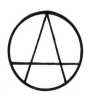

xxv

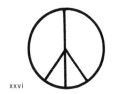

xxvi

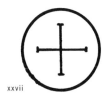

xxvii

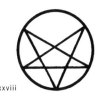

xxviii

'The Jew, seducer of sluts...'

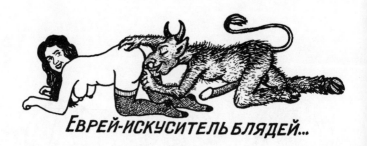

ЕВРЕЙ-ИСКУСИТЕЛЬ БЛЯДЕЙ...

Corrective Labour Camp, Leningrad. 1973.

An anti-Semitic youth tattoo. In the Russian Empire, and later in Soviet Russia, anti-Semitism (and antagonism towards other ethnicities) was always strong among uneducated Russians. During Soviet times they played the role of the 'bigger brother' and having been brought up with a sense of aggression, they were always looking for someone to blame. The backward among the Russian population have always envied Jews: their high level of education, organisational skills, abstinence from alcohol, and their contempt for the indolent 'lumpen proletariat'. These uneducated, retrograde Russians live only for the moment, thoughtlessly accepting propaganda informing them that Russia is surrounded by hostile people who intend to destroy Russian values.

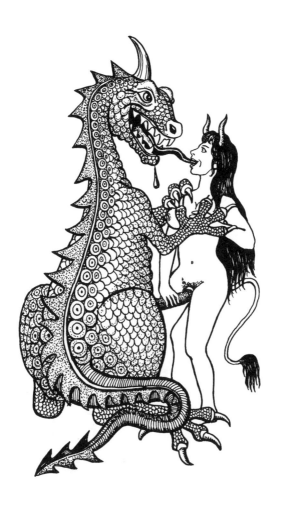

Corrective Labour Camp No.9.

A male decorative pornographic tattoo. These tattoos became popular among younger convicts after chewing gum wrappers depicting cartoon characters became available in the early 1990s.

The skeleton holds the Order of the October Revolution. Text on the sign reads **'90 million were killed'**. Text on the skeleton's sash reads **'Communists, repent!!!'**. Text underneath reads **'Down with the Communist Party!'**.

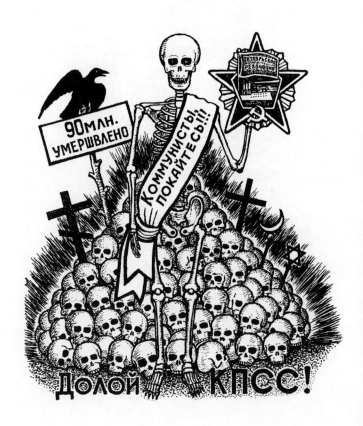

Dzhidastroy Corrective Labour Camp, Buryat-Mongol ASSR. 1960s.

An anti-communist tattoo.

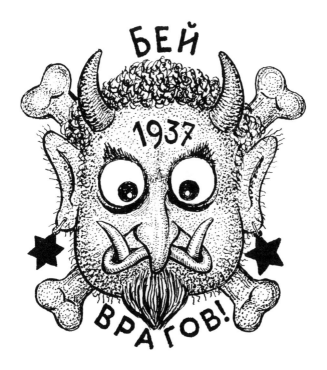

Kraslag. 1951.

A rare tattoo of a 'lifer' who was the son of a participant in the Antonov Peasant Revolt of the 1920s. Troops commanded by Marshal Mikhail Tukhachevsky used Soviet tanks and poisonous gas to suppress the revolt. The cavalry of Grigory Kotovsky – infamous for their cruelty, especially towards women, children, and the elderly – also participated in the suppression. In the 1930s the NKVD hunted down relatives of the participants and sent them to the Gulag.

Various texts read 'A man always wants to, but can't always do it, and a woman can always do it, but doesn't always want to'. 'Love is a grand affair'. 'One should be caring with a woman'. 'What woman wants is what God wants'. 'Farewell and keep loving me'. 'I lived and loved'. 'Wine, women, and song'.

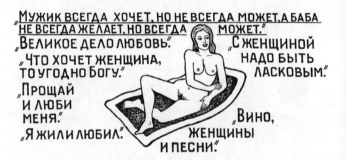

Leningrad Region. 1967.

Various phrases accompanying men's tattoos of women. These tattoos, found on various parts of the body, often looked like epaulets. They were popular in the men's corrective labour camps of Leningrad and the Leningrad Region in the 1960s and 1970s.

Text on the donkey's book reads **'Communist Party Charter'**. Text on the bear's book reads **'Lenin'**. Text in the box reads reads **'The Communist Party is our epoch's mind, honour, and conscience!'**. (A typical slogan of the Soviet era.)

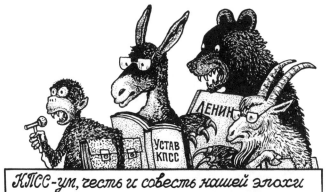

КПСС-ум, честь и совесть нашей эпохи

„Политзверинец ЦК КПСС,","Они правят нами."
Молодежная. Редкая. Наносится на ягодицу.

Maximum Security Corrective Labour Camp No.9, Goreloveo, Krasnoselsky District, Leningrad Region. 1959. Buttock.

This rare youth tattoo is known as the 'Political Zoo of the Central Committee of the Communist Party', or more simply as: 'They rule us'.

Text at the bottom reads **'Kill Masonic Yids!'**.

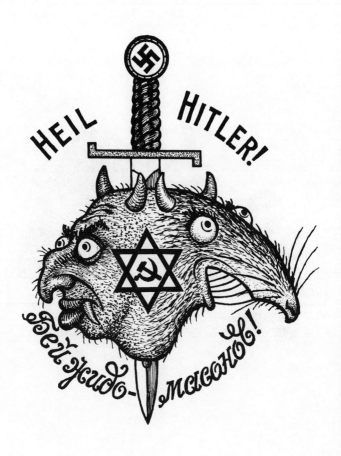

Nadvornaya Police Department, Ivano-Frankovskaya Region, West Ukraine. 1961.

Nationalist Ukrainian tattoo.

'The Russian people, in these difficult times, need their own leader, an Adolf Ivanovich Hitler, to fight against the Jews who rob Russia. They sneaked into the higher echelons of power, just as they did in 1917, and are doing Satanic harm in order to destroy the Russian land.'

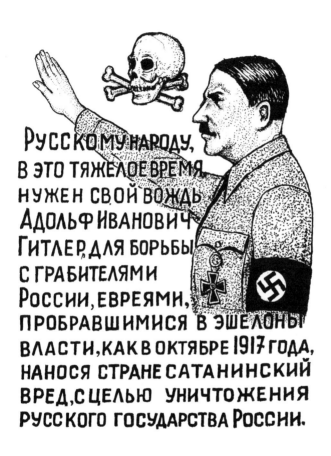

РУССКОМУ НАРОДУ, В ЭТО ТЯЖЕЛОЕ ВРЕМЯ, НУЖЕН СВОЙ ВОЖДЬ АДОЛЬФ ИВАНОВИЧ ГИТЛЕР, ДЛЯ БОРЬБЫ С ГРАБИТЕЛЯМИ РОССИИ, ЕВРЕЯМИ, ПРОБРАВШИМИСЯ В ЭШЕЛОНЫ ВЛАСТИ, КАК В ОКТЯБРЕ 1917 ГОДА, НАНОСЯ СТРАНЕ САТАНИНСКИЙ ВРЕД, С ЦЕЛЬЮ УНИЧТОЖЕНИЯ РУССКОГО ГОСУДАРСТВА РОССИИ.

Enkhaluk, Buryatia. 2000.

The tattoo of an ex-convict sentenced under Article 58-10 of the Criminal Code of RSFSR of 1926 for anti-Soviet propaganda; and under Article 206 of the Criminal Code of RSFSR of 1960 for hooliganism. He served these terms in both the Ust-Kura Corrective Labour Camp and Angarlag in the Irkutsk Region. He was released under a pardon issued by Mikhail Gorbachev in 1987.

Text on the left reads **'Glory to the Communist Party!!!'**. Text at the top and bottom reads **'The joy of a farmer from AgroGulag, the Honourable Worker of Socialist Labour'**. Text on the award reads **'Lenin'**.

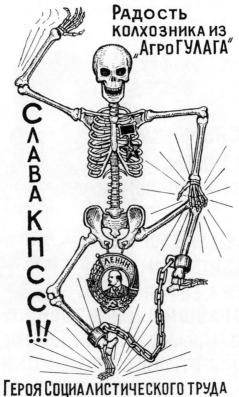

Corrective Labour Camp No.9. 1981. Hip.

A caricature of the Communist Party. The tattoo of an *otritsala* (a convict who refuses to submit to any kind of authority), who was frustrated with the length of his sentence (nine years). He was caught stealing food and gasoline from a *kolkhoz* (collective farm) warehouse. According to the bearer, the tattoo symbolises 'a *kolkhoz* farmer after paying taxes to the government'. Another popular interpretation is: 'I turned in the meat, the skin, the fur, and the balls. Now I'll just turn in my bones for recycling and that'll be it.' Variants of this tattoo depicting a skeleton were popular in the 1950s and 1960s among convicts opposed to the Communist Party.

Text (translated from the original Mongolian) reads **'The most difficult years for Russia are the years of the snake: 1905, 1917, 1929, 1941, 1953, 1965, 1972, 1989, 2001, 2013, and 2025 – the year when Russia will collapse'**.

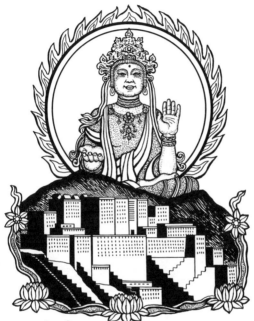

ДЛЯ РОССИИ САМЫЕ ТЯЖЕЛЫЕ ЭТО
ГОДЫ „ЗМЕИ": 1905, 1917, 1929, 1941, 1953,
1965, 1972, 1989, 2001, 2013, 2025-БУДЕТ
ПОЛНЫЙ РАЗВАЛ РОССИИ

Enisey Railroad Station, Kraslag. 1956. Chest.

A rare Kalmyk Buddhist tattoo. It's meaning can be interpreted as: 'O Great Buddha, punish the Kremlin gang of executors and murderers'.

Text reads **'SLON'**. This acronym, which spells the Russian word for 'elephant', has various interpretations: **'Death to police from knives'**; **'Bitches only love the authorities'**; **'Bitches love a sharp knife'**; **'My heart is longing for you alone, forever'**.

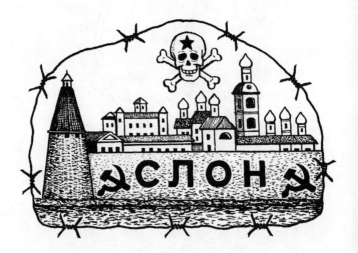

Konyashin Hospital. 1985. Left side of the chest.

The tattoo of a legitimate thief nicknamed 'Fartovy' who died peacefully in his sleep from a heart attack at the age of eighty-four. According to 'Fartovy', he had served a total of forty-two years in prison.

'Lord, save your humble servant Yuri from misfortune!'

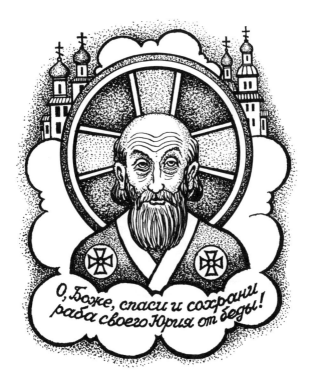

1960s. Chest.

A thieves' lucky charm tattoo.

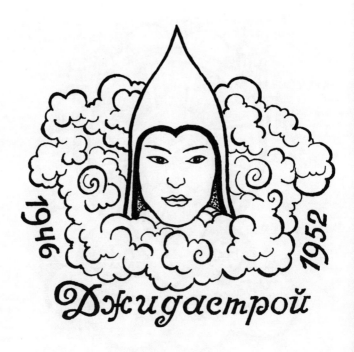

Corrective Labour Camp, Ulan-Ude, Dzhidinsky Region.

The tattoo of a Buriat-Mongol criminal. It imitates a Russian good luck charm.

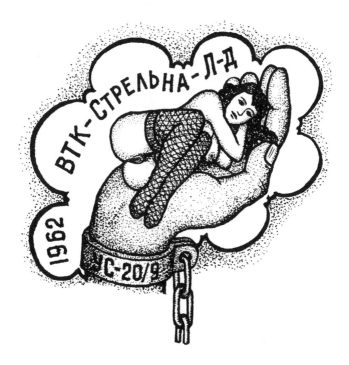

Corrective Prison Camp No.9. 1970s. Hip.

Men's youth tattoo. The bearer was transferred to the adult corrective prison camp from a juvenile correctional institution.

Specialised Prison Camp, Ust-Kut. 1950s. Hip.

An invitation to the Black Mass.

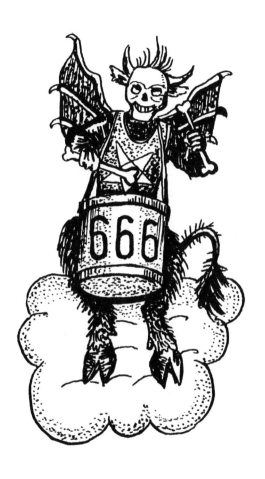

Regional Hospital of the Ministry of Internal Affairs, 1 Khokhryakova Street, Leningrad. 1972. Left hip.

A variant of an invitation to the Black Mass.

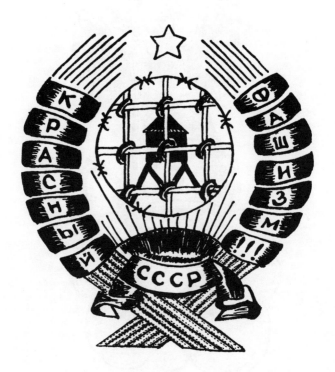

Detention Centre No.2, 39 Lebedeva Street, Leningrad. 1990. Left hip.

A *portachka* (poorly executed youth tattoo) of a derivative USSR coat of arms. The bearer was an open opponent of the Communist Party and frustrated with the length of his term. He was sentenced under Article 89 of the Criminal Code of the RSFSR of 1960 for the appropriation of national and public property.

ДОНСКОЕ КАЗАЧЕСТВО

Police Department No.41, 10 Kupchinskaya Street, St. Petersburg. 1999.

Tattoo on the left shoulder of a convict sentenced in 1990 under Article 206 of the Criminal Code of the RSFSR for hooliganism. The image was copied from a beer label. He considered himself a descendant of the Don Cossacks. He was detained for being intoxicated.

Text at the top reads **'Communist Party. KGB'**. Text on Gorbachev's forehead reads **'Perestrelka!!!'** (literally 'shootout', the word looks and sounds similar to perestroika). Text underneath reads **'Mishka the Collective Farm Worker'**. Mishka is a diminutive of Mikhail (Gorbachev).

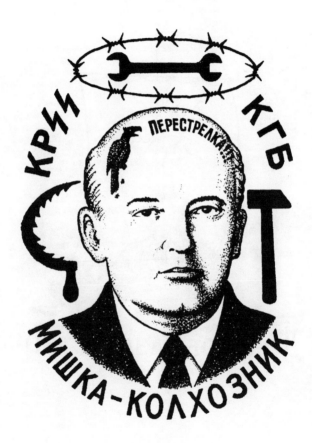

Detention Centre for Minor Offenders, 6 Kalyaeva Street, Leningrad. 1992. Hip.

A thieves' tattoo. The bearer was sentenced twice under Article 144 of the Criminal Code of the RSFSR for theft. He had been imprisoned for fifteen days for debauchery in his apartment.

Text on the left reads **'The law of the Communist Party of the Soviet Union is like a cart's pole...'**. An alteration of a proverb which states 'Any law has a loophole'. Text on the right reads **'A Soviet prosecutor from the Public Prosecutor's Office'**. The root of the word 'prosecutor' is altered to read 'dick'. Text on the book reads **'Criminal Code'**. Text on the penis reads **'Law'**.

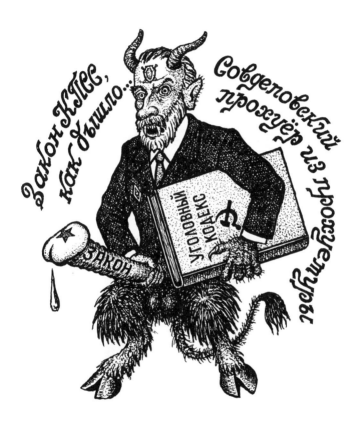

A typical criminal 'baring teeth at the authorities' tattoo. Widespread in the 1970s, this tattoo is called 'The All-Knowing Public Prosecutor', and has several variants.

Texts on the foreheads read **'Dog. Communist Party. Slave'**. Text on the tattoo parodies the words of the Soviet national anthem **'The Union of starving republics has been forever united by Kremlin Russia'**.

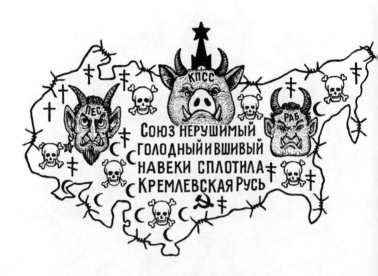

Corrective Labour Camp, Alma-Ata. 1972. Shoulder blade.

A 'baring teeth at the authorities' caricature tattoo. The map depicts the location of mass-murders of Muslims and Christians by communists.

The text on the scythe reads **'Glory to the Soviet Communist Party!'**. The text at the bottom reads **'And Lenin is still a young bloody devil. October is still ahead!'** (A parody of a popular Soviet song, the real lyric is: 'And Lenin is so young and youthful. October is still ahead.') Dates on the heads **'1887'** the year of Lenin's birth.**'1917'** the year of the October Revolution.

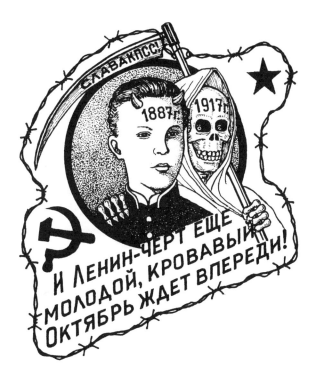

Military Unit 48868, 25 Strelbishchenskaya Street, Leningrad. 1976. Hip.

The tattoo of a Dagestani soldier from an engineering battalion.

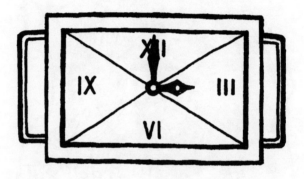

Special Detention Centre for Misdemeanours, 6 Kalyaeva Street, Leningrad.
1960s. Left wrist.

A tattoo from the Gulag era worn like a wristwatch. It means 'I did my time
in full' – the prison term was not reduced because of good behaviour or good
labour. The phrase 'One day was mine, two of the guard,' was used to
describe the system where a convict's sentence might be reduced by as much
as a third if he obeyed the authorities and fulfilled his labour quota by one
hundred and fifty-one percent. In reality this was a very rare occurrence.

'Warning! Informer'. The Russian 'seksot' comes from 'SEKretny SOTrudnik' (secret employee).

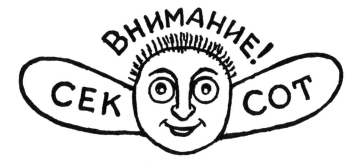

Angarlag Specialised Prison Camp, Bratsk. 1954.

The forcibly applied tattoo of a prisoner who informed on his cell mates.

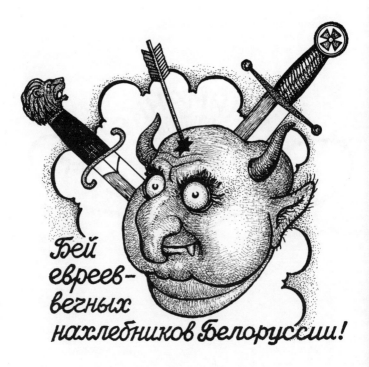

Voronezhskie Public Baths, Leningrad. 1970. Right hip.

This anti-Semitic Belorussian tattoo was made in the Oresh Detention Centre. The bearer had been sentenced to four years in prison after a fight in a local club. He served his term in a corrective labour camp in the Arkhangelsk Region. In 1966, he came to Leningrad and married the sister of one of his fellow inmates. He settled in Leningrad and worked in the Glavleningradstroy construction department together with his wife.

'Whores, kobylkas, kovyryalkas, koblas, and pinks [prison slang for active lesbians] **are better off dead!'**

Бляäям, кобылкам, ковыряялкам, коблам, розовым жить на свете вредно!

Ukhtasanlag Prison Camp, Komi ASSR. 1950s.

The tattoo of a prisoner serving twenty-five years. He had murdered his wife and her lesbian partner, after discovering them at home together. He was sentenced by the Decree of the Presidium of the Supreme Council on 26th May 1947.

Text (translated from the original German) reads **'Everyone is led by his passion! Do not succumb to misfortune, but boldly meet it!'**

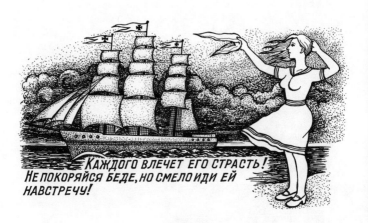

Prisoner of war camp, Sverdlovsk. 1950. Back and shoulder blade.

This tattoo commemorates the Academy of Sea Cadets in Warnem-Jund. The bearer was a naval signaler during the war who was captured in Stettun in 1945.

'1 kopeck. 1960'.

Corrective Prison Camp No.6. 1960s.

A thieves' tattoo called 'The Cheap Whore'. The prisoner who wore this tattoo was sentenced under Article 144 of the Criminal Code of the RFSR for theft of valuables from homes. The stolen items were found at his girlfriend's apartment. She assisted the investigation by revealing where the items came from, and when he had acquired them. The dates coincided with when the thefts were reported.

Popular beetle tattoos.

i This popular thieves' tattoo is the symbol of a pickpocket, a 'pincher'. Tattoos of this type made on both sides of the neck denote multiple violations of prison regulations. Corrective Labour Camp No.7, Leningrad Region. 1960s. Between the thumb and the index finger.

ii A *portachka* (poorly executed youth tattoo) from a female convict sentenced by the Decree of the Presidium of the Supreme Council on 4th June 1947. An extreme *otritsalovka*, (anti-social and anti-Soviet), she referred to communists as infidels and regularly breached prison regulations. She was convinced that this lucky charm tattoo would bring her good fortune in and out of prison. The letter *M* stands for her name, Margarita. The cross denotes that she was baptised. Bedbugs are the the prisoners' inseparable companions. The cells were full of them, constantly biting feet and legs. Taishetlag Specialised Prison Camp for Women. 1950s. Left forearm.

iii In thieves' mythology the scarab is the symbol of good luck and happy living. The bearer of this tattoo, nicknamed 'Macha', was sentenced twice for theft. A former inhabitant of the Juvenile Corrective Institution in Teltsy, he told me that the scarab brought him good luck – he always had a full stomach. Angarlag Specialised Prison Camp, Bratsk, Irkutsk Region. 1950s. Stomach (and often other parts of the body).

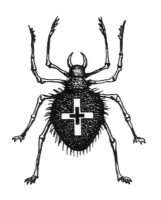

i

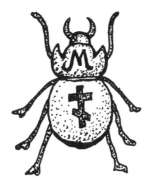

ii

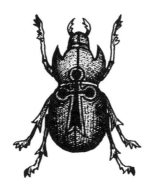

iii

The correct English text should read **'Satan, not God, rules the world!'**

Not Yo but Devib
zules a wzld!

Prison No.1, Leningrad. 1956. Left side of the chest.

Satan is depicted as a woman holding the globe.

A passive homosexual's tattoo.

Text at the top reads **'Werewolf of the Soviet Union'** the word 'sovok' (shovel) is used as a pejorative name for the Soviet Union. Text on the book cover reads **'Privileges of the People's Deputies of the Russian Federation'**. Text around the barbed wire reads **'His place is in jail, and he's still prancing on a rostrum in the State Duma…'**.

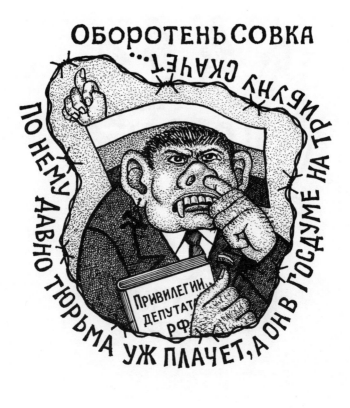

Corrective Labour Camp No.4, Forposovo, Leningrad Region. 1981. Left hip.

A political caricature tattoo from a prisoner sentenced for hooliganism after he'd written obscenities on a socialist competition poster. He also received five years under Article 109 of the Criminal Code of the RSFSR for seriously injuring two private entrepreneurs who, according to him, had refused to pay after he'd repaired their car.

Text on Gorbachev's forehead reads **'Perestrelka!!!'** (literally 'shootout', the word looks and sounds similar to perestroika). The symbol below the word is the state quality mark of the USSR, which was applied to consumer goods of the highest quality. Text underneath reads **'Mikhail Raisovich is a hero of Foros. The Kremlin's scapegoat.'** 'Raisovich' is a made up patronymic, which stems from the name of Gorbachev's wife, Raisa. 'Foros' is the resort town in Crimea where Gorbachev spent four days of forced isolation during the 1991 Soviet coup attempt.

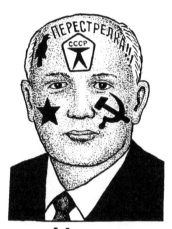

Hospital No.32, 4 Lasaretny Lane, Leningrad. 1993. Buttock.

An anti-communist caricature tattoo of a prisoner sentenced under Article 206 of the Criminal Code of the RSFSR for hooliganism.

Text at the top reads **'Love forever!'**. Text in the the hearts reads **'Peter. Hilda'**.

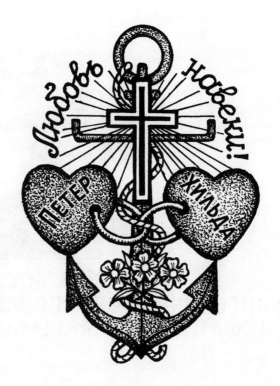

Prisoner of war camp, Leningrad. 1954.

A lyrical keepsake tattoo.

Glory to the Communist Party!

Corrective Labour Camp No.9, Gorelovo, Leningrad Region. 1980s. Stomach.

A rare thieves' tattoo. 'Baring teeth at the authorities' it expresses hostility towards the Communist Party and law enforcement agencies.

The Latin text reads **'I'll make you remember me'**.

Faciam ut mei memineris

Detention Centre No.2, 39 Lebedeva Street, Leningrad. 1971. Hip, stomach.

A youth tattoo from the 1960s and 1970s. Worn by prisoners who opposed
law enforcement organisations.

Voronezhskie Baths, Ligovsky Prospekt, Leningrad. 1978.

An artistic 'baring teeth at the authorities' tattoo called 'The Big Boss of the Zoo'. Widespread in the 1970s and 1980s.

'AIDS test'

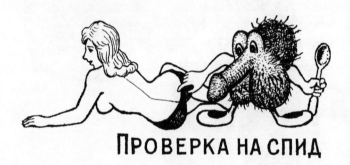

ПРОВЕРКА НА СПИД

Detention Centre No.2. 1995.

A humorous *portachka* (poorly executed youth tattoo).

The French text reads **'What woman wants is what God wants'** (a woman's will is God's will).

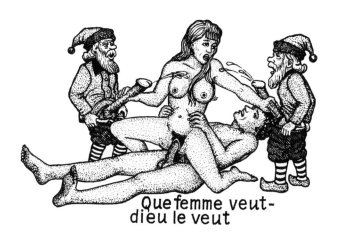

Que femme veut- dieu le veut

Detention Centre No.1, Leningrad. 1992.

A humorous tattoo.

'1917–1987. You should think with your head, not your arse, like they do in the Kremlin!'

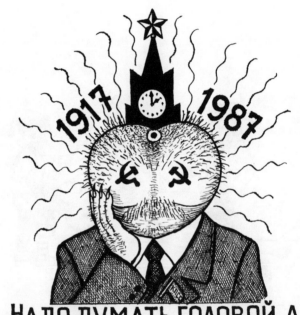

НАДО ДУМАТЬ ГОЛОВОЙ, А НЕ ЖОПОЙ КАК В КРЕМАЕ!

Police Department No.27, Kuibyshev Regional Department of Internal Affairs, 3 Krylova Street, Leningrad. 1989. Right hip.

A 'baring teeth at the authorities' tattoo, applied in Corrective Labour Camp No.7, Yablonevka, Leningrad. The bearer was detained for urinating in the entrance hall of a residential building in Ostrovskogo Square while intoxicated. He was sentenced for a misdemeanour.

Surrounding text reads **'Rotten prosecutor'**. Text on the book reads **'Business'**.

1960s. Stomach, hip, or buttocks.

A typical criminal 'baring teeth at the authorities' tattoo. This has several variants. In criminal slang 'rotten' means 'experienced criminal investigator'.

Various thieves' stars.

i The tattoo of a thief and robber nicknamed 'Afghani'. After being detained at Moskovsky Railroad Station as a homeless person, he was taken to a detention centre at 10 Bakunina Street to have his ID checked. He turned out to be wanted by the Kiev Department of Internal Affairs for a series of robberies, and fleeing from a Ukrainian prison escort. 'Afghani' was ethnically Russian, born in Kharkov. He was demobilised in 1976. He had been previously imprisoned for robbery in Ukraine. Copied in Leningrad. 1989.

ii The tattoo of an authoritative pickpocket, nicknamed 'Yasha the Pianist'. A university dropout, he was very experienced and careful. Two crews of policemen from the Pickpocket Detention Unit of the Department of Internal Affairs in Lenoblgorispolkom, had been trying to catch him for a week. They finally caught him red-handed in the Passage Department Store. The tattoo means: 'May God give me wisdom, luck, and power'. After his last term in prison in the 1970s, he emigrated to Israel. Copied in Police Department No.27, Kuibyshev District, Leningrad. 1963.

iii One of the numerous 'counterfeit' tattoos imitating a true thieves' tattoo. Worn by *shushera* and *shelupen* (petty thieves) who attempt to gain influence among inmates in prisons where nobody knows them. They insult the wardens and intentionally seek conflict with the prison authorities in their attempts to show off in front of other prisoners. They are usually punished by their fellow inmates using 'Lenin's method of persuasion by force' – a beating. It takes a long time for them to recover from such 'persuasion'. Copied in Prison No.1, Leningrad. 1940s–1950s.

iv A thieves' tattoo called a 'Personal File' or a 'Cross of Articles'. The numbers refer to the articles of the Criminal Code of the RSFSR under which the bearer, nicknamed 'Vanya the Key Keeper', was sentenced. He was being treated for delirium tremens. Copied in Kashchenko Hospital, Leningrad Region. 1970s.

i

ii

iii

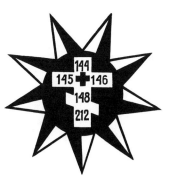

iv

v The tattoo of a thief from Ukraine called Pavlo. He had been sentenced twice, first for stealing fuel for a relative in 1946 when he was seventeen, then in 1951 under the Decree of the Presidium of the Supreme Council on 26th May 1947. During his second term, he was sent to work on the construction of the Moscow-Volga canal. There he befriended other thieves from Ukraine. He and his friends had 'protected' the prisoners in the camp from Moscow thieves. His tattoo means 'Save me, Lord, from starving, poverty, police, and communists.' Copied at the Kakhovskoe Reservoir, Skelki, Zaporoshskaya Region. 1960s.

vi The star of an authoritative thief who was transferred from the Butyrskaya Prison in Moscow to a prison in Leningrad. He was sentenced under The Decree of the Presidium of the Supreme Council on 4th June 1947. Copied at 6-8 Konstantinogradskaya Street, Leningrad. 1948.

vii A popular tattoo among young convicts. From the 1960s, it was widespread in the prison system throughout the USSR, especially in the North-West Region. It was particularly popular among relatively authoritative thieves and hooligans who strived to gain greater leadership, but avoided open confrontation with prison authorities. Copied at US-20/4 Institution, Fornosovo, Tosno District, Leningrad Region. 1998.

viii The tattoo of an authoritative thief, nicknamed 'Kitty'. He was sentenced to twenty years in prison under the Decree of the Presidium of the Supreme Council on 4th June 1947. The tattoo can be interpreted as 'Thief, conceal your life' and 'Kill stoolies and *choshoks*. They infect healthy people.' A *choshok* is a degraded convict who does all the dirty, shameful work. Copied in Prison No.1, Leningrad 1960s.

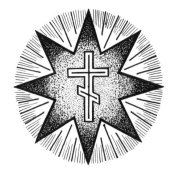

v

vi

vii

viii

ix The tattoo of an authoritative thief from Rostov-on-Don sentenced for a series of thefts and robberies in the resort of Stavropol Krai. The meaning of the tattoo is 'Man is wolf to man', or 'Wolves exist so that sheep won't sleep'. Copied in Nalchik Corrective Labour Camp. 1958.

x The tattoo of an authoritative thief from Odessa called Stanislav. It means 'I was born a thief', 'My profession is theft', 'I don't want to work and I'm not going to work. I'm not a slave'. Copied in Odessa. 1960s.

xi A Russian nationalist thieves' tattoo which means 'To Holy Russia, United and Indivisible!' or 'Long Live Monarchy!' Imperial Russian chauvinism is widespread in Primorsky Krai, in the extreme South-East Region, where this tattoo was made. This greatly offends the local people who have lived there for thousands of years. Copied in Vladivostok Prison. 1950s.

xii The tattoo of an authoritative 'legitimate' thief, nicknamed 'Luxe', born in 1929. It's meaning is 'I have never been and never will be a slave. My spirit and my body are free.' An ethnic Russian from Latvia, he was one of the prison's *pakhans* (criminal bosses), who was in open opposition to the Communist Party. When the Soviets came to power in Latvia, they took away his family's house. His parents and close relatives were persecuted and died in the Vorkutlag prison camps. He survived and spent his childhood and adolescence in orphanages and juvenile prisons, where he became a thief. He specialised in stealing goods from railroad freight cars. He never stole from workers or peasants, which he considered to be shameful. In total he'd spent over eighteen years in prison. He believes it 'an act of honour and valour' to steal public and national property from the government. He passed ten exams while in the Corrective Labour Camp of Komi ASSR. He likes reading fiction and believes that books have had a great influence on him. Copied at the Ministry of Internal Affairs Regional Hospital, Leningrad. 1969.

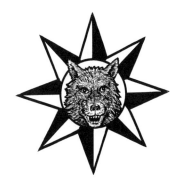

ix

x

xi

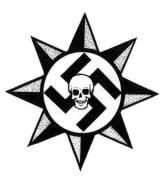

xii

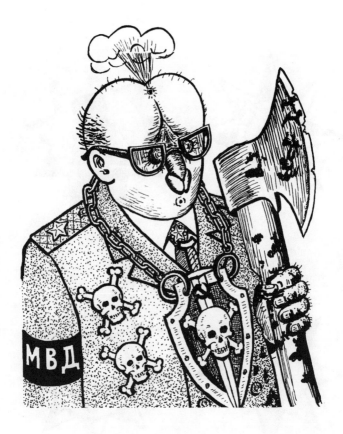

A tattoo known as: 'Master of the head and shoulder business. Likes Pushkin, especially the line that goes, "The beautiful impulses of the soul ..."' The word 'soul' is a pun. The genitive *dushi*, is spelled the same as the imperative of the verb 'to strangle', so it can also be interpreted as 'Strangle beautiful impulses'.

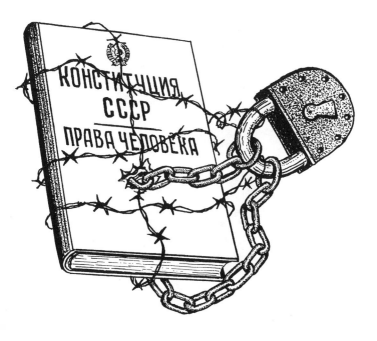

Detention Centre No.1, Leningrad. 1971. Right side.

A tattoo on the right side of a convict, nicknamed 'Hammer'. In 1962 he was sentenced under Article 206 of the Criminal Code of the RSFSR of 1960 for hooliganism. He was sentenced again for hooliganism in 1969.

This tattoo of Joseph Stalin symbolises, 'Wake up! Communist recidivists are robbing Russia. Soon they'll steal your last pair of trousers and your grub!'

Text at the top reads: **'Warden of the Socialist Camp'**. Text under the silhouettes reads: **'K. Marx. V. Lenin'**. Text under Stalin reads: **'Gulag. NKVD'**. The map features the names of prison camps across Russia.

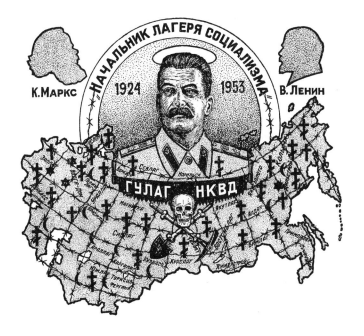

This tattoo is commonly known as 'The warden of the Socialist Camp – father to all nations.'

Text around the picture of Basayev (Shamil Basayev, a militant Islamist and a leader of the Chechen separatist movement) reads **'Basayev, hero of the Chechen people. Kill the invaders!'** Text underneath reads **'Kremlin pigs!!! Send your children, well-fed suckling pigs, to the Chechen war. We'll make them into stewed meat, can them, and ship them to Moscow as Freight 200.** (Freight 200 is the code for dead soldiers shipped home in metal caskets.) **Don't send children that were robbed by Jews, or poor Mashkas and Vankas'** (Mashka and Vanka are typical Russian names.)

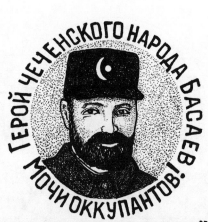

КРЕМЛЕВСКИЕ СВИНЕИ!!!
ПОСЫЛАЙТЕ НА ВОЙНУ В ЧЕЧНЮ
СВОИХ ДЕТЕЙ-ОТКОРМЛЕНЫХ
ПОРОСЯТ, МЫ ИЗ НИХ СДЕЛАЕМ
ХОРОШУЮ ТУШОНКУ И ПОШЛЕМ В
МОСКВУ „ГРУЗОМ 200" НЕ ПОСЫЛАЙ-
ТЕ ДЕТЕЙ, ОГРАБЛЕНЫХ ЕВРЕЯМИ,
НИЩИХ МАШЕК, ДА ВАНЕК.

Mosque, 5 Kronversky Prospekt, St. Petersburg. 2003. Right side of chest.

The tattoo of a Chechen nationalist.

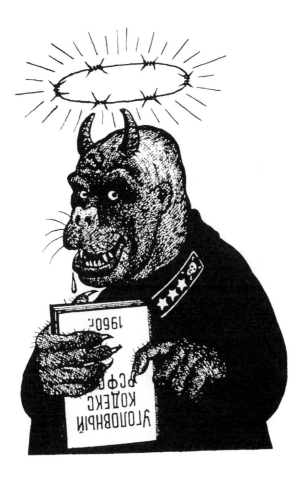

Detention Centre No.1, Leningrad. 1960.

A caricature tattoo. It became widespread in the 1960s after a new edition of the Criminal Code of the RSFSR was approved on 27th October 1960.

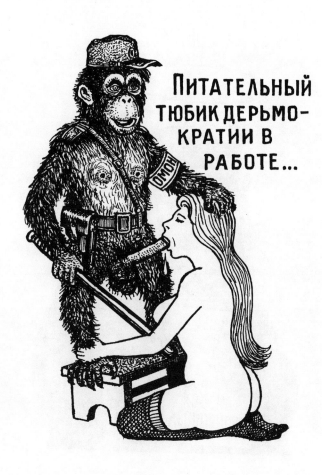

'**The nutritional tube of democracy in action...**' The word democracy is misspelt 'dermokratia', dermo means 'crap' in Russian. The monkey's armband reads **'OMON'** which stands for Otryad Militsii Osobogo Naznacheniya, 'Special Purpose Police Squad'.

ПИТАТЕЛЬНЫЙ ТЮБИК ДЕРЬМО-КРАТИИ В РАБОТЕ...

1 Svechnoy Lane, St. Petersburg. 1995. Hip.

A youth's, pornographic tattoo. Various versions exist.

176

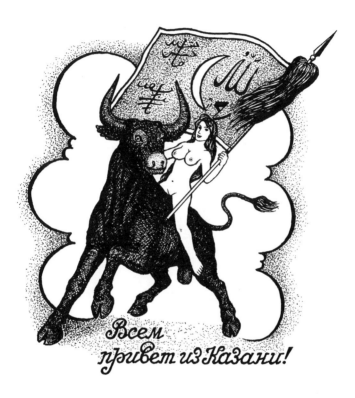

Hospital No.14, 19 Kosinova Street, St. Petersburg. 1995.

A nationalist's patriotic greeting tattoo.

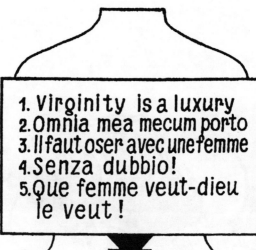
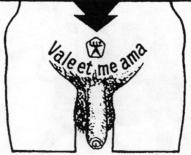

Examples of male genital tattoos.

1. 'Virginity is a luxury'
2. 'I carry with me all that is mine'
3. 'One must take risks with a woman'
4. 'Without doubt'
5. 'What a woman wants, God wants too!'
On the drawing: 'Farewell and love me'

Examples of male genital tattoos.

1. **'Teat'**
2. **'Cheeky'**
3. **'Member of the Soviet Communist Party'**
4. **'The joy of love'** (French)
5. **'Without words'** (French)

On the drawing: **'Hands up!!!'** (Russian transliteration from German)

Text on the left arm reads **'I was born into torments, I don't need happiness'**. Text on the right arm reads **'VIKA'** (the wearer's name). **'VTK'** (three years in an Educational Corrective Labour Camp – three barbs on the wire above the abbreviation). **'ITK'** (four years in a Corrective Labour Camp – four barbs on the wire below the abbreviation).

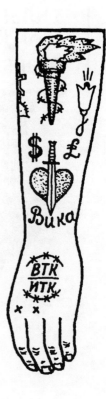

Examples of typical male forearm tattoos.

Text on the left arm reads **'Vera'** both the word for 'faith' and a name. **'I have not forgotten my mother who gave birth to me'**. Text on the right arm reads **'Mother forgive me!'**. **'Death to the police'**.

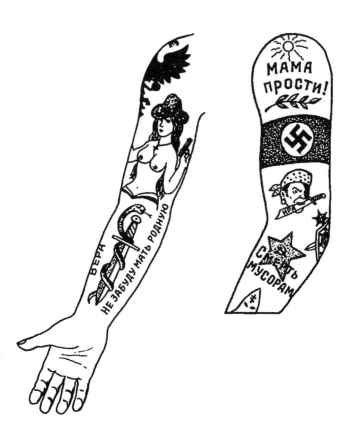

Text across the top of both buttocks reads **'The League of all-Soviet Lenin Communist Masturbators'**. Text across the bottom of both buttocks reads **'Put it in the hole!'**.

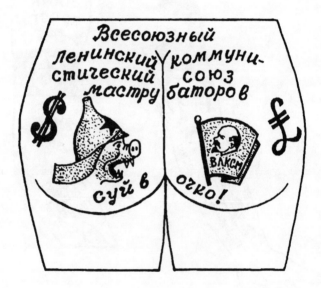

The forced buttock tattoos of a convict named Levitsky. He had been 'sunk' (punished) by his fellow inmates for stealing from students at a construction camp.

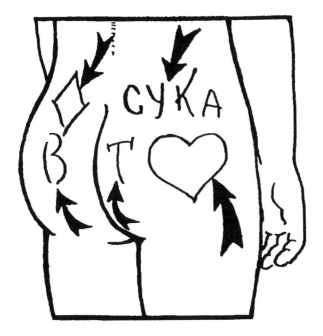

Thieves who had been ‘sunk’ were often punished by having ‘heart and knave’ card figures cut with a razor into their buttocks.

Various ring crosses. Each cross marks a conviction and prison term.

Forefinger: 'My mother was a believer, my father a party member'.

Middle finger: A yin-yang sign, the Chinese symbol of universalism. Tattooed by thieves of Sino-Russian nationality.

Third and little finger, and two symbols to the right of the hand: rare ring crosses belonging to old experienced thieves.

On the wrist: a motif made up of multiple crosses, reminiscent of a bracelet. This was worn by thieves from the Western Ukraine and Northern Bukovina who were exiled to Eastern Siberia.

Above the hand: common variants of ring crosses.

Below the hand: ring crosses worn by theives of non-Slav origin (as are the rings on the fore and middle fingers).

'VITYA' – Convict's name.

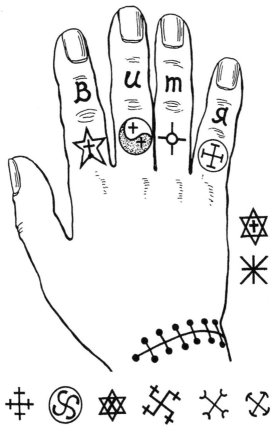

Forcibly applied hand and ring tattoos. They were applied to the *chushki* (filthy ones), the *pidor* (queers), *petuhi* (cocks), and the *golubye* (pederasts).

From the top:
'PIDOR' – 'Queer'.
'Suum cuigue...' (*sic*) 'Everybody gets what they deserve'.
Crosses on knuckles – 'Trips to the zone'. Two crosses mean 'I have been to prison twice'.
Little finger: *Pidor* – a humiliated, raped convict.
Third finger: 'I'm a cunt thief'. Convicted for violent sexual crime, Article 117 of the Penal Code of the RSFSR.
Middle finger: *Vafler* – a passive partaker in oral sex.
Forefinger: Cockerel – a traitor.
'Masha' – Maria, nickname.

Text around the top reads **'In 1917, the Jews climbed on Russia's back and they won't get off of it'**. Text underneath reads **'Sneaky Jews, when they infiltrate another country or nation they always try to perfidiously seize power, rob the people, and ruin its land'**.

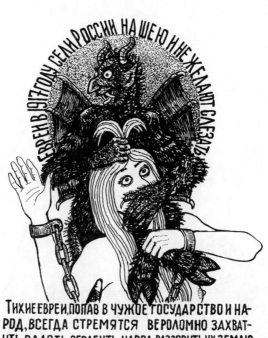

ЕВРЕИ В 1917 ГОДУ СЕЛИ РОССИИ НА ШЕЮ И НЕ ЖЕЛАЮТ СЛЕЗАТЬ

ТИХИЕ ЕВРЕИ, ПОПАВ В ЧУЖОЕ ГОСУДАРСТВО И НА-
РОД, ВСЕГДА СТРЕМЯТСЯ ВЕРОЛОМНО ЗАХВАТ-
ИТЬ ВЛАСТЬ, ОГРАБИТЬ НАРОД, РАЗЗОРИТЬ ИХ ЗЕМЛЮ.

Angarlag. 1950s.

A tattoo belonging to a prisoner of the Angarlag Corrective Labour Camp who worked as an electrician at a construction site. His name was Peter and he said he hated Jews. In 1930, the Irkutsk OGPU had executed his father and sent his mother to prison where she died. Peter and his sister were arrested as the children of a counter-revolutionary. According to Peter, the highest officials in the OGPU were all Jews. Peter despised criminals too, explaining that hard-labour convicts had sided with the Bolsheviks, who considered them to be socially close to 'their Judas-Satanist power'. The tattoo was made in 1948 by his friend from the Culture and Education Department of the prison camp, who worked there as an artist – he was also the son of a counter-revolutionary and shared Peter's hatred of Jews. He blamed them for ruining Russia, by worming their way into high government positions after the October Revolution. Both convicts seemed to be from well-educated families of the intelligentsia.

Text above the heads reads **'Mafia. Shock therapy. Corruption'**. Text underneath reads **'Czar Borukh and Pashka the Mercedes attacked the Parliament with tanks, they're bread bloodsucking Jews, those tapeworm oligarchs. He started the bloodbath in Chechnya, forgetting that vengeance has no expiration date'**. 'Czar Borukh' refers to Boris Yeltsin and 'Pashka the Mercedes' to his Defence Minister, Pavel Grachev.

Baikal shore. 2000.

Caricature tattoo of an ex-convict.

Corrective Labour Camp No.5. 1971. Hip.

Young thief's tattoo. A running stallion symbolises freedom and the hope of escaping punishment. The tattoo is characteristic of recidivist thieves, usually 'visitors' (thieves from other cities) or gypsies.

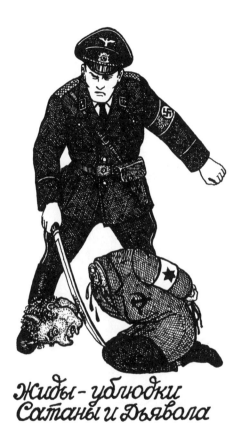

Жиды - ублюдки
Сатаны и Дьявола

Omlaga Specialised Prison Camp, Omsk. 1951.

A fascist, anti-Semitic tattoo. This and similar nationalist tattoos were widespread in the Gulag among convicts of Slavic origin (Russians, Belorussians, and Ukrainians). The administration of the camps set prisoners of different ethnicities against each other so that they wouldn't unite against the system. The tried and tested principle of divide and rule was a cornerstone of Gulag penal practices.

The Devil holds papers titled **'Charges'**. The title of the book is **'Laws'**.

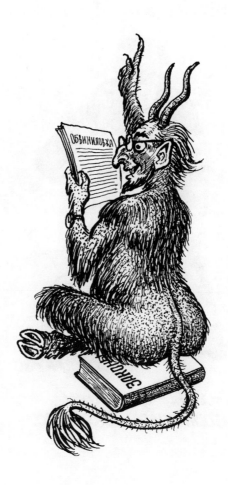

1960s.

This tattoo is called 'The All-Knowing Prosecutor of the Most Democratic Communist Power in the World'. It was popular in the 1960s in prisons across the USSR.

Text on the truncheon reads **'Squadron of the Ministry of Internal Affairs of the USSR'**. Text on the tin mug reads **'Ration'**.

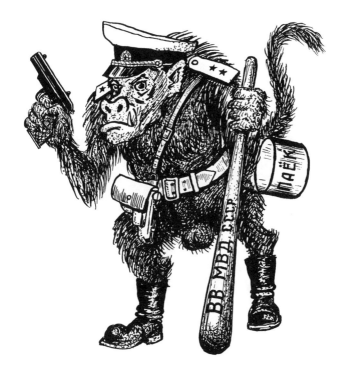

Tuberculosis Ward, Regional Hospital of the Ministry of Internal Affairs of the USSR, 1 Khokhryakova Street, Leningrad. 1960s. Left hip.

This is the caricature tattoo of a criminal who opposes the law enforcement organisations. It can be tattooed on different parts of the body. It's called 'The Vologda Escort' and convicts who saw it would repeat this ditty:

> If you're under the Vologda Escort
> Don't whimper or whine.
> A step to the right is propaganda,
> A step to the left is provocation.
> Jump and it's considered an attempt to escape.
> The escort will shoot to kill without warning.

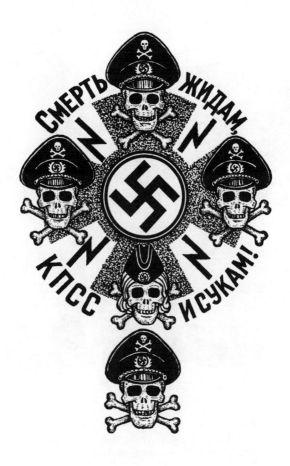

Corrective Labour Camp No.6. 1970s.

A fascist 'baring teeth at the authorities' youth tattoo. These were usually worn by persistent violators of prison regulations. In the 1950s and 1960s the prison authorities would forcibly remove this type of tattoo using surgery without anaesthetic.

'I steal where Yids and the Communist Party failed to steal'

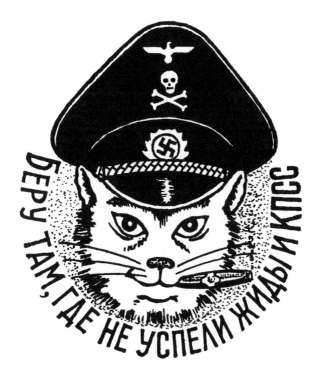

Shoulder or hip.

A thieves' tattoo depicting an SS 'defense squadron' cat. Widespread among younger convicts.

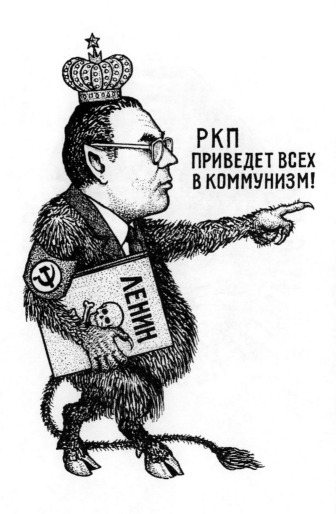

Ministry of Internal Affairs Regional Hospital, 1 Khokhryakova Street, St. Petersburg. 1996. Buttock.

A pejorative youth tattoo on the buttock. Brezhnev's finger points towards the bearer's anus.

Leningrad. 1980s. Left side of chest.

The decorative tattoo of a military construction worker from the Baltic States. He wanted to emigrate to America at the earliest opportunity.

Text on the left reads **'Who else could I wage a little war against?'**. Text on Brezhnev's forehead reads **'Glory to the Communist Party!'**.

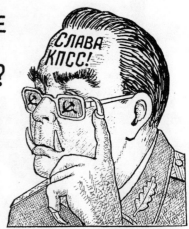

СКЕМ БЫ ЕЩЕ МАЛЕНЬКО ПОВОЕВАТЬ?

Specialised Detoxication Centre, Frunzensky District Police Department, 3 Dnepropetrovskaya Street, Leningrad. Left buttock. 1970s.

A caricature youth tattoo called 'Lyonka the Generalissimo of the Soviet Shovel Thinking a Deep Thought'. (Lyonka is diminutive for Leonid.) The wearer had previously been sentenced under Article 206 of the Criminal Code of the RSFSR of 1960 for hooliganism.

Text on the wings reads **'Marxism. Slavery. Famine. Poverty. Communism. Tyranny. VChK-KGB. Gulag'**. Text wrapped around the body reads **'Freedom. Equality. Brotherhood'**.

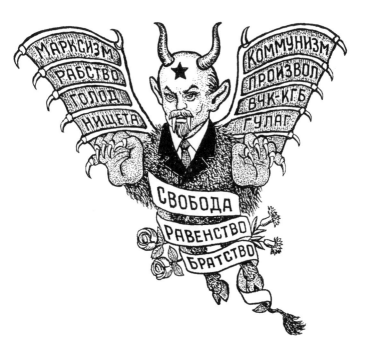

Detention Centre No.1, Leningrad. 1970s. Stomach.

The tattoo belonging to a convict nicknamed 'Danube', from Balashikha, in the Moscow Region. He had been sentenced under Article 145 of the Criminal Code of the RSFSR of 1960 to five years in prison at the Corrective Labour Camp in Komi ASSR. Following his release he stole from the Kirov Marble Palace of Culture while intoxicated, and was arrested again. During his first term he was put in a punishment cell for more than fifty days for 'pressing' the rules (breaching the internal prison regulations). He cited this as the reason for his tattoo.

Text at the top reads **'Burkandia'**. Text within the barbed wire reads **'Decree of the Presidium of the Supreme Council on 4th June 1947'**.

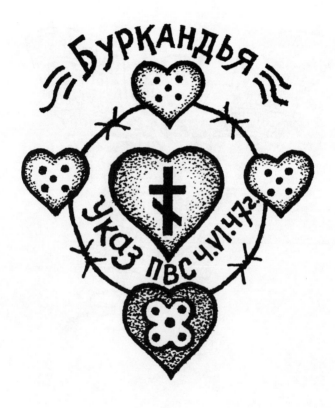

A symbol of love and friendship amongst the thieves' 'family'.

Text inside the chain link reads **'Article 73 of the Criminal Code'**. Text at the bottom reads **'Yayalag Corrective Labour Camp. 1952'**.

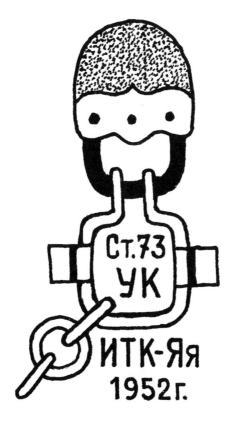

Yayalag Corrective Labour Camp, Kemerovo Region. 1950s. Forearm.

A semi-*portachka* (poorly executed youth tattoo) tattooed on a convict sentenced under Article 73 of the Criminal Code of the RSFSR of 1926 for resistance against the authorities.

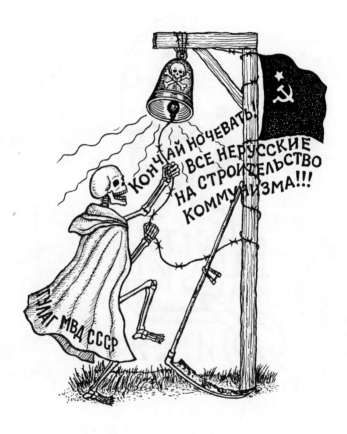

Angarlag Specialised Prison Camp. 1950s. Back.

This tattoo was forcibly applied to a Bashkir man who was formerly a party official. He had been sentenced to twenty-five years in prison.

Text at the top reads 'A slut will yield even to the Devil...'. Text at bottom reads 'A Marxist propagandist: Oy, I can already see the bright future!'.

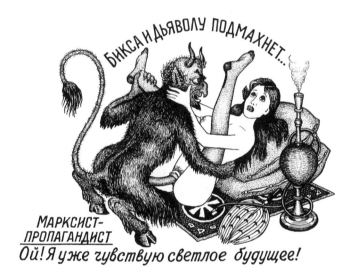

Corrective Labour Camp No.9. 1972.

A youth shaming tattoo. This image was forcibly applied to the back of a man who lost at cards and had failed to pay his five thousand ruble debt.

Text across the top reads **'In 2025, the Year of the Snake, the Land of Fools – Russia – will fall apart'**. Text at the bottom reads **'One cannot fathom Boris with the mind. His folly can't be measured with a yardstick. Only Soviet idiots and scum continue to believe in him'.**

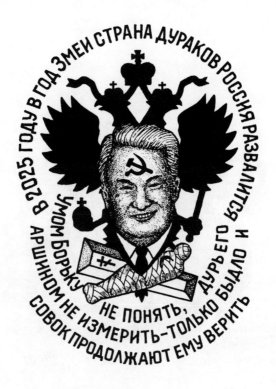

The apartment of A. Enikeev. 1997.

This is a parody of the famous poem by Fyodor Tyutchev:

> One cannot fathom Russia with the mind,
> She can't be measured with a common yardstick.
> She is unique unto herself.
> The only way is to believe in her.

Mahmud, the wearer of this tattoo came from Kalmykia. He fought in Grozny and other parts of Chechnya from 1994 to 1996, where he blew up two tanks and an armoured personnel carrier before being wounded by shrapnel. He grieves over the death of Dudaev (the assassinated President of Chechnya). He wanted to present him with a silver dagger set, as Imam Shamil had done with his warriors. The tattoo was made by an artist in Makhachkala.

Text surrounding the pigs reads **'Small predators'**. Text on the oil barrel reads **'Privatiser from the Communist Party. Oil-Gas-Myrdin'**. The word 'privatiser' is misspelt with the root khvat (to snatch). The '-Myrdin' is derived from the last name of Viktor Chernomyrdin, Prime Minister of Russia from 1992 to 1998.

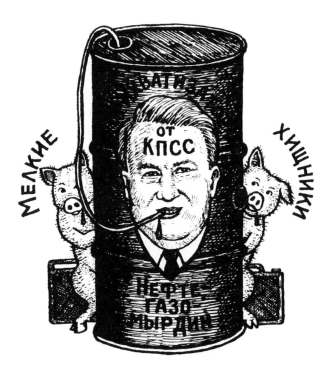

Detention Centre No.1. 1997. Hip.

An anti-party tattoo. The bearer was sentenced to seven years imprisonment for extortion under Article 145 of the Criminal Code of the RSFSR and Article 226-G of the Criminal Code of the Russian Federation.

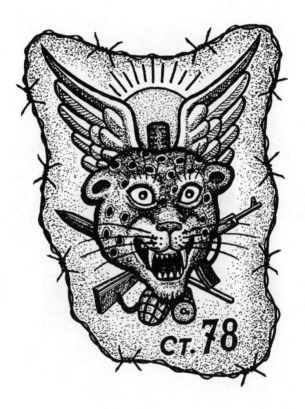

Corrective Labour Camp No.9. 1970s. Shoulder.

This prisoner was sentenced under Article 78 of the Criminal Code of the RFSR for smuggling contraband, he received ten years. The tattoo is known among thieves as 'Varila' (from *navar*, a slang term for 'profit').

Text on the skull's forehead reads **'Communist Party of the Soviet Union'**. Text underneath reads **'You've chosen the right path, comrades!'**.

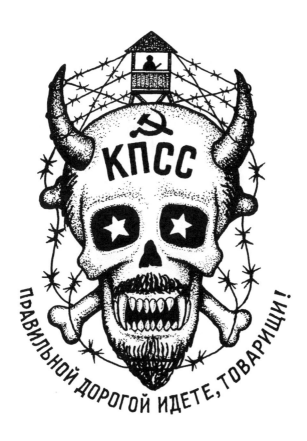

Kraslag Corrective Labour Camp, Kansk, Krasnoyarsk Krai. 1960s.

An anti-Soviet thieves' tattoo, widespread in the 1960s.

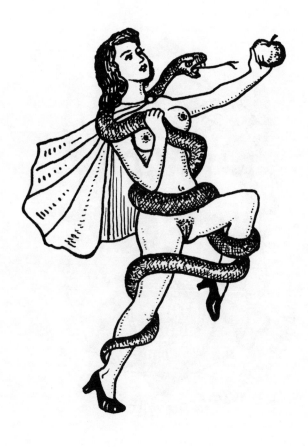

Back.

Tattoo of a passive homosexual.

The text reads **'Oh, fickle fortune, smile on me once more. 1972'**. The text on the manacle reads **'ITK-7'** (Corrective Labour Camp No.7).

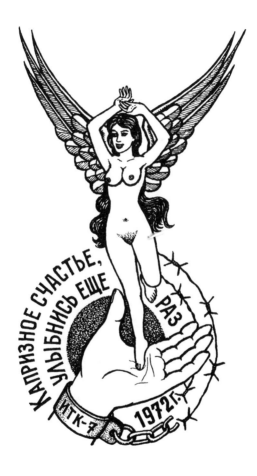

Detention Centre for Minor Offenders, 6 Kalyaeva Street, Leningrad. 1981.

This thieves' tattoo is known as 'Winged Fickle Fortune'. The wearer dreams of committing a bold, large-scale theft allowing him to give up his life of crime.

Text on top and bottom reads **'The Scary Dicks of the Land of Fools'**. Text on penises reads **'Everything for the people!'**. The book is **'Capital'** by Karl Marx.

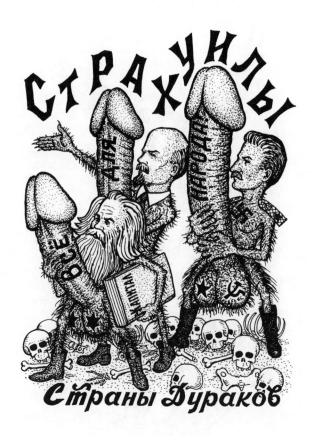

Corrective Prison Camp No.9. 1989.

An anti-social tattoo, a caricature of the ideologists and leaders of the Communist Party. The bearer of the tattoo was a persistent violator of prison regulations who refused to work.

A parody the national anthem of the USSR, the text at the top reads **'The Union of starving republics have been forever united by the Kremlin Russia. The indivisible Union, hungry and lice-ridden, has been forever conquered by the Yids'**. Text on the penis reads **'The law in the Soviet Union is like a cart's pole...'**. An alteration of the first part of a proverb meaning 'Any law has a loophole'. Text at the bottom (translated from Estonian) reads **'Russians bring communism with its lawlessness and slavery to Europe and the rest of the world. They don't want freedom. That's what we say in Estonia'**.

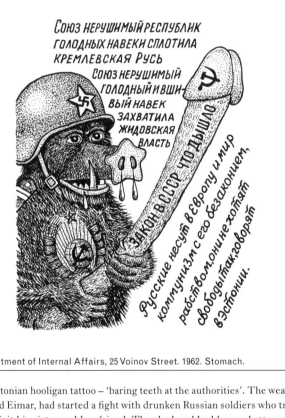

Department of Internal Affairs, 25 Voinov Street. 1962. Stomach.

An Estonian hooligan tattoo – 'baring teeth at the authorities'. The wearer, named Eimar, had started a fight with drunken Russian soldiers who tried to solicit his sister and her friend. They had grabbed her and attempted to tear off her dress. After Eimar and his two friends had beaten them up, they were detained by the police and local militia. He was sentenced to four years in prison. His sister and her friend were not called to the hearings. I gave him cigarettes, matches, and a razor as payment for copying his tattoo. Eimar claimed Russians to be the worst people in the world, explaining that they were all alcoholics, hooligans, thieves, and loafers, who lived under the misconception that they were the supreme nation. He thought that they were worse than Nazis.

The criminal finger ring tattoos of gang leader N. Ryabov. He was detained in the Komi Autonomous Soviet Socialist Republic camps.

From the top:

'FRIDEN' – 'Peace' in German.

Single dot: 'I escaped from prison'.

Scarab: a symbol of good luck and happy living.

Crosses on knuckles – 'Trips to the zone'. 'I have been to prison three times'.

Forefinger: a thieves' cross. Convicted for theft, burglary and robbery according to Articles 144, 145 and 146 of the RSFSR Penal Code.

Middle finger: 'Prestige', 'I am a gang leader'.

Third finger: 'The Cormorant' in criminals' jargon. Convicted for robbery according to 146 of the RSFSR Penal Code.

Little finger: Convicted for disorderly conduct.

'1954' – Date of birth.

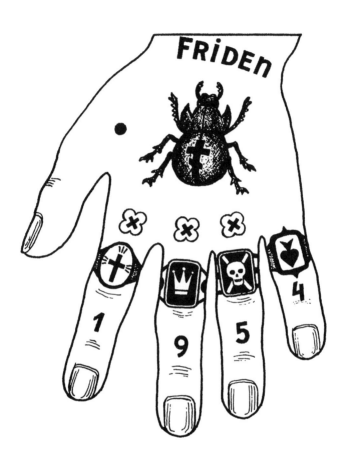

Alexei Zashchuk's criminal finger ring tattoos. A convict of Belorussian nationality, his mother was a cleaning lady in a German headquarters during the Nazi occupation. There she met Alexei's father, Hans. When the German troops fled from Belorussia back to Germany Alexei's mother left with Hans. However in early 1944, the Soviet authorities imprisoned her in a camp. Soon after she gave birth to Alexei.

From the top:

Five dots: 'Four guard towers and me', 'I've been in prison'.

'I was conceived in the free world, and born in the Gulag – 1944'

Crosses on knuckles: 'Trips to the zone'. Two crosses mean 'I have been to prison twice'.

Forefinger: 'I'm an anarchist'. An anti-social convict, hostile to the authorities.

Middle finger: 'I was convicted for theft and banditry'. 'I am an important thief belonging to the prison elite'. 'I am a gang leader'.

Third finger: 'I am dissatisfied with my sentence!'. **'BOG'** – 'The state is convicted' or 'I shall rob again'.

Little finger: 'I am an anarchist'.

'HANS' – His father's christian name.

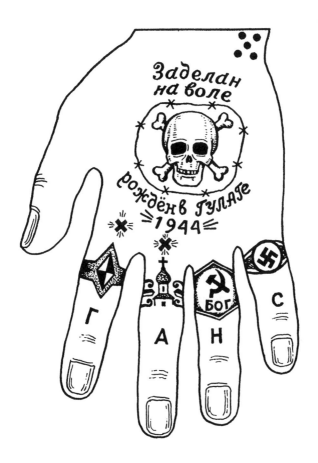

Заделан
на воле

рождён в ГУЛАГе
1944

Г А Н С

БОГ

Prison No.1 (Kresty), Leningrad. 1979. Stomach.

A rare tattoo called 'August'. The bearer is from Sevastopol. Sentenced
under Article 117 of the Criminal Code of the RSFSR.

ВЕЛИКОЕ ДЕЛО-ЛЮБОВЬ

US-20/4 Institution, Leningrad Region. 1967. Left side of the stomach.

A portrait of the prisoner's fiancé copied from a photograph. The prisoner, Afanasy, nicknamed 'Alfred', had been sentenced (under Article 108 of the Criminal Code of the RSFSR) to seven years in prison for severely beating an acquaintance of his younger sister. The acquaintance was persistent in his attempts to befriend her, pressing her to spend time with him and his friends, which she had resisted.

Text at the top reads **'Get out of my sight, you slut! Or I'll stick my no-name voucher that I got from the Kremlin up your arse, instead of giving you paradise – a bright future in heaven'**. Text on the body of the Devil reads **'Democrat privatiser'**. (Both words are misspelt. The root of 'democrat' is replaced with dermo – 'faeces,' and the root of 'privatiser' is replaced with prikhvat – from khvatat, 'to snatch'.) Text at the bottom reads **'Please Lord! I've already been stripped naked by Satan. He left me with no means to survive. He simply robbed me!'**.

Maximum Security Corrective Labour Camp No.9. 1995. Left shoulder blade.

Decorative, anti-religious youth tattoo. Depicting Jesus, Mary Magdalene, and the 'Soviet Devil'. The tattoo of an 'opposing' convict, who was sentenced under Article 108 of the Criminal Code of the RSFSR for severely beating an executive of the company where he worked. They had refused to pay him after he had set up the company's equipment.

The letters on the axe **'ITK'** stand for Corrective Labour Camp. Text underneath reads **'Hey, boss! Cut the quota and bump up the ration!'**.

НАЧАЛЬНИК, СБАВЬ НОРМУ, ПРИБАВЬ ПАЙКУ!

Kashchenko Hospital in Nikolskoe settlement, Gatchina District, Leningrad Region. 1976. Right hip.

The tattoo of a prisoner, nicknamed 'Zhora', sentenced under Article 89 of the Criminal Code of the RSFSR of 1960. During his ten years without parole he worked lumbering timber at the Arkhangelsk Region Corrective Labour Camp in Karpgory. He was released in 1972.

Chest.

A thieves' symbol of good luck and the power of 'authoritative' thieves.

'Destroy the Communist Party!'

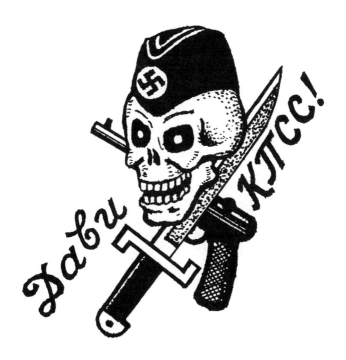

1970s–1990s. Various parts of the body except the back.

A tattoo worn by anarchists who opposed the Soviet state, communists, law enforcement organisations, and prison authorities.

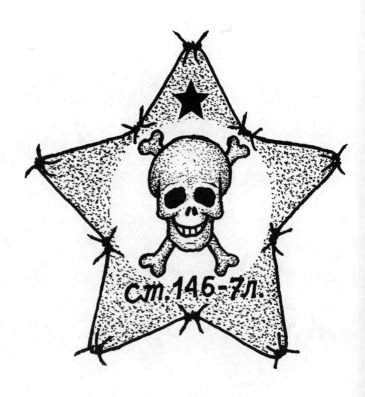

Leningrad. 1991.

The tattoo of a prisoner who was transferred from juvenile prison to Corrective Labour Camp No.9 when he turned eighteen. He was sentenced under Article 146 of the Criminal Code of the RSFSR of 1960 for an assault committed as part of a gang of minors. The tattoo means: 'All that is thine and yours have always been mine and ours.'

Text on the brick and below reads **'A Gulag con – is a brick in the foundation of communism in the USSR'.**

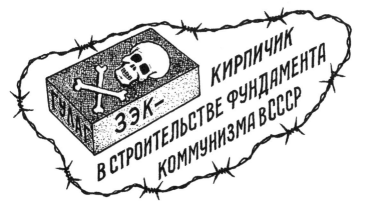

Maximum Security Corrective Labour Camp No.9, Leningrad. 1990. Hip.

Such tattoos were applied to different parts of the body of well-read convicts with a secondary education, who had pretensions to intellectualism. This tattoo was copied from a convict sentenced under Article 89 of the Criminal Code of the RSFSR of 1960, nicknamed 'Graduate', or 'Prison PhD'.

Text on top reads **'We're all shovels!'** (from 'sovok', literally 'shovel', a derogatory slang term for the Soviet Union). Text at the bottom reads **'If you want misfortune in your life, then love my family!'**.

1980s. Hip.

A decorative anti-Soviet tattoo.

Text on top reads **'With their Marxist experiments, the Jews have murdered over 70 million people in the USSR'**. The book is **'Capital'** by Karl Marx. Text at the bottom reads **'Yid's Marxism for Russia is bloody onanism'**.

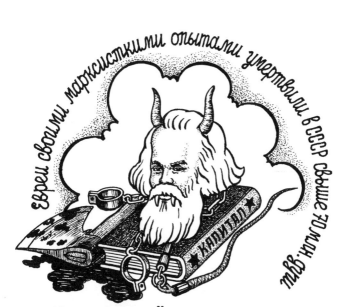

ЖИДОВСКИЙ МАРКСИЗМ ДЛЯ
РОССИИ-КРОВАВЫЙ ОНАНИЗМ

Special Detention Centre for Administrative Violations, 6 Kalyaeva Street, Leningrad. 1980. Hip.

An anti-communist tattoo, which was popular in prisons of Leningrad, Moscow, and the Baltic States. The wearer was sentenced under Article 146 of the Criminal Code of the RSFSR of 1960, for violent robbery on a train.

'Comrades, I'll make you forget not just about eating, but also drinking! You'll only have this much [vodka] once in every communist five-year plan – on Lenin's birthday – to preserve your health for the construction of communism.'

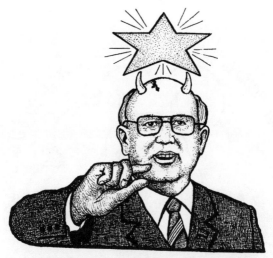

„Я ВАС, ТОВАРИЩИ, НЕ ТОЛЬ-
КО ЕСТЬ ОТУЧУ, НО И ПИТЬ!
РАЗ В КОММУНИСТИЧЕСКУЮ
ПЯТИЛЕТКУ ВОТ ПОСТОЛЕЧ-
КУ В ДЕНЬ РОЖДЕНИЯ ЛЕНИНА
ПРИНИМАТЬ, ЧТОБЫ СОХРАН-
ИТЬ ЗДОРОВЬЕ ДЛЯ СТРОИ-
ТЕЛЬСТВА КОММУНИЗМА."

Regional Hospital of the Ministry of Internal Affairs, 1 Khokhryakova Street, St. Petersburg, 1996. Buttock.

A caricature tattoo.

Tuberculosis Ward, Regional Hospital of the Ministry of Internal Affairs, 1 Khokhryakova Street, Leningrad. 1970s. Left buttock.

A youth thieves' tattoo belonging to a convict, nicknamed 'Fedya the Railroad Wagon' who had been sentenced three times for theft.

The letters **'BBK'** stand for Belomorsko-Baltiyskiy Kanal (the White Sea-Baltic Canal).

Botkin Hospital morgue, 3-4 Mirgorodskaya Street, Leningrad. 1968. Right hip.

The tattoo of a former prisoner who had worked on the construction of the White Sea-Baltic Canal. He was an invalid (his left leg was missing from the knee).

A thieves' warning tattoo. A bomb with a burning fuse translates as 'Be careful with me, or your soul will fly to heaven and your body will be shattered into tiny pieces.'

'Tightwad filcher'

Corrective Labour Camp No.6, Obukhovo, Leningrad. 1961. Back.

A tattoo from a convict sentenced for hooliganism under Article 206 of the Criminal Code of the RSFSR. He stole three packs of cigarettes and some sweets from the lockers of his fellow inmates. He was discovered and beaten up. It was decided by a group of 'authoritative' thieves that this tattoo should be forcibly applied as punishment.

Text on top reads **'Article 117-3** [of the Criminal Code]'. Text at the bottom reads **'Furry-faced thief, burglar of the furry safe'**.

Prison No.1 (Kresty), 7 Arsenal Embankment, Leningrad. 1956. Back.

Tattoo copied from a convict sentenced for rape.

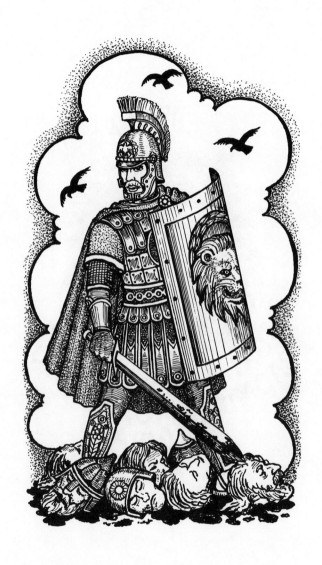

Corrective Labour Camp No.9, Gorelovo, Leningrad. 1990s. Chest.

Men's thieves' tattoo. Characteristic of a 'fighter' against cruelty.

'Death to the Jews and to the Communist Party, who murdered the Russian Emperor!'

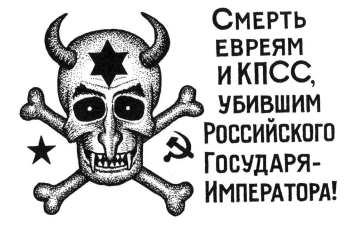

Corrective Labour Camp, Sverdlovsk. 1960s. Chest.

The bearer of this tattoo explained it like this: 'Nobody has ever hurt Russia and Europe more than the Jews. They provoked revolutions and took power using the hands of those they had deceived. We must start the White Terror against the Jews as soon as possible, not only in our country, but across the world.'

Text encircling the image reads **'Since 1917, Jews have murdered 90 million people, 60 million of which were Russians'**. Text on the left reads **'Beat the Jews, save the planet!'**.

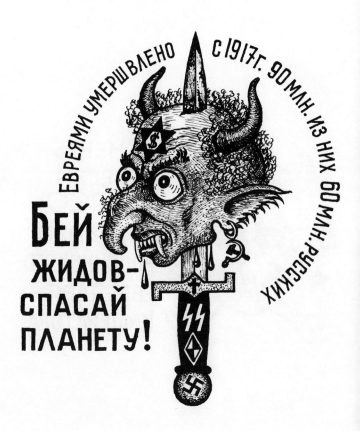

Special Detention Centre for Misdemeanours, 6 Kalyaeva Street. Stomach.

A fascist, anti-Semitic youth tattoo. Jews arouse a savage hatred among the lowest classes of Russians and non-Russians. They are connected in their minds with Marxist teachings about 'the bright future', 'equality, brotherhood, and freedom', and similar utopian ideals they feel have been denied them by the Jews. Throughout the USSR companies and organisations with Jewish employees have been called 'synagogues', or 'Jewish sinecures', and other pejorative names.

Text in the clouds reads **'May the land where roses die from the stench of Yids and the Communist Party be damned!'** .Text on the knuckles reads **'Yids'** and **'Communist Party'**.

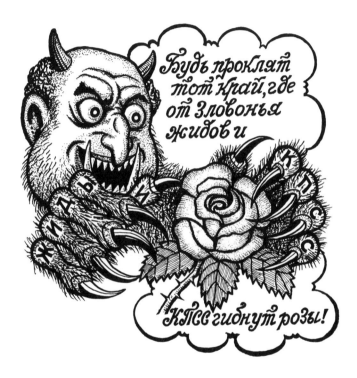

Corrective Labour Camp No.5, Metallostroy. 1968. Right hip.

An anti-Semitic tattoo made in the Strelna Juvenile Prison, Petrodvorets District. When he turned eighteen, the bearer was sent to Metallostroy to finish his two year sentence for organised robbery.

'INFORMER'

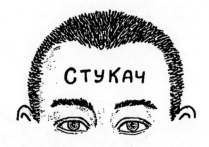

'ENEMY OF THE PEOPLE'

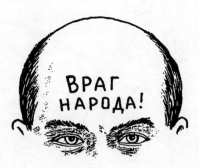

'KULAK' (Wealthy peasant)

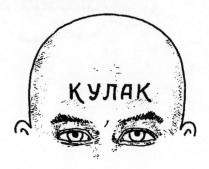

Examples of forcibly applied forehead tattoos. These were made using a knife or razor to cut deep into the victim's face.

'CLASS ENEMY'

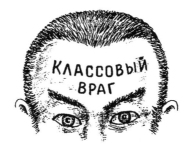

'I AM A BITCH'

'BLUE' (Pederast)

Other inscriptions were also common among both male and female convicts including: 'I AM A DOG'; 'RUBBISH HEAP' and 'MULE OF THE SOVIET COMMUNIST PARTY'.

Tattoos forcibly applied to the top of the shaven head.

 i Brains inside.
 ii Not offended.
 iii The Communist Party has shat in my brain.

Voluntarily made, popular tattoos. Worn on the forehead by *otritsalokva*, (severe violators of prison regulations):

 iv Gulag slave.
 v Slave to the Communist Party.
 vi Slave to the Ministry of Internal Affairs.

Old forcibly applied tattoos. Made on the foreheads of political prisoners by regular prisoners, often on an initiative from the Gulag administration:

 vii White clothes moth.
 viii Enemy of the VKP(b). (*Vsesoyuznaya kommunisticheskaya partiya bolshevikov* – The All-Soviet Communist Party of Bolsheviks.)
 ix Contra-Revolutionary.
 x Dog's breed.

Applied to the foreheads of informers:

 xi Judas.
 xii Chummy devil.
 xiii Stoolie.

Applied to the foreheads of passive homosexuals:

 xiv Goat.
 xv Rooster.
 xvi Queer.
 xvii Cock-sucker.

Applied to the foreheads of prisoners sentenced for rape and child molesting:

 xviii Bull.
 xix Stud.
 xx Slave of the muff.
 xxi Cunt face.
 xxii Cunt sufferer.
 xxiii Vampire.

Applied to the foreheads of non-authoritative prisoners. They are intimidated by other inmates for stealing food or cigarettes from fellow prisoners, failure to keep a promise, and severe violation of the prison code of ethics:

 xxiv Shit eater.
 xxv Yid.
 xxvi Arse kisser.
 xxvii Petty rat.
 xxviii Fly eater.
 xxix Bullshitter.
 xxx Cockmouth.
 xxxi Demon.
 xxxii Ugly face.
 xxxiii Jackal.
 xxxiv I'm nobody.

ЗДЕСЬ ЕСТЬ МОЗГИ *Не в схизаю!*

i ii

Мои мозги не засраны КПСС

iii

РАБ ГУЛАГА РАБ КПСС *Раб МВД*

iv v vi

Белая моль Враг ВКП(б)

vii viii

Контрик СОБАЧЬЯ ПОРОДА

ix x

ИУДА КУМОВСКОЙ ЧЕРТ *Стукаг*

xi xii xiii

КОЗЕЛ ПЕТУХ *Пидор Хуесос*

xiv xv xvi xvii

БЫЧОК ЖЕРЕБЧИК РАБ шмоньки

xviii xix xx

МОХНОРЫ-ЛЫЙ ПИЗДОСТРАДАЛЕЦ ВАМПИР

xxi xxii xxiii

ГОВНОЕД ЖИД ЖОПОЛИЗ КУСОШНИК

xxiv xxv xxvi xxvii

МУХОЕД *Фуфломёт Хуеплёт Чёрт*

xxviii xxix xxx xxxi

ЧУВЫРЛА *Шакал Я шелупень*

xxxii xxxiii xxxiv

'Beat Ukrainian traitors!!!'

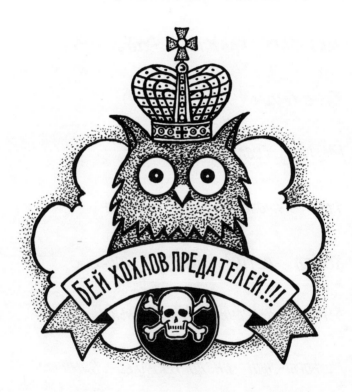

Prison No.1 (Kresty), 7 Arsenal Embankment, Leningrad. 1950s. Shoulder.

A thieves' tattoo.

Text at the top reads **'This is how MVD turnkeys are being made'** (MVD – 'Ministerstvo Vnutrennikh Del', Ministry of Internal Affairs). Text at the bottom reads **'US-20/9** [prison code]. **Gorelovo, Leningrad. Krasnoselsky District'.**

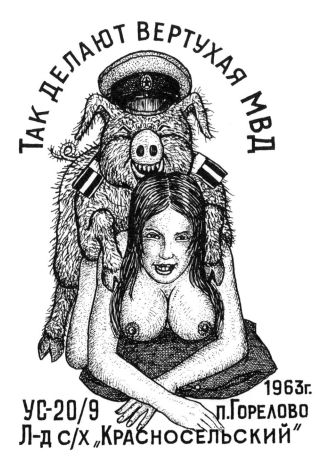

Maximum Security Corrective Labour Camp No.9, Leningrad. 1963. Back.

A very rare men's *otritsalovka* (severe violator of prison regulations) tattoo. The bearer was sentenced twice for theft and robbery under Articles 144 and 145 of the Criminal Code of the RSFSR.

Text on the left leg reads **'I am longing for heaven'**, **'Article 188'** (convicted for escaping from prison). Text on the right leg reads **'They got worn out'**. Text on the foot at the bottom reads **'Sweet Freedom'**, **'I'm high** [on drugs]', **'Article 188'** (convicted for escaping from prison).

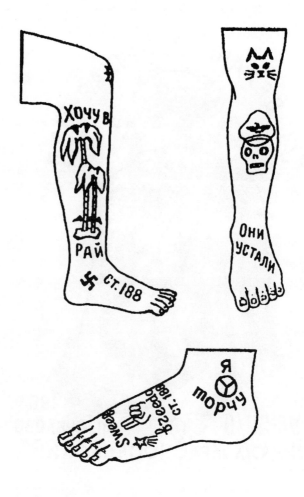

Typical leg and foot tattoos. On these parts of the body, apart from designs connected with their function (shackles on the ankles, fetters etc.), it is common to find inscriptions and motifs reflecting the cruelties of the Soviet regime and prison staff.

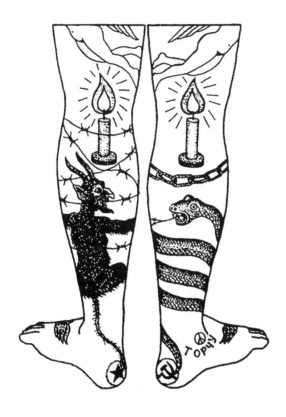

The peace symbol on the right ankle is closely associated with drug subculture. During the 1960s it was considered a symbol of the antichrist (representing the broken cross of Christianity), as well as having several other occult interpretations.

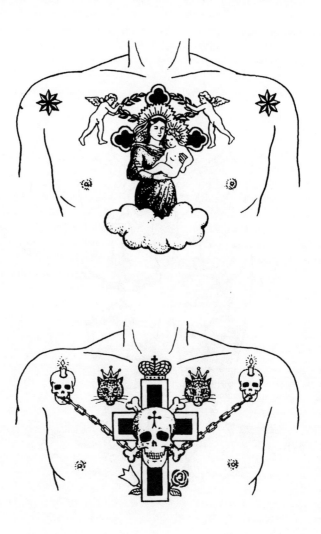

Examples of chest tattoos. Thieves tattoo insignia of rank, spiders and the so-called 'Dark' or 'Thieves' stars on their shoulders. Thieves' crosses, churches, the Mother of God and Virgin Mary (who saves sinful souls) are reserved for the more high-ranking parts of the body – the chest (the most significant area) and the back. The exclusive role of the theives' crosses (above), which are similar to the Russian Orthodox priests' and bishops' pectoral crosses, is to indicate rank and dignity.

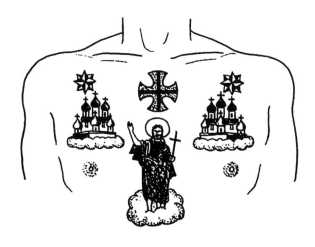

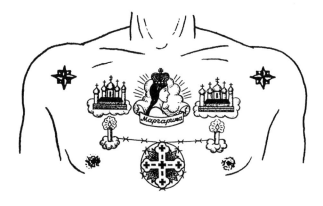

One of the most popular chest tattoos in a traditional style is the Salvator Mundi – The Risen Christ, the Saviour of the World (top). As well as depicting rank, chest tattoos can also carry important information. The image of Saint Margaret in profile (bottom), means that the criminal in question was a gang leader. On two occasions he spent five year terms in St. Petersburg's Kresty prison – this is revealed by the cross-shaped ground plan of the prison and the two five-domed churches, as well as the ten spikes on the barbed wire.

Kraslag, Stroykrasmash. 1950s. Chest, shoulder, hip.

A Latvian anti-Russian tattoo.

Text in corrupted Latin reads **'I hope without any hope'**.

Contpa spem spero

Corrective Labour Camp No.7, Yablonovka, Leningrad. 1972. Hip or forearm.

A mermaid sitting on an anchor symbolises the parting with freedom, restricted written communication, and limited alcohol. It was popular in the 1960s and 1970s among both male and female criminals.

'Authoritative President of Belorussia, Alexander Lukashenko'

Cardiological Ward, Skoraya Pomoshch Hospital, 3-5 Budapeshtskaya Street, St. Petersburg. Left side of the chest.

An anti-Semitic tattoo of a prisoner called Victor who was sentenced to five years for running over a cyclist. He served time in Corrective Labour Camp No.4, Leningrad Region, where he got this tattoo. He explained it like this: 'Colonial Russia is rat-ridden and robbed clean. Our iron president and his team will not let the thieving oligarch Yids from the Kremlin rule Belorussia.'

'Old thieves know that in 1907 the chief commie pakhan and his partners in crime busted the cash register on the Prince George steamboat in the Black Sea – to fund the obshchak of commie Bolsheviks'. 'Pakhan' means criminal boss, 'Obshchak' means monetary fund in criminal slang.

СТАРЫЕ ВОРЫ ЗНАЮТ-
ГЛАВНЫЙ ПАХАНЮГА
КОММУНЯК В 1907 ГОДУ
ГРАБАНУЛ ПАРОХОДНУЮ КАССУ-
„ЦЕЦАРЕВИЧ ГЕОРГИЙ"на ЧЕРНОМ
МОРЕ С ПОДЕЛЬНИКАМИ ДЛЯ КАССЫ
ОБЩАКА БОЛЬШЕВИКОВ-КОММУНЯК

Regional Hospital of the Ministry of Internal Affairs, 1 Khokhryakova Street, Leningrad. 1969. Right shin.

The tattoo of an 'authoritative' thief with multiple sentences. He had served terms in Komi ASSR, Arkhangelsk Region, The Urals, Kolyma, and in the West and East of Siberia. According to the bearer, nicknamed 'Pitersky', he'd spent a total of forty-one years in prison. He was sixty-seven years old and had tuberculosis in his lungs and bones.

Text at the top reads **'You – Kurat! March on to the bright future!!!'** (Kurat is a derogatory Russian nickname for Estonians. It comes from the most common Estonian colloquial swearword – kurat, 'the Devil'.) Text on the left side reads **'Deadly karma of Jewish ideological Communism...'**. Text on the woman's body reads **'Estonia'**. Text at the bottom reads **'"Voluntary" creation of the Communist Party of the Jewish kolkhoz AgroGulag'**. A kolkhoz is a collective farm.

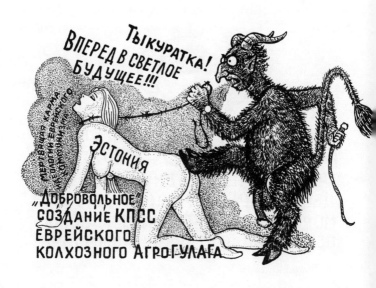

Zelenogorsk, Sestroretsk District, Leningrad. 1961. Stomach.

The bearer of this image was heavily tattooed on the chest, shoulders and forearms. He was an anti-Soviet and anti-Zionist Estonian prisoner from Tallinn. He had been detained in the summer of 1961 for beating up a group of hooligans who were attacking four Estonians in Zelenogorsk. The tattoo was made by a Russian tattoo artist from Zelenogorsk who is married to an Estonian and fluent in the language.

'Death to bitches!'

Public bathhouse, Zheleznodorozhny District, Ulan-Ude, Buryatiskaya ASSR. 1960s. Stomach.

The tattoo of an authoritative criminal. He was sentenced by the Decree of the Presidium of the Supreme Council on 4th June 1947 for stealing meat from a production plant and flour from a mill. He spent ten years in the Dzhidy Corrective Labour Camp.

Text on the bone reads **'20. 1. 90. Baku'**. Text underneath reads **'Mishka the Hunchback. The Executor'**. 'Mishka' is a diminutive of Mikhail Gorbachev. 'Gorbach' means hunchback in Russian.

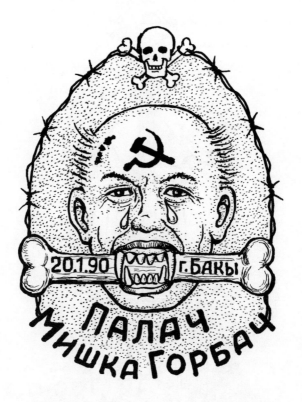

Sennoy Marketplace, St. Petersburg. 1997. Shoulder.

The tattoo of an Azerbaijani man. An ex-convict, he was sentenced under Article 206 of the Criminal Code of the RSFSR of 1960 to six years in prison for fighting with Armenians at a marketplace in Rostov-on-Don. He served his term in the Rostov Region from 1982–1988. The tattoo was made in Baku by his friend from Dagestan. It commemorates two of his relatives, who were killed on 20th January 1990 when Soviet forces cracked down on Azeri protesters in Baku. Azerbaijanis see this date as the birth of their Republic. It is referred to as 'Black Saturday'.

Prison No.1, Leningrad. 1948.

A decorative youth tattoo called 'I believe in good luck'.

This is the tattoo of an inmate called Momma, who was the leader of a group of 'untouchables'. These convicts are shamed and raped as punishment for various violations of the criminal code – breaking criminal rules, transgressing prison ethics, or informing. The criminal code forbids touching these convicts. Called 'roosters', *chuchkas*, or *chukhans,* they are physically and morally broken. Rejected and kicked by other prisoners, they are forced to eat from their own dishes, sit at designated seats in the canteen, and stand in designated places during morning and evening calls. They do the dirtiest, lowest jobs in the prison. They are slaves of the slaves.

Angarlag Specialised Prison Camp, Irkutsk Region. 1950s. Stomach.

One of the most popular tattoos of the criminal world during the 1950s and 1960s. Dozens of variants of the cat, the symbol of thieves, existed. Copied from the stomach of an 'authoritative' thief nicknamed 'Sashka Studeny'.

Text at the top reads **'Polish chicken'**. Text at the bottom reads **'If you dare cackle anything against us, we'll roast you on a skewer...'**. Text on the flag reads **'I'm a Polish chicken. I love you Russians already!!!'**.

Konyashin Hospital, 98 Moskovsky Prospekt, Leningrad. 1985. Left shoulder.

The tattoo of a man who helped to suppress the Polish revolt against Gomuka's communist regime in 1962. Wladyslaw Gomulka was a Polish communist leader and the Kremlin's protégé. The bearer of the tattoo served in a motorised infantry battalion and the tank-borne infantry.

Irkutsk. 1967. Hip.

The tattoo of an old 'legitimate' thief, nicknamed 'Golova' (chief or head). He had spent a total of thirty-one years – more than half his life – in prison.

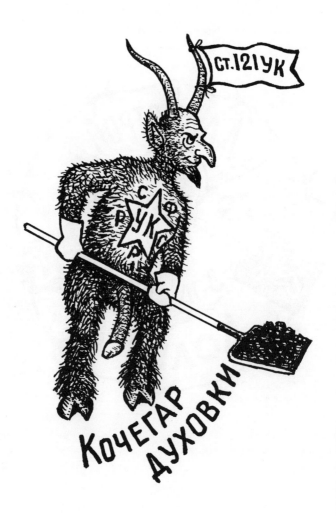

Prison Hospital of the Ministry of Internal Affairs, 1 Khokhryakova Street, Leningrad. 1972. Back.

The bearer was sentenced to seven years in prison under Article 121 of the Criminal Code of RSFSR for sodomy.

Chest, stomach, shoulder, forearm.

This image of the Devil and a woman can either mean that a woman pushed the bearer to commit a crime, or that both the Devil and woman are hatched from the same egg.

Text at the top reads **'Doctor of fiscal, sexual, and pederastic sciences'**.
Text at the bottom reads **'Cock-sucker. Stoolie. Bunghole'**.

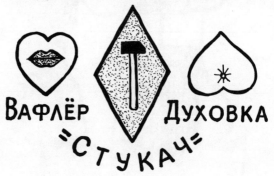

10 Ekaterininsky Prospekt, St. Petersburg. 1993. Back.

Forcibly applied shaming tattoo on the back of a man who was an informer in a corrective labour camp. Such tattoos were common from the 1950s to the 1960s but became very rare in the 1980s and 1990s.

Text at the top reads **'Communist'**. Text across the middle reads **'Glory to the Communist Party!'**. Text on the plinth reads **'Stagnation, bingeing, embezzlement'**.

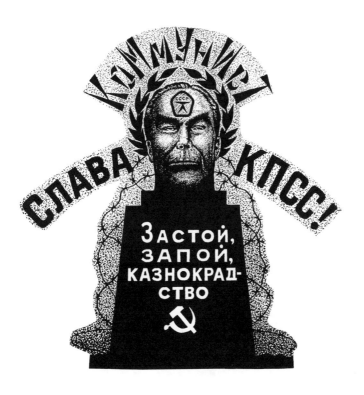

An artistic caricature tattoo. It is known as 'The Monument', a reference to the poem of the same name by Alexander Pushkin, the first line reads:

I have erected to myself a monument not made by human hand.

Text on the top and bottom reads **'The Russian swine have always turned everything upside down and dragged Tatars into communism'**. Text across the centre reads **'Punished by Allah!'**. Text (upside down) on the pig reads **'Gulag'**. Text within the circle reads **'Russia in the bright future'**.

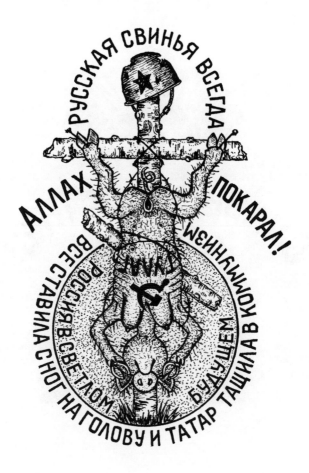

Lenkarz Carburettor Plant, 5 Samoylovoy Street, Leningrad. 1986. Hip.

The bearer of the tattoo, Khasan Sharafudinov, had it made while he was in prison in the Tatar ASSR. He had been sentenced under Article 108 of the Criminal Code of the RSFSR of 1960 to eight years for severe battery, after a Russian had called him 'a Tatar mug'. During the hearing Khasan had told the jury, 'That Russian lives on our Tatar land and insults and humiliates our people. I punished him for that.'

Text on the banner reads **'Forward, towards communism!'**. Texts on the foreheads read **'Priest. Slave of OGPU. Spy. Kulak. Slave of NKVD.'** OGPU – Objedinennoe Gosudarstvennoe Politicheskoe Upravlenie 'Unified State Political Directorate'. Kulak literally 'fist, tightfisted person'. The kulaks were wealthy peasants who resisted Stalin's forced collectivisation – millions were arrested, exiled, or killed. NKVD – Narodny Komissariat Vnutrennikh Del 'People's Commissariat of Internal Affairs'. Text underneath reads **'Breeders in Yid and Satanic Russian Social Democratic Workers Party, the All-Soviet Communist Party of Bolsheviks, and the Communist Party bred a new nation of convicts in Solovkia and the White Sea-Baltic Canal, and settled eighteen million of them in the Gulag Archipelago of the Land of Fools'.**

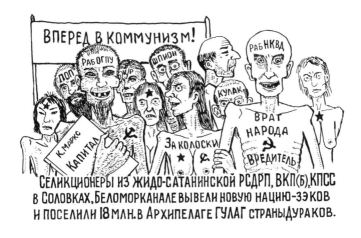

Ligovsky Prospekt, Leningrad. 1966.

A variant of a Ukrainian anti-Soviet caricature tattoo. Made by tattoo artist Vladimir Fedorov for an ex-convict named Ivan. He had served two terms. The first was on the charge of burning stacks of hay in a *kolkhoz* (collective farm). According to Ivan, he was accused by the head of the *kolkhoz*, because he was angry with him. The head was a former member of *Kombed* (*komitet bednoty* – 'the Committee of the Poor') and had dekulakised Ivan's grandfather. (The Soviet repression, deportation and execution of well-off peasants, 'dekulakisation', took place between 1929-1932.) Ivan was imprisoned a second time for selling moonshine to support himself.

EVEN DEATH CAN DiE

Corpse No.3295, City Morgue, 10 Ekaterinisky Prospekt, St. Petersburg. 1995.
Left shoulder.

A very rare men's tattoo.

Text on the scythe reads **'Retribution'**. Text in the speech bubble reads **'I didn't shiver as much in prison, when I tortured and killed two innocent cons. It was real quick – Bang! – and your soul is flying up to the trial in Heaven!...'**. Text on the board around the prisoner's neck reads **'Article 136 of the Criminal Code of the RSFSR'**. Text below reads **'Kraslag – Stroykrasmash'**.

Tulun, Irkutsk Region, Vostsiblag. 1949.

The tattoo of an ex-Kraslag convict, who worked in the Stroykrasmash Corrective Labour Camp. He was sentenced under Article 74 of the Criminal Code of the RSFSR for hooliganism. His brother and his brother's friend (an authoritative thief) were also imprisoned for hooliganism. They were both executed following an order of the Special Prison Court in 1954. After serving his term, Fedulovykh asked a tattoo artist to add the figure of a Cheka execution officer to his tattoo. (The Cheka – Troops for the Internal Defense of the Republic – were the forerunners of the KGB, a police force that, as well as keeping the citizens in line, were also responsible for running the labour camps and the Gulag system.)

Exclamations at the top read **'Shoot! Rob! Smash! Grab!'**. Text at the bottom reads **'In 1917, Jews deceitfully came to power and killed a million priests. They robbed, closed, and ruined churches and monasteries – something that the Mongols, the French, and even Hitler's armies didn't do. Jews did more wrong to Russia than Genghis Khan, Napoleon Bonaparte, and Adolf Hitler put together'**.

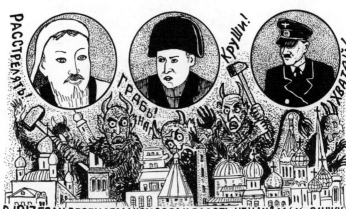

Enkhaluk, Buryatia. 2000.

A rare and original tattoo belonging to an ex-convict named Oleg, who was in jail for hooliganism. In 1937, the Irkutsk NKVD executed his grandfather, – a priest – along with other clergymen, as enemies of the people. During the Civil War of 1918-1921, his uncle fought in Kolchak's White Army against the Bolshevik's 5th Army. He was wounded and taken prisoner by the 'Reds'. A Jewish commissar ordered cold water to be poured on him and other captured commanders of the White Army. They were left to freeze to death, the extreme winter temperatures turning them into human ice statues. Oleg was full of hatred toward Jews, considering them speculators who had ruined czarist Russia. The tattoo was made by a Buryat-Mongol artist after Oleg had served his term.

Text at the top reads **'Yids – Judases and satanists. 1917 is the year of Satan. Bolsheviks – Communists'**. Text on the left reads **'Yids, Satan's shitouts, murdered 40 million Russians'**. Text underneath reads **'Jews will ruin Russia and will lead the anarchy... 1886. F. Dostoyevsky'**.

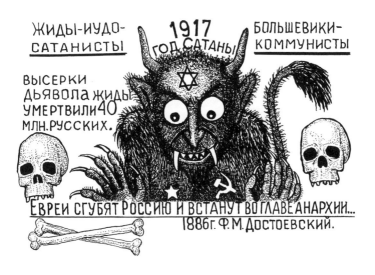

Tulun, Irkutsk Region, Vostsiblag. 1949.

An anti-Semitic tattoo of a prisoner, nicknamed 'Gokha', sentenced under the Decree of the Presidium of the Supreme Council on 4th June 1947 for large-scale theft of foodstuffs from military warehouses. His hatred of the Jews stemmed from his uncle's murder at the hands of a jewish Cheka officer. His uncle had been an officer in the Alexander Kolchak Army and was captured by Bolsheviks of the 5th Army. He was interrogated by the Irkutsk Cheka, under the command of a Jew named Blulkin. They put his uncle into a *masatka* – a forty gallon barrel lined with sharp nails – and rolled it around the yard. When removed from the *masatka*, the victim's corpse was almost completely drained of blood from the hundreds of nail punctures in the body. Gokha learned about the death of his uncle from a friend who worked as a janitor at the Cheka headquarters.

Psychiatric Asylum of the Ministry of Internal Affairs, 10 Mikhailova Street, Leningrad. 1942. Right hip.

This tattoo dates from the early 1940s. In czarist Russia, such tattoos were applied to murderers. During the early Soviet era, in an attempt to gain authority among other convicts, some prisoners tattooed KAT intentionally, as if they had been in jail in czarist Russia.

Specialised Labour Camp in Kitoy, Irkutsk Region. 1959. Back.

The tattoo of a homosexual, nicknamed 'The Cook'. Sentenced for rape under the Decree of the Presidium of the Supreme Council on 4th January 1949.

The text on the book's spine reads **'Capital'**. Text under the left angel reads **'God's trial of the leader of the world's proletariat'**. Text under the right angel reads **'Punishment of the boss of ghouls'**.

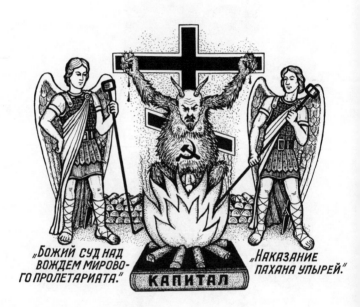

Konyashin Hospital No.21, 104 Moskovsky Prospekt, Leningrad. 1985. Back.

Caricature tattoo of the 'leader of the world's proletariat', V. Lenin. This tattoo belongs to a convict named Vladimir. He had been sentenced under Article 89 of the Criminal Code of the RSFSR of 1960 to ten years in the corrective labour camps of Shalakusha and Puskoozero.

Text on the man's chest reads **'Ivan the Terrible'**. Text top and bottom reads **'No one invited the Satanic Jews to Russia. We'll cut off their heads, drown them in rivers, and hang those sneaking Jews. Soon the Yids will ruin the church of Russian christians, and exterminate Russians and other peoples of Russia'.**

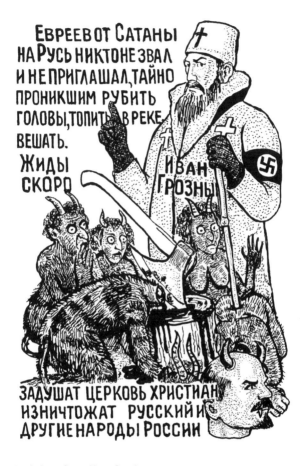

Corrective Labour Camp No.9, Gorelovo. 1965.

The tattoo of a prisoner named Fedorov who was sentenced under Article 144 of the Criminal Code of the RSFSR of 1960 for robbery. He claimed he had 'quit' his criminal life after becoming a father. He had many historical books and according to him, Ivan the Terrible was Russia's first führer – he destroyed his compatriots and was a great enemy of the Jews. This 'fact' was particularly to Fedorov's liking: he described Jews as a 'virus', and referred to them as 'devils'.

Drawings. Female Tattoos

Special Detention Centre, 10 Bakunina Street, Leningrad. 1962. Left shoulder.

Decorative tattoo of a female gypsy. She had been sentenced twice for swindling, receiving her first sentence in Kishinev, Moldavian SSR.

The French text reads **'What woman wants is what God wants'**.

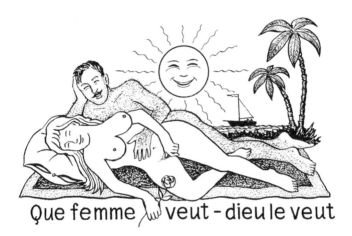

Que femme veut - dieu le veut

Leningrad. 1966. Left side of stomach.

The tattoo of a female prisoner who had been sentenced under Article 206 of the Criminal Code of the RSFSR for starting a fight while intoxicated. In the dormitory of the Krasnoye Znamya Factory at 1 Barochnaya Street, in a fit of jealousy, she had smashed a bottle of wine over the head of her roommate.

Hospital morgue, 93 Toreza Prospekt, St. Petersburg. 1966. Under left breast.

A semi-*portachka* (poorly executed juvenile prison tattoo), popular among *koblas* (active lesbians). This tattoo was copied from the body of a woman who had drowned while intoxicated in the Verkhneye Suzdalskoye Lake. The message of the tattoo is 'I see everything. It is hard to deceive me.' The message is addressed to passive lesbians, the partners of the *kobla,* who assume the role of the man in sexual relationships.

'I'm a prostitute from St. Petersburg. I don't steal and don't cheat. My clients love me. I was born for sex...'

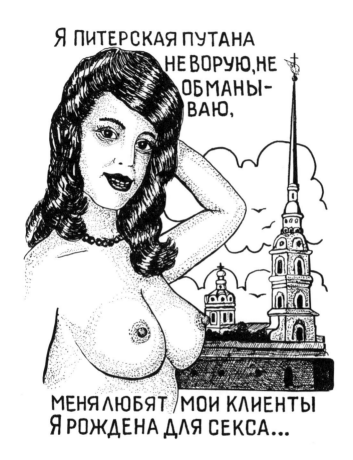

Detention Centre for the Homeless of the Department of Internal Affairs, 10 Bakunina Street, Leningrad. 1968.

Semi-*portachka* tattoo of a prostitute.

'I love you more than life itself!'

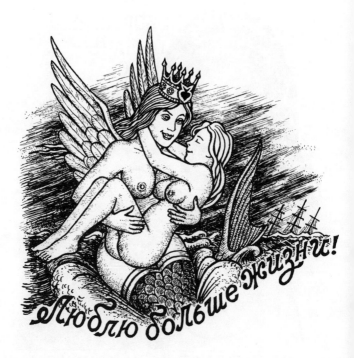

Люблю больше жизни!

1970s.

An active lesbian's artistic tattoo. Made by a professional tattoo artist.

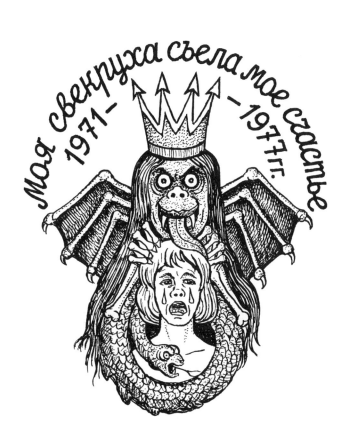

Detention Centre No.2, 39 Akademika Lebedeva Street, Leningrad. 1980s.
Right shoulder.

The head of a witch with the body of a snake entangling a woman's head.
This women's tattoo is called 'The Grip of a Cruel Fate'. The bearer, a
convict named Katya, was sentenced in the 1970s under Article 108 of the
Criminal Code of the RSFSR for severely beating her mother-in-law. She
was later sentenced again for hooliganism.

The misspelt Latin reads: **'Thus do we reach the stars'**.

Sis itur ad astra

Shoulder, stomach.

This tattoo signifies a 'Regret for lost freedom'. The tattoo may also show the date of imprisonment and the number of years left to serve.

Hip, stomach.

This image symbolises a single mother in prison.

Special Detention Centre for Misdemeanours, 6 Kalyaeva Street, Leningrad.

The tattoo of a *kobla*, *kovyryalka*, or 'husband' – an active lesbian.

The abbreviation reads **'MSREDZh'** which stands for 'Muzhskaya sperma rajsky eleksir dlya zhenshchin' (Men's sperm is a heavenly elixir for women).

Detention Centre, 39 Lebedeva Street, Leningrad.

This tattoo was copied from a prostitute sentenced under Article 115 of the Criminal Code of the RSFSR for infecting her clients with venereal disease. A palm tree is the symbol of heaven.

'Girls, find yourself a generous hand. You'll be fed, dressed, and entertained, and you'll pay with your body...'

1 Svechnoy Pereulok 'The House of Tramps', St. Petersburg. Lower abdomen.

An artistic tattoo belonging to a young prostitute.

Detention Centre No.2. 1990. Pubis.

A youth tattoo known as 'The Smoker'. Made in a women's corrective labour camp in Novozybkov, Bryansk Region in 1990.

Corrective Labour Camp No.2 for Women, Sablino, Leningrad Region. 1962. Hip.

A memorial women's tattoo. Different versions of this tattoo can also be found on men. The bearer was sentenced under Article 115 of the Criminal Code of the RSFSR for infecting a number of men with gonorrhea.

The poem reads '**Damn you, Kolyma, though they call you a Wondrous Planet, I'm bound to go crazy here. There's no coming back from here**'.

Specialised Detention Centre, Leningrad.

A musical memorial tattoo, imitating similar male criminal tattoos.

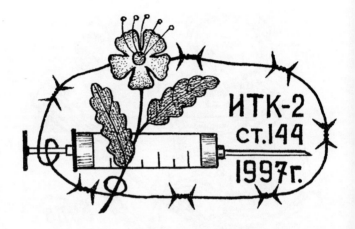

St. Petersburg. 1998. Left forearm.

The tattoo of a drug addict sentenced under Article 144 of the Criminal Code of the RSFSR of 1960 to three years in prison for theft. She was released from prison in 1997. She had been detained at Kupchino metro station after trying to ride without paying. Her name was Larisa and she was born in the Pskov Region in 1973. Before her imprisonment, she lived in a dormitory on Tallinskaya Street and worked at a construction site. She became an addict with the help of her friend Victor, with whom she committed many thefts. All the money made from selling the stolen goods was spent on drugs, purchased at a *tolkuchka* (a small flea market) in the Okhta district of St. Petersburg. Her parents had died and she was staying with a friend she'd met in prison. Victor had been sentenced to six years. Now she was looking for a job, but couldn't find one. Her story is typical of many drug addicts. She claimed that prison had cured her addiction.

The text is full of misspellings and reads **'Mother of God, I'm not a thief!!!
Save and protect me. I collected ears of wheat to feed myself and my
children and they jailed me for seven years!!!'**.

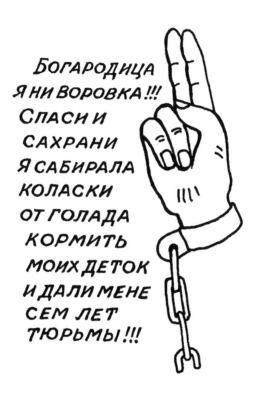

*Богародица
я ни воровка!!!
Спаси и
сахрани
я сабирала
коласки
от голада
кормить
моих деток
и дали мене
сем лет
тюрьмы!!!*

Left shoulder.

Tattoo of an ex-convict known as 'Aunt Pasha' who worked as a janitor at the
Ulan-Ude Steam Engine Construction Plant. She was from the Ziminsky
District in the Irkutsk Region. Of her three children, only her eldest
daughter, Anna, survived. Her husband had been killed in the Great Patriotic
War. When asked about the tattoo, she said: 'I was young and stupid. Every
girl in our group of 'field-mice' convicts had served for stealing wheat. Our
terms ended during the war, but we didn't get out before 1945. From 1936
to the end of war I was doing lumbering, then closer to the end of my term
I was put on crops. I served nine years instead of seven.

Text translated from the original Yiddish reads **'I'm a Jew – from the Palestine Branch'**.

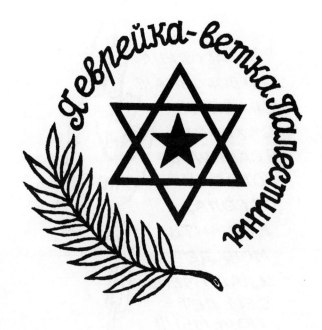

Corrective Labour Camp No.2. 1975.

The wearer explained the tattoo like this: 'My mother is Jewish and my father is Russian. My father drank a lot, and when he did he called us both Yids. When I was seventeen they divorced. I've always thought of myself as Jewish, even though my passport says I'm Russian. In school I was a good student. But my classmates envied me and called me a cheapskate and a Yid. They put smoldering cigarette butts in the pockets of my coat; they tore and stained my textbooks with ink; they even beat me. I hate Russians, they're worse than the Nazis. They're always looking for enemies and praising themselves. I was sentenced under Article 88 [of the Criminal Code of RSFSR of 1960] for foreign currency.' (Until the end of 1976 it was illegal for individuals to possess or deal in currencies other than the ruble.)

Text at the top reads **'Gentlemen fuckers, sex is life!'**. Text at the bottom reads **'Girls and women who don't have orgasms are godforsaken!'**. The monogram **'LSS'** between her legs stands for 'Lyublyu superseks' (I love super sex).

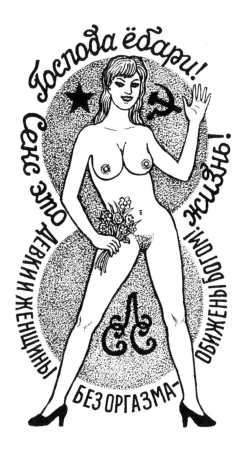

Specialised Detention Centre of the North-West Transport Department, Ministry of Internal Affairs, Leningrad. 1974. Left shoulder blade.

The tattoo of a woman sentenced for hooliganism under Article 206 of the Criminal Code of the RSFSR. She was detained along with other homeless people in a railroad depot. The tattoo was made in a Corrective Labour Camp for Women in Komi ASSR by an inmate who had formerly been an art student in Moscow.

Various female phrase tattoos.

i 'Cruel fate took away my freedom and hope'. A hooligan tattoo worn on the hip. Detention Centre No.2, Leningrad. 1970s.

ii 'I live and let live in jail'. A thieves' tattoo worn on the forearm. Kraslaga Corrective Labour Camp, Zlobino. 1950s.

iii The French text reads: 'What woman wants is what God wants'. A prostitute's tattoo worn on the lower stomach. She had been sentenced under Article 88 of the Criminal Code for carrying out transactions in foreign currencies. Corrective Labour Camp No.2, Leningrad. 1970s.

iv 'I keep my belongings close'. A prostitute's tattoo worn on the pubis. Corrective Labour Camp No.2, Sablino, Leningrad. 1970s.

v 'Blacks, yellow-skins, and Yids – scram from Russia!' A fascist tattoo called 'The Anarchist'. Worn on the hip. Detention Centre No.2, 39 Akademika Lebedeva Street, Leningrad.

vi 'I'm a criminal, but I'm no slut or prostitute'. A thieves' tattoo worn on the forearm. Glassworks, Women's Corrective Labour Camp, Ulan-Ude. 1950s.

vii 'Mama, forgive your sinning daughter'. A thieves' tattoo, made in Kungur Women's Corrective Labour Camp. Worn on the forearm. Copied in the Detention Centre for Misdemeanours, 19 Kalyaeva Street, Leningrad. 1980s.

i

ii

iii

iv

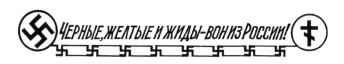

v

vi

vii

1980s. Hip.

The meaning of this tattoo is: 'I will only kneel before the Queen of Heaven and Jesus Christ. I will never get out of jail alive.'

Women's tattoos on the lower leg and ankle, made in salons using several colours. Decorative tattoos like these are especially popular among promiscuous women and prostitutes.

Corrective Labour Camp No.2 for Women, Sablino, Leningrad Region. 1981. Lower stomach.

A female tattoo imitating a male tattoo. The bearer was a prostitute and thief who had robbed her drunken clients in their apartments. She was sentenced under Article 144 of the Criminal Code of the RSFSR.

Top set of toes reads: **'Prisoner of the Department of Corrective Labour Camps'**. Bottom set of toes reads: **'I'm the daughter of sin'**.

Common toe tattoos.

Texts consisting of ten letters were usually tattooed on the toes. For example: 'Aldanstroy'; 'MVD is my casket' (MVD – *Ministerstvo vnutrennikh del*: Ministry of Internal Affairs); 'Yakutlag MVD'; 'Keep the suit up'; 'Mother, forgive me'; etc.

'They are happier than us convicts. Ozerlag Department of Penitentiary Institutions'

Они счастливие
нас зэчек УМЗ
„Озерлага"

Mariinsk Corrective Labour Camp for Women, Kemerov Region. 1955. Left shoulder blade.

Copied from a prisoner sentenced under the Decree of the Presidium of the Supreme Council on 4th June 1947.

'Love and sex rule the world!'

В Мирам
правят
любовь
и секс!

1 Svechnoy Lane, Leningrad. 1992. Stomach.

A prostitute's tattoo.

'Farewell, freedom!'

Odessa Corrective Labour Camp. 1960. Stomach.

Women's tattoo symbolising the loss of freedom and loving parents; a bitter and unhappy fate; the burden of loneliness; and disappointment in life. Such tattoos are usually worn on the stomach and back and are widespread among female convicts, sentenced for various crimes.

Text surrounding the syringe reads **'KKK. FIMA'**. In junkie slang 'KKK' stands for the hallucinogenic drug ayahuasca. 'FIMA' is a man's name. Letters around the penis read **'EPRON–EVZhMS!!!'**. The acronym 'EPRON' stands for 'Erot, podari radost onoy nenasytnoj' (Eros, bring joy to one insatiable woman). The abbreviation 'EVZhMS' stands for 'Eleksir vechnoy zhenskoy molodsti – sperma' (Sperm – elixir of eternal youth for women).

Stomach, hip, shoulder blade.

A tattoo meaning: 'I love sex and drugs'.

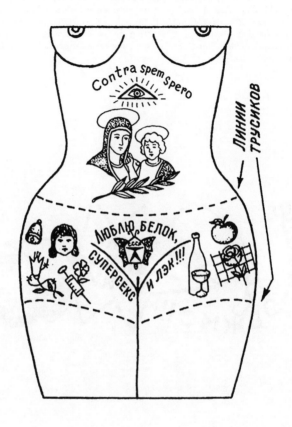

Example of female torso tattoos.

Vertical text on right side reads: line of the panties.

From top to bottom:

'Contra spem spero' – 'Hopelessly I hope'.

'I love spunk, supersex and blowjobs!!!' – around the genitals.

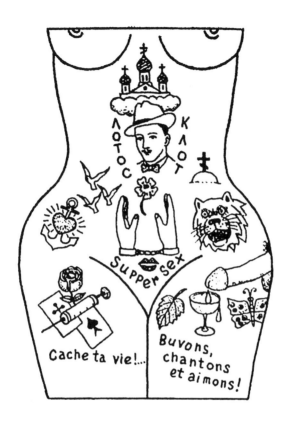

Example of female torso tattoos.

From top to bottom:

'LOTOS' – Acronym standing for *Lyublyu odnu / odnogo tebya ochen silno* (I love only you very much).

'KLOT' – Acronym standing for *Klyanus lyubit odnu tebya* (I swear to love only you).

'SUPERSEX' – above genitals.

'Cache ta vie!...' – 'Hide your life'.

'Buvons, chantons et aimons!' – 'Let's drink, sing and love'.

Maria Alekseyeva's criminal finger ring tattoos. She committed suicide in 1992 following a heavy drinking bout.

From the top:
'NINA' – 'I was not and will not be an official'.

Single dot: 'I once escaped from an educational work colony'.

Devil's head: 'I don't give in to the director of the reform school'.

Crosses on knuckles – 'Trips to the zone'. 'I have been to prison three times'.

Forefinger: 'I've done time in St. Petersburg's Kresty Prison'.

Middle finger: 'I don't give my hand to coppers, I'm a real thief!' (Only found on female convicts).

Third finger: 'Greetings thieves!'

Little finger: 'I'm a teenage thief' (A female version of this thieves cross).

'1961' – Date of birth.

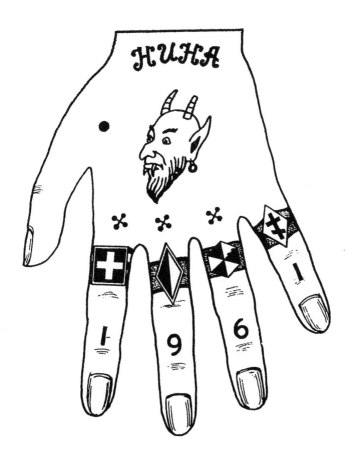

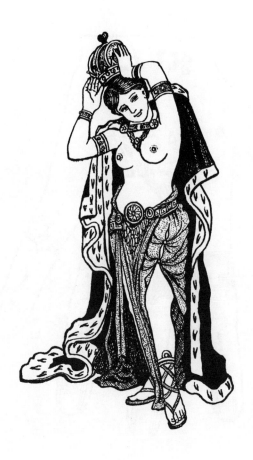

Detention Centre, Leningrad. 1960s. Hip.

Tattoo popular among both men and women. The men's interpretation is 'If I were to sleep with a woman, then it would only be a queen. If I were to steal, then it would be no less than a million'. The women's interpretation is 'To live and love life like a queen'.

'The food provision programme of the Communist Party is being fulfilled!'

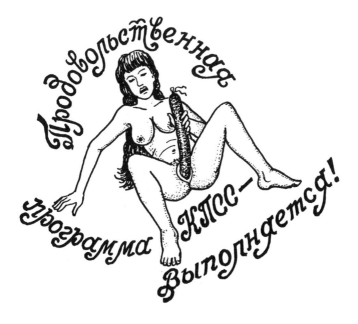

Hip.

A female 'hooligan' tattoo.

'IRKA-ENTR' this abbreviation stands for 'I razluka kazhetsya adom, esli net tebya ryadom' (Separation is worse than hell, when you're not beside me).

US-20/2 Institution, Leningrad Region. 1970s. Stomach.

Rages of jealousy are very common in corrective institutions for women, especially at dances. Often they take the form of ferocious fights, where hair is torn out and faces are scratched and bitten. Passive lesbians fight over *koblas* (active lesbians). *Koblas* fight over beautiful and passionate passive lesbians. The prison administration tries not to split 'lovers' into separate cells or working teams.

'KLOT'. The acronym 'KLOT' stands for 'Klyanus lyubit odnu tebya' (I swear to love only you).

Corrective Labour Camp No.2 for Women, Sablino, Leningrad Region. 1967. Right shoulder.

This tattoo is a depiction of a lily, the symbol of a passive lesbian. The eye represents the supervision of an 'authoritative' active lesbian, the lips symbolise voluptuousness.

'Forgive me, Mother! It's all my fault. Forgive me!'

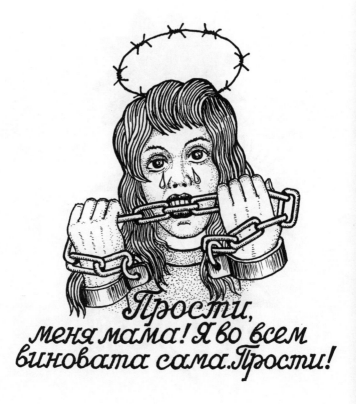

Omlaga Corrective Labour Camp. 1950s. Stomach.

During the 1950s such tattoos and their variants were popular among female convicts sentenced for theft.

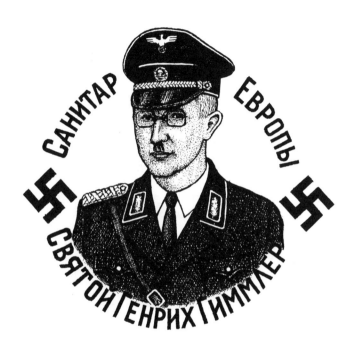

Molodezhnoe, Sestroretsk District, Leningrad. 1979. Stomach.

Rare Estonian woman's decorative tattoo. The wearer's uncle had served in the Nazi SS during the Great Patriotic War.

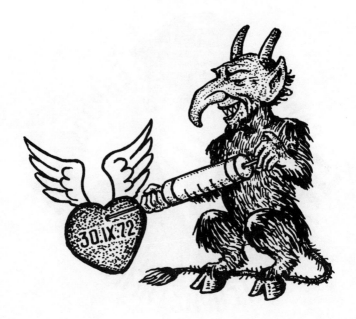

Shoulder, hip, or forearm.

Tattoos depicting the Devil are common on men and women. Here the numbers on the heart denote the date: 30. 09. 1972.

Text at the top reads **'Mother, forgive me!'**. Text in the barbed wire reads **'Article 144** [of the Criminal Code]. **BOG. Rybinsk'**.

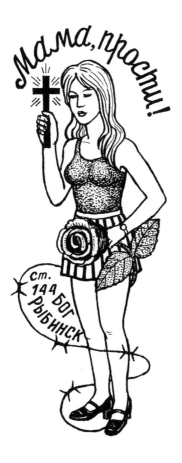

Leningrad Detention Centre. 1972. Hip.

The bearer of the tattoo was a young female pickpocket. Born in Rybinsk, she studied in a Leningrad college to be a seamstress. She turned eighteen while in prison. The acronym *BOG* (literally 'GOD') stands for *Byla osuzhdena gosudarstvom* (I was sentenced by the government).

Photographs. Section Two

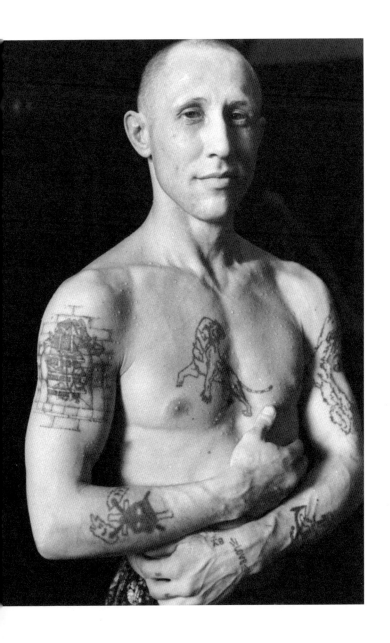

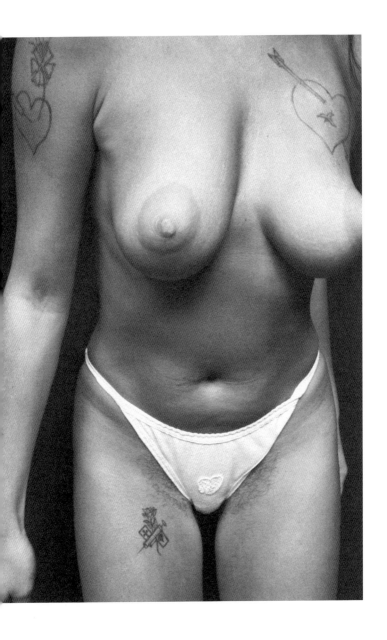

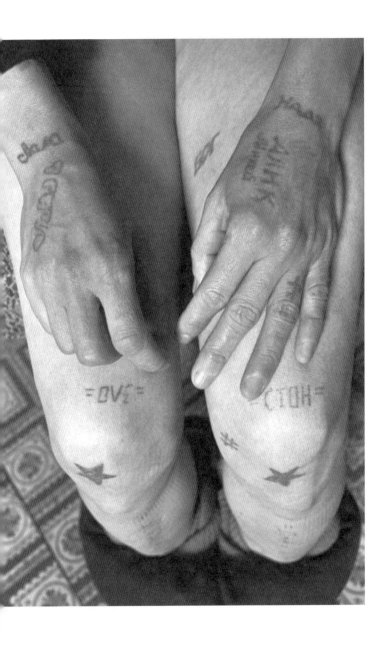

321

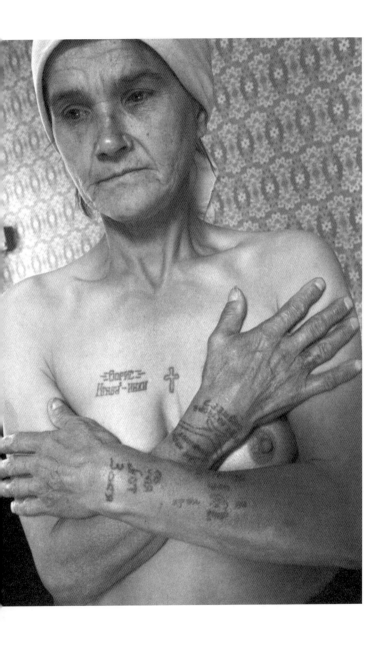

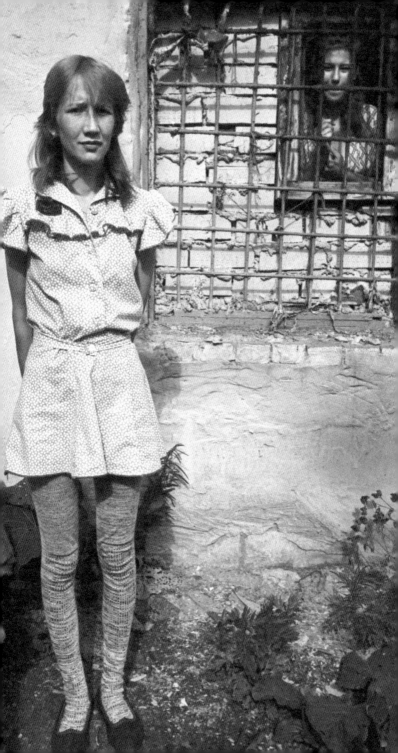

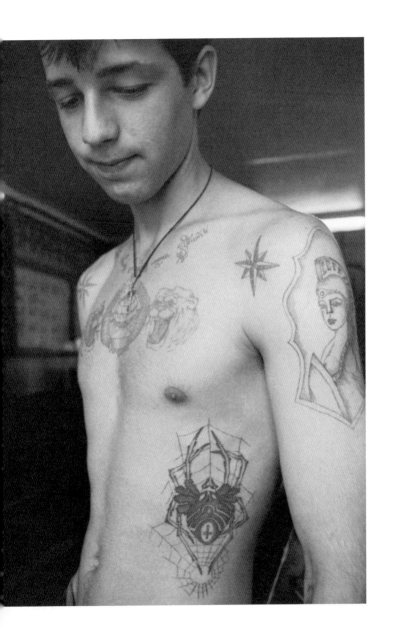

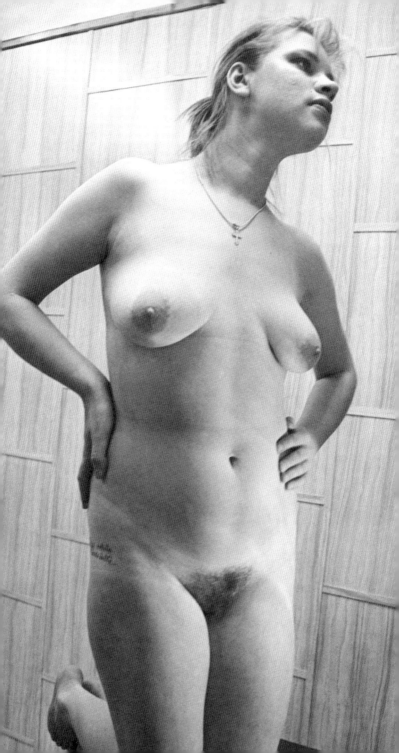

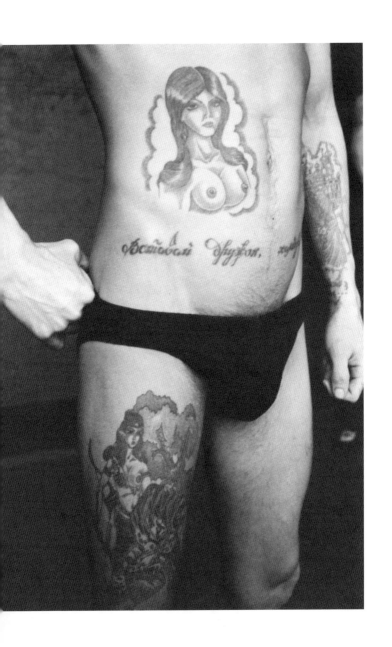

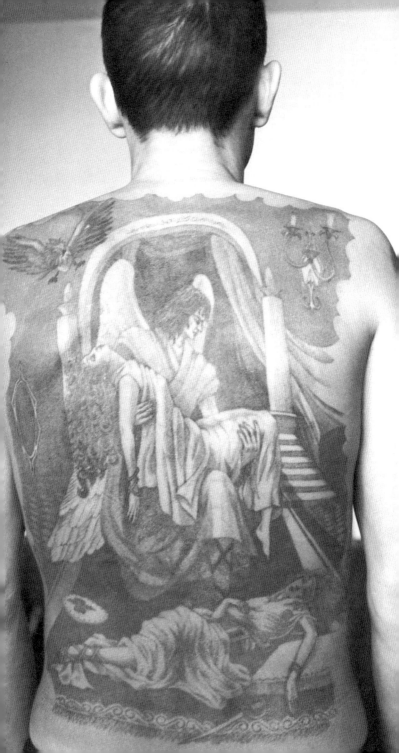

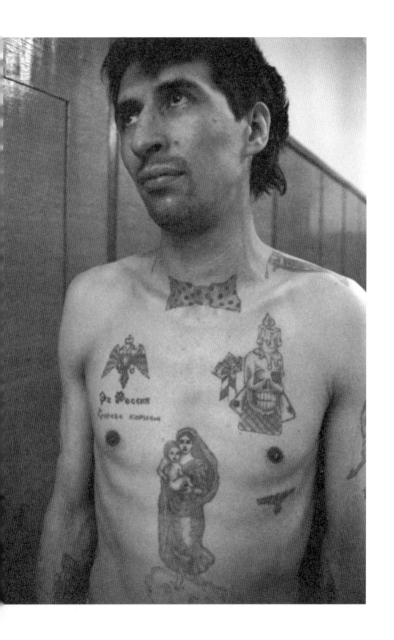

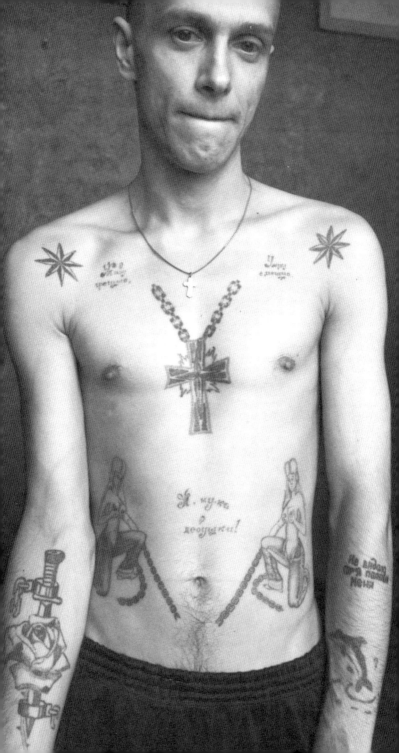

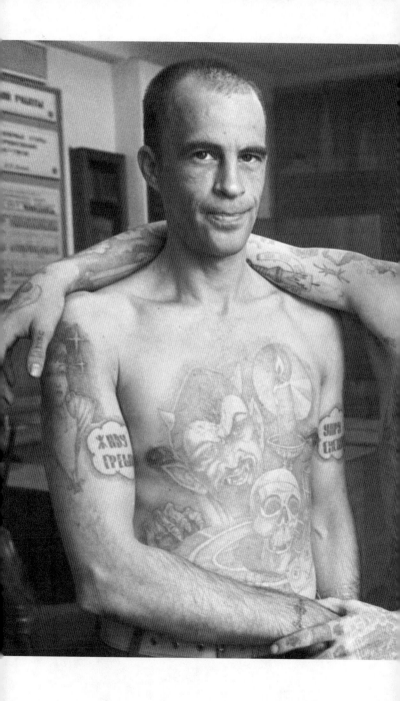

338

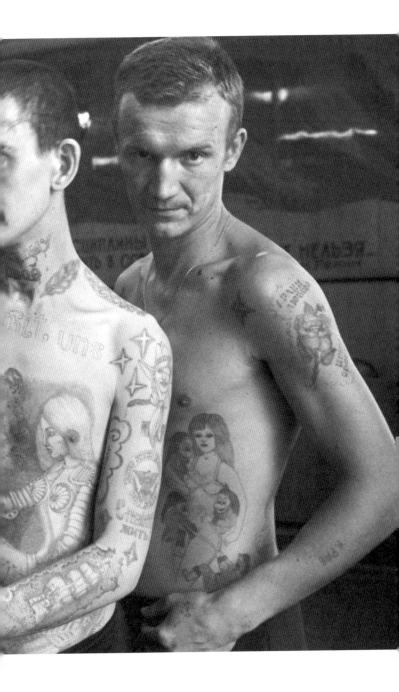

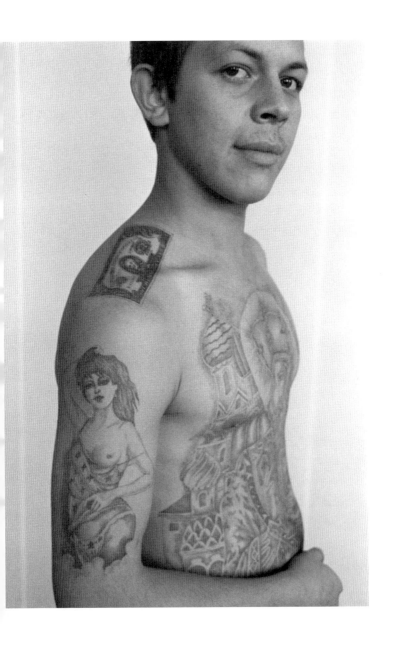

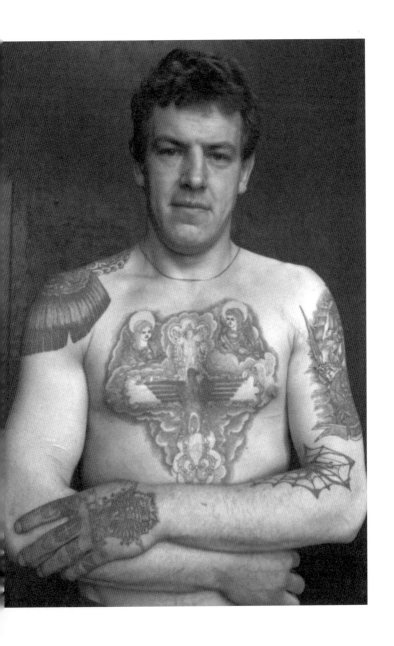

343

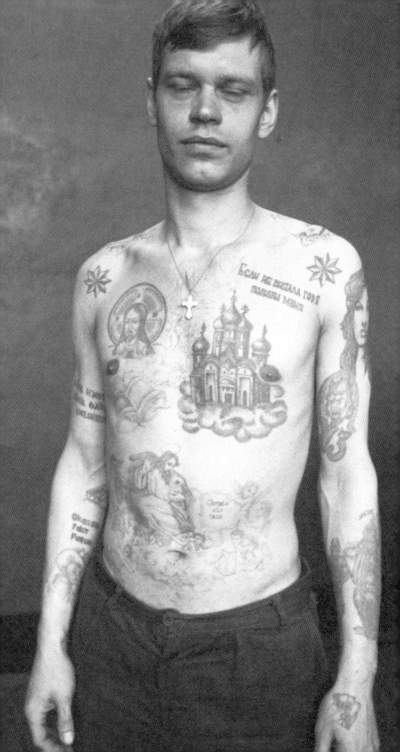

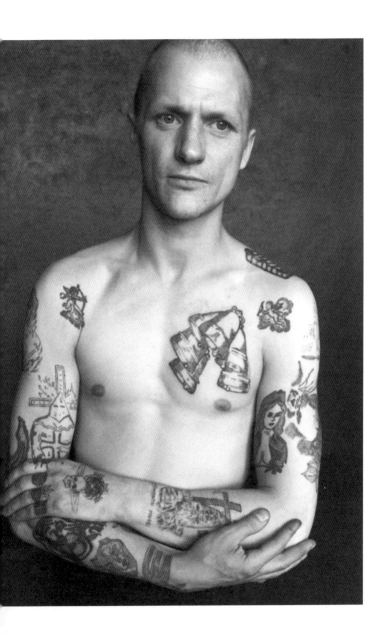

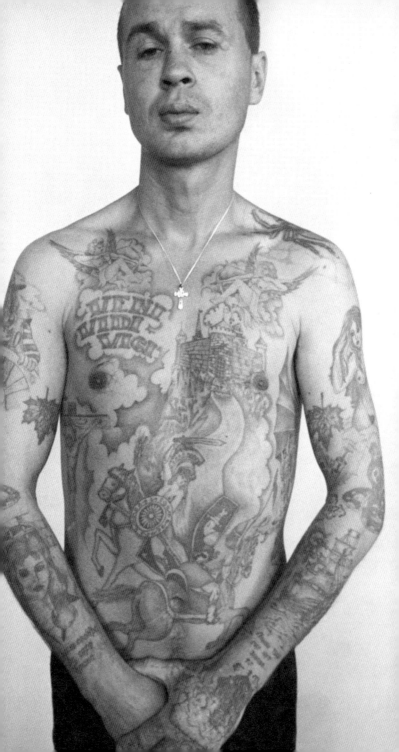

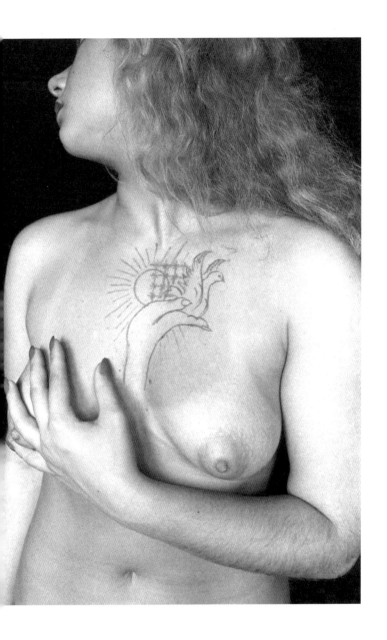

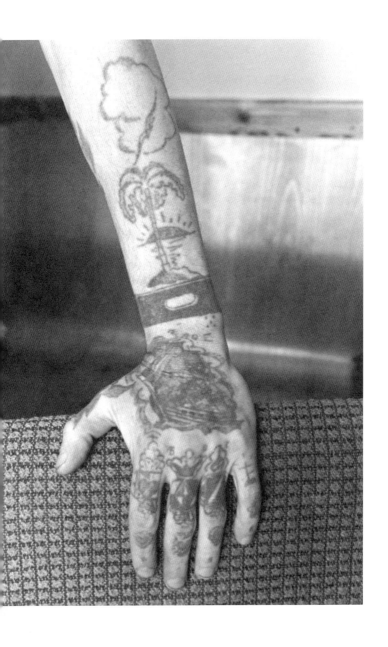

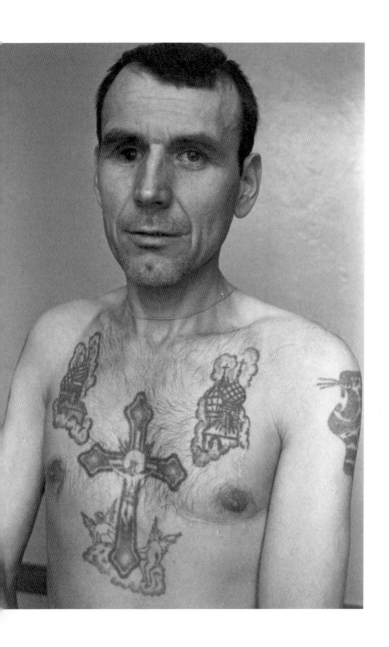

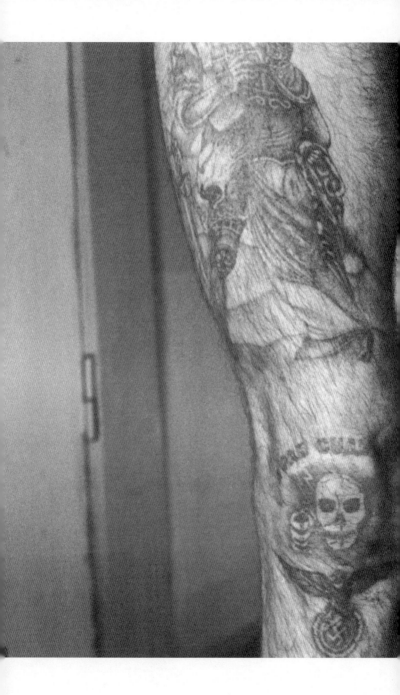

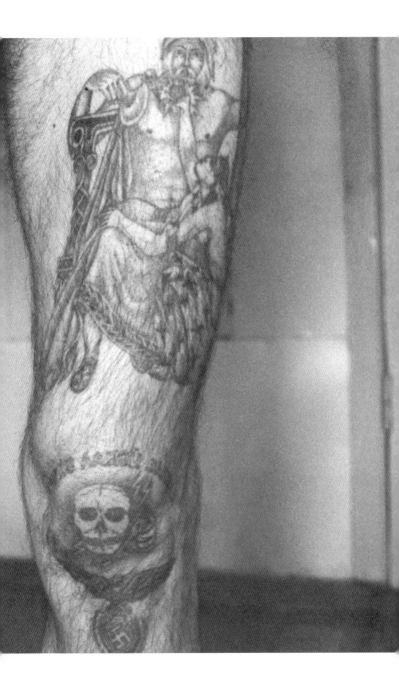

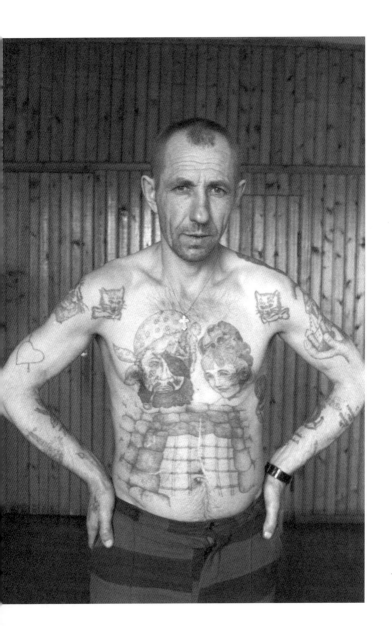

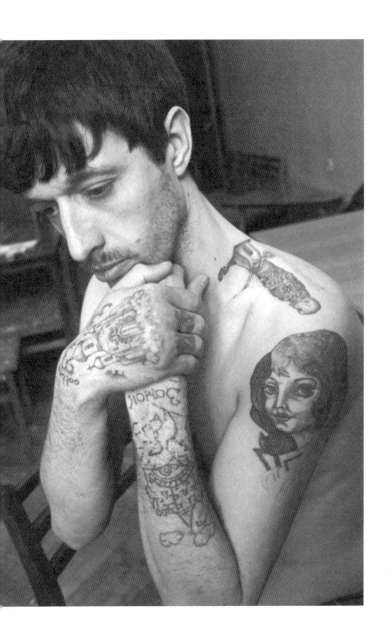

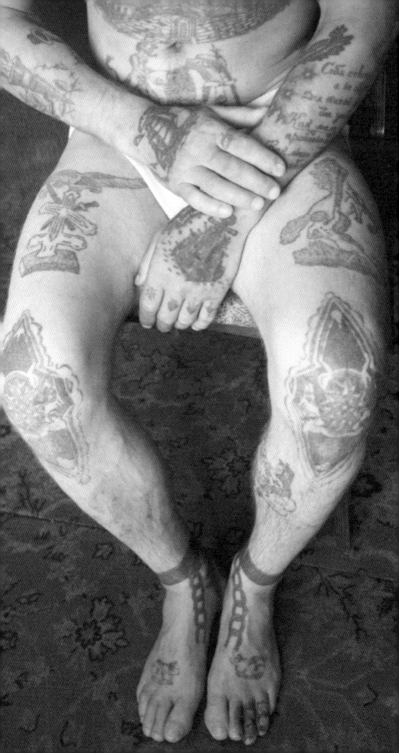

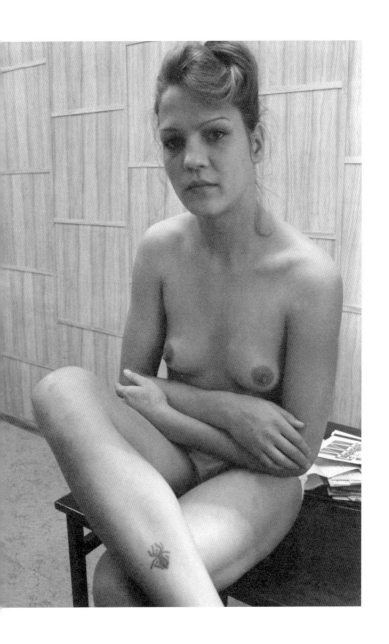

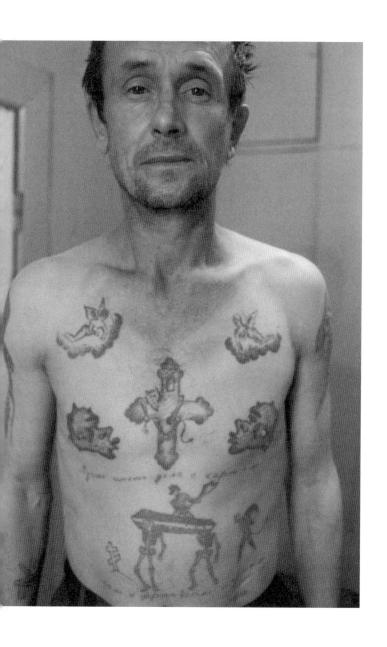

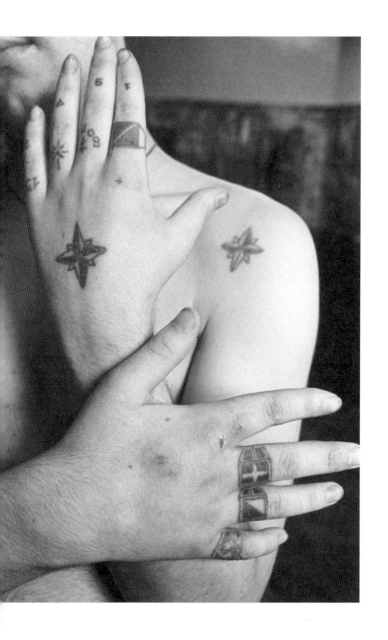

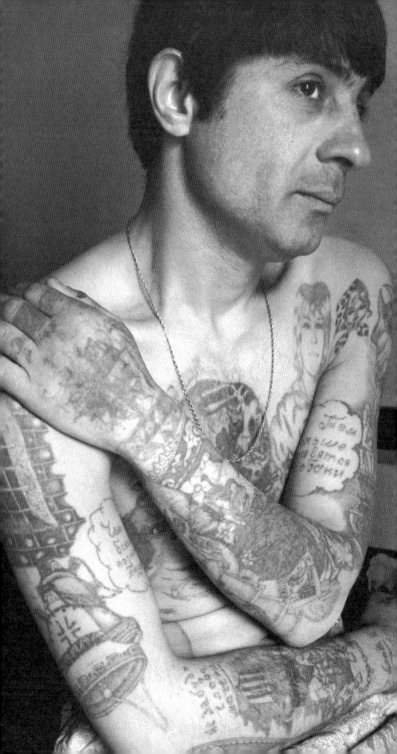

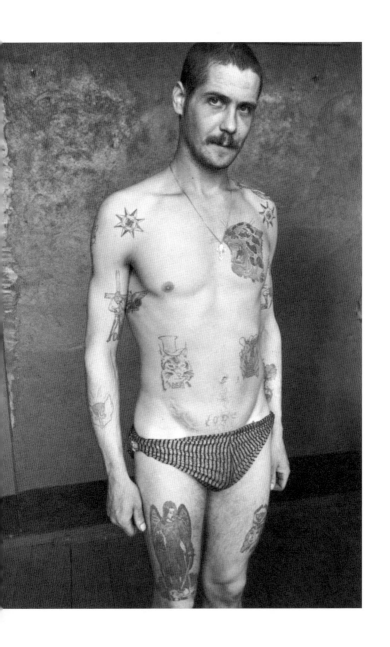

The photographs in this book were taken by Sergei Vasiliev between 1989 and 1993 at the following locations.

Corrective Labour Colony Lopatkovo, Sverdlovsk Region. 1992.
Erotic tattoos: the inscription on the stomach reads 'A key to women's hearts'. The word on the penis reads: 'Cad' (p 83).

Corrective Labour Colony Gari, Forest Camps, Northern Sverdlovsk Region. 1992. (p 47).

Corrective Labour Colony No.2 Chelyabinsk Region. 1990.
Convicts pose in the commandant's office before their release (p 7). Convicts gather in the main hall to listen to the orthodox priest, Father Georgiy for the first time during the Soviet period. This event was organised by the photographer (p 28-29).

Corrective Labour Colony No.5 Nizhnyi Tagil, Sverdlovsk Region. 1991.
A group of convicts convicted of drug-related crimes (p 338).

Corrective Labour Colony No.5 Obukhovo, St. Petersburg. 1992.
(p 87, 327).

Corrective Labour Colony No.6 Farnosovo, Leningrad Region. 1992.
The tattoo reads 'they sleep' (p 72-73).

Corrective Labour Colony No.6. Kopeisk, Chelyabinsk Region. 1989.
Convicts clear snow from the prison courtyard, Soviet propaganda posters cover the wall behind (p 30). A lion on a prostrate woman signifies that the owner of the tattoo is 'angry at the authorities' and is 'prepared to fight anyone who questions his dignity'. This convict had been 'lowered' (punished), and was repressed and violated by other convicts (p 79).

Corrective Labour Colony No.8 Chelyabinsk Region. 1990.
(p 317).

Corrective Labour Colony No.9. Gorelovo, Leningrad Region. 1992.
This image of a monster is intended to intimidate other prisoners and give significance to the wearer within his circle (p 11). This tattoo was made in memory of a loved one (p 331). A cut on the cheek is forcibly applied as a punishment to any convict who has informed or betrayed his fellow inmates to the authorities (p 3).

Corrective Labour Colony No.12 Nizhnyi Tagil, Sverdlovsk Region. 1991.
The finest tattoos are made in the Ural labour colonies. Convicts try to get transferred here so they can be tattooed by the artists in these camps (p 5). Prison is this thief's 'home', he is of the highest rank in the thieves' social hierarchy (p 71). Portraits of the Father of the Gulag (Stalin) and the Father of the Thaw (Khrushchev) (p 69).

Corrective Labour Colony No.14 Puksinka, Sverdlovsk Region.1992.

A colony where recidivists are sent. The convicts have just returned from a tree cutting site (p 34). The tattoo on the lower stomach reads: 'Come on, girls!' (p 67). A 'legitimate' thief with many convictions (p 371). A thief with many convictions who was later murdered in the camp (p 363).

Corrective Labour Colony No.40 Kungur, Perm Region. 1991.

An authoritative, 'legitimate' thief (p 94-95).

Female Corrective Labour Colony No.2 Sablino, Leningrad Region. 1991.

(p 9, 329, 365).

Female Corrective Labour Colony No.5 Chelyabinsk. 1990.

The shoulder and breast carry 'love tattoos', on the right leg is a symbol of drug addiction (p 319).

Female Corrective Labour Colony No.6 Nizhnyi Tagil, Sverdlovsk Region. 1991.

This woman was later admitted to a mental institution (p 325). The 'treble clef' on the finger signifies: 'I lived merrily' (p 59).

Female Corrective Labour Colony No.32 Perm Region. 1991.

'STON' stands for 'all my misfortunes are with you'(p 321). The tattoos of an 'active' lesbian (p 323).

Kresty Prison, 'The Crosses' St. Petersburg. 1992.

A new group of convicts arrives in the inner yard (p 376-377). The exercise yard (p 36).

Prison Hospital. Special Medical Centre 20/12 St. Petersburg. 1992.

A convict suffering from tuberculosis (p 355).

Special Colony Pelysh, Northern Taiga Region. 1992.

The tattoos on the knees read: 'slave of fate, but not a servant of the law'. A skull is a symbol of the anarchy; the swastika means that the bearer 'will never be corrected' (p356).

Strict Regime Corrective Labour Colony No.12 San-Donato, Nizhnyi Tagil, Sverdlovsk Region. 1991.

The tattooed body of a 'legitimate' thief (p 349).

Strict Regime Corrective Labour Colony Vagel, Sverdlovsk Region. 1993.

(p 65).

Strict Regime Corrective Labour Colony Sosva, Sverdlovsk Region. 1992.

(p 97, 99).

Contemporary Tattoos in Russian Prisons

Alexander Sidorov

Perestroika and the Renaissance of Criminal Tattoos

The Russian criminal tattoo has many different names: *naboy* (punchwork), *nakolka* (needlework), *rospis* (drawings), *shtamp* (stamping), and *portachka* (a poorly executed juvenile prison tattoo). Terms like *regalka* (from regalia) and *armaturka* have long since disappeared, tattoos were sometimes referred to as *regalka* when they served as distinguishing marks in the prison hierarchy. The word *armaturka* was common after the Great Patriotic War (Second World War) and derived from the German *armtatu* (arm tattoo). The multitude of nicknames indicates the significance of tattoos in the prison community.

Today, for many, the tattoo has lost its symbolic meaning. Even as late as the 1980s the well known dissident and former labour camp prisoner Vitaly Abramkin,[1] when asked if a convict's tattoos corresponded to their identity, responded:

> It did until recently – the number of church domes tattooed on the chest matched the number of terms served, a puss-in-boots denoted a pickpocket, a circle with a dot inside on the forearm or over the upper lip meant a *gunsel* (a passive homosexual)... Unsanctioned tattoos were outlawed, and the bearer would be punished and forcibly tattooed. But that was all in the past – now professional criminals don't tattoo themselves at all.

However, criminal tattoos, while losing their function of indicating the wearers place within the hierarchy, retained their appeal for criminals. In Russia during the 1980s and 1990s there has been a significant interest in the criminal subculture in general, and the tattoo in particular.

Kolshchiks (Tattoo Artists)

Criminal tattoos are usually blue, multicoloured tattoos have only recently appeared. Originally, the ink was home-made, a mixture of soot, sugar, ashes, and urine. The most common way of applying a tattoo was to bind three or four sewing (or syringe) needles to a match with thread. Sometimes, staples or sharpened paperclips were used. Another method

involved a *shtamp* (literally a 'seal') – a plank with needles arranged to form the desired design. These crude methods have become a thing of the past. Today ink from a ballpoint pen is used instead. An electric shaver can easily be refashioned into a tattoo machine, as well as making the process of tattooing less painful, this also facilitates the addition of shades and hues. The machine moves the needle up and down at a rate of a few hundred oscillations a minute, puncturing the skin to a depth of up to a millimetre. To prevent infection, urine is often applied to the freshly tattooed skin. In Russian criminal parlance, a tattoo artist is called a *kolshchik* (from *kolot*, to pierce). A *kolshchik* must not only be good at tattooing, but must also understand the meaning of the tattoos.

Aggressive Tattoos

The *oskal* (bared teeth), is an image of a snarling tiger, leopard, lynx, lion, or other feline predator baring its teeth. It is common among convicts who are hostile to the authorities, tattooed on the left or right side of the chest or the upper arm. During the Soviet era, it was also known as *oskal na Sovetskuy vlast* (baring your teeth at the Soviet authorities). See photograph on page 11: 'The Devil's sneer'.

The next most popular are the various combinations of a snake, dagger, knife, sword, axe, and scull. They denote revenge, threat, attack, steadfastness, and cruelty.

The 'thief's star', a tattoo in the shape of a compass rose, is sometimes an eight-pointed star in various configurations or a Star of David. On the shoulders it means: 'I'll never wear epaulets'. On the knees: 'I will not kneel before the cops'. See photograph on page 373: *KOT – Korennoy Obitatel Tyurmy* (Native prison inhabitant), thieves' stars, bared teeth.

Juvenile offenders like to tattoo five-pointed stars or epaulets with stars on the soles of their feet, so they trample on the official insignia of Russian police. In pre-trial cells guards will beat young detainees with rubber truncheons on the soles of their feet.

Other typical aggressive tattoos:

1. A knife in a hand, bound with fetters: a *baklan* (petty criminal). Also without fetters: the desire to avenge a fallen comrade.

2. A dagger with a snake coiled around it: 'I am a confirmed robber and thief' (not a caste, but a specialisation). If a dagger is plunged into a scull it denotes an authoritative legitimate thief. If the dagger is plunged into a tree stump: 'King of the criminal suite'.

3. A tulip pierced by a dagger: 'Death to the public prosecutor' or more generally: 'Revenge against the agents of law enforcement'.

4. Two tulip heads on a branching stem: the symbol of a blood feud, also found as a ring tattoo.

5. A heart pierced with an arrow and dagger: 'Revenge against those who

betrayed the thieves' code'. Sometimes accompanied by the inscription: 'for treachery'. It also means: 'I'll kill for a friend'.

6. The Orthodox cross (with two crossbars) above a grave mound: 'I will take revenge on the activists, even at the cost of my mother's life'; or: 'Death to the *bugors*!' A *bugor* (literally a 'mound') is the chief of a group of activist convicts. If the mound is a light colour the revenge is still to be carried out. If dark then revenge has been taken, on the thumb.

7. The head of a woman, a knife, and a rose: a vow to avenge infidelity, on the forearm.

8. A gladiator with a sword: a convict who is appointed to settle accounts with those condemned by the community of thieves. Today it signifies: 'I am a sadist and vandal', on the shoulder and back.

9. A spider with no web: an 'ideological' offender, on the left side of neck.

10. Two bulls ready to fight; a fight between two gladiators; knights; *bogatyrs* (medieval Russian knights); a knight fighting a serpent or dragon (St. George): readiness to fight for leadership and aggression towards the police, on the back and chest.

11. The Criminal Code of Russia pierced with a dagger: 'Death to the Public Prosecutor'.

12. A pirate, often holding a knife between his teeth, with the letters *IRA* on the knife: an inclination to brutality, sadism, and a negative attitude toward activists – prisoners who openly collaborate with prison authorities. *IRA* stands for *Idu rezat aktiv* (I'm off to kill the activists), on the shoulder and chest.

Informative Tattoos

Informative Tattoos contain information about the bearer, his outlook on life, his predilections, and his rank in the criminal world.

1. Five dots arranged in the manner of a dice: the four dots on the sides signify watch towers, the central dot represents the convict, meaning 'I've been in prison', on the wrist just below the base of the palm.

2. Small crosses: each cross represents a term. Dots around the crosses represent the number of years served, on the knuckles.

3. Numbers: year of birth, on the middle phalanges.

4. Letters: name of the bearer or their beloved, on the middle phalanges.

5. A large dot: an escapee, the number of dots corresponds to the number of escapes, between the thumb and the index finger.

6. A spider in a spider web: a drug addict, between the thumb and the index finger, sometimes on the back of the hand near the veins.

7. A tulip in a hand: the bearer turned sixteen in prison, on the shoulder.

8. A dagger entwined with a rose against a background of prison bars: the bearer turned seventeen in prison, on the shoulder and forearm.

9. A rose held in hands: the bearer turned eighteen in juvenile prison, on the shoulder.

10. Barbed wire: the number of barbs on the wire stands for the number of years spent in prison (or years sentenced). If coiled, the number of coils denotes the number of terms.

11. Daisies: the bearer was part of a criminal gang. The petals represent the number of members in the gang. Initials may be tattooed on the petals.

12. Church domes: the number of sentences. The number of crosses over the domes denote the terms served in full (to the bell). If on the thigh or forearm, the church is usually depicted resting on the palm of a hand. If the term exceeds five years the wrist of the hand holding the church is in manacles, on the chest, shoulder, back, or the back of the hand.

See photograph on page 85: church with domes on the thigh.

13. A tied, chained or crucified woman being burned, or a woman sitting on a kopeck coin: a woman pushed the bearer into crime, the coin denotes a prostitute. The number of burning logs indicates the years of the sentence, on the chest, shin or thigh.

14. An executioner beheading a woman: sentenced for the murder of a woman, on the chest or the front of the thigh.

15. A scull, dagger, and snake in various combinations: theft or robbery.

16. An epaulet pierced through with a knife: the bearer was sentenced for the murder or assault of a policeman, on the shoulder.

17. Scull and crossbones: the death sentence has been commuted to life imprisonment (today this only means life imprisonment).

18. The cross of an Orthodox grave with three crossbars: the bearer has been sentenced for murder.

19. A scull with wings: the bearer has been sentenced for theft or robbery.

20. A white dove: a happy childhood. If the dove is placed against a background of bars the bearer spent his childhood in places of detention.

21. A brigantine with sails; a running deer; an eagle with a suitcase in its talons (the suitcase often bears the inscriptions 'Ukhta – Sochi', 'Magadan – Crimea', etc.): the bearer is a potential escapee.

See photograph on page 81: a brigantine on the arm.

22. An anchor: symbolises a life of freedom. An anchor and a cable with a knot at one end can sometimes mean: 'I'm tying up this life of crime'.

'Professional' Tattoos

Professional tattoos indicate specialisation in a specific criminal activity or the bearer's position in the criminal hierarchy.

1. Traditionally, crucifixes and eagles on the chest; officer's shoulder straps and epaulets on the shoulders; a cat's face on the chest; and thieves' stars denoted an authoritative criminal. Today, the original meanings have been lost. Some criminals now tattoo naked women, dollar bills, and so on, instead of epaulets – these tattoos only signify that they belong to the criminal class and intend to persist in their life of crime. The head of a cat, for example, symbolises luck and caution. The cat is also the symbol

of a pickpocket. At one time, a bow tie was forcibly added to the picture of the cat's head on pickpockets who had broken the thieves' code and sided with the police or prison authorities. Now, however, cats with bow ties have become common and there is no stigma attached to them.

See photograph on page 71: an epaulet with the bearer's initials.

2. An Orthodox cross: a pickpocket, on arms and shoulders.

3. Beetles, ants, cockroaches, bumblebees, flies, and spiders (without a cobweb): a pickpocket. The acronym *ZhUK* (literally 'beetle') stands for *Zhelayu Udachnykh Krazh* (may your theft be a success). As well as being a totem of a pickpocket, the scarab beetle is generally considered to bring luck to the wearer, on the hands, occasionally other parts of the body.

See photograph on page 57.

4. A spider in a web: a native prison inhabitant, or *krytnik* (from *krytaya* meaning 'roofed', slang for jail, as opposed to *zona* or *chalka* for labour camp). Recently, these tattoos have become the attributes of drug addicts, on the shoulders, neck, or the back of the head.

5. Card suits: a 'player' or card swindler. Suits are in a specific order: clubs, spades, diamonds, and hearts. The initial letters of the Russian words for card suits – *kresti*, *vini*, *bubny*, and *chervy* – thus form an abbreviation that stands for *Kogda Vyidu Budu Chelovekom* (I'll be a man when I get out). The slang term *chelovek* (man or person) means an 'honourable' criminal, often tattooed as a bracelet on the wrist.

6. A monk writing in a book with a quill pen: a 'scribe'. A pickpocket who is skilled at using a razor, knife, or a sharpened coin to surreptitiously slit open pockets, handbags, etc.

Forcible Shaming Tattoos

Forshmachnye or shaming tattoos were forcibly applied in order to stigmatise the wearer.

1. A naked woman entwined with a snake: a passive homosexual, on the back. Any depiction of a naked woman on the back was once looked down upon and denoted a passive homosexual. This was intended to give the active homosexual the illusion of copulating with a woman.

2. A crown containing the 'red' card suits (diamonds and hearts): 'King of all suits', a passive homosexual who will engage in all forms of sodomy, on the back.

3. 'Beauty marks' (dots): different positions on the face denote meaning. Between the eyebrows: a 'bitch' (a convict who has betrayed the thieves' brotherhood and sided with the authorities). Rarely this also signifies a *chushok*: an untidy, degraded convict who does all the dirty, shameful work. Dots beneath the eyes or on the cheeks: a passive homosexual. Near the lips: a *vafler*, a passive partaker in oral sex. On the nose: a *stukach*, a 'stoolie', a prisoner who informs on others to the authorities. On the chin: a *krysa*, a 'rat', a prisoner who steals from other prisoners.

4. A rat: a *krysa* (see previous).

5. The ace of hearts: a *fuflyzhnik*, a person who is unable to pay his debts. Shaming tattoos also exist in the form of finger rings.

[The views of Alexander Sidorov differ from those of Danzig Baldaev on the subject of shaming tattoos. Baldaev's drawings contain images that to the untrained eye appear erotic but have, according to the evidence he gathered at the time of drawing, been meted out as punishments (for losing at cards etc., see drawing on page 203). However, Sidorov maintains that these tattoos have been misinterpreted by Baldaev and that erotic shaming tattoos only ever consist of one subject: a woman entwined with a serpent, which is forcibly tattooed on the back of the victim. The reader should be aware that these contrary viewpoints exist and continue to provoke debate between respected experts in the field.]

Tattoos on the Buttocks

Tattoos on the buttocks are applied to passive homosexuals. These are usually eyes, one on each buttock. This practice gave rise to the saying, 'I'll pull your eyes down to your arse and make you blink.' It's widely accepted that no self-respecting convict would ever tattoo their buttocks. Mikhail Gernet in his book *The History of the Czar Prison* (1960-1963),[2] states that tattoos on the buttocks indicated passive homosexuality, although he did come across an exception to this rule:

> We have learned of a single case in which a gentleman demonstrated a tattoo for the benefit of entertaining his fellow inmates... He had a cat tattooed on one of his buttocks and a mouse running away from the cat on the other. When the convict strolled in the cell, having bared his buttocks, the effect was of the cat chasing the mouse.

In his poem *Aska* (1942–1943),[3] the former labour camp prisoner Igor Mikhailov describes a similar tattoo across a woman's buttocks:

> On two snow white lower hemispheres,
> Right where they met,
> A mouse almost touched a cat,
> The cat's ferocious paw in mid-air ready to strike.
> The picture while static
> Wasn't all that attractive.
> But when you were lucky enough to see
> Zaichik naked strolling before you,
> You froze in awe,
> As the mouse run away from the cat
> Into its hole,
> While the cat tried to catch it with its paw

It is likely that from the 1920s to the 1940s it was not only passive homosexuals who tattooed their buttocks. Today however, at least among men, tattoos on the buttocks are widely considered to be 'shaming' and are not applied.

Sentimental Tattoos

The subject matter of sentimental tattoos depends greatly on the imagination of the tattoo artist. Most are accompanied by inscriptions.

1. A rising sun or a seagull: a longing for freedom. From the end of the 1940s to the end of the 1960s, the number of long rays stood for the number of terms served, and the short rays for the number of years served. Seagulls were usually depicted in the sky, and below the horizon the word 'Freedom' or the name of the prison was tattooed. Originally, this tattoo was called 'Hi there, thieves!'

2. A torch: comradeship in prison. Often accompanied by the initials of a friend, on the hand.

3. The Devil carrying a bag: 'The Devil carried my happiness away'.

4. A handshake with hands in manacles: friendship in prison, on the hand, forearm, or shoulder.

5. A knife, a revolver, bullets, a bottle, a wine glass, a woman's head, a syringe, ampoules, playing cards, and money in various combinations: 'This'll be the end of us'.

See photograph on page 69, a variant on the 'This'll be the end of us' theme: money, robbery (swastika), politicians (Lenin, Stalin, Khrushchev), a DPNK: *Dezhurny Pomoshnik Nachalnika Kolonii* (Assistant Prison Warden) armband, truncheon, a woman's brain under a microscope: 'I can see through those bitches'.

6. A leaf: 'Torn away from life'.

See photograph on page 65: depicting erotic and sentimental motifs.

Erotic Tattoos

In many erotic tattoos the focal point is the male organ. For example, two women pulling ropes in opposite directions are tattooed below the belt line, implying the ropes are tied to the penis. Numerous inscriptions such as: 'Hey, girls!'; 'Taste it, it's yummy'; and 'Don't be scared. It doesn't bite'; are also very common. The state quality mark of the USSR was often tattooed on the penis itself, this symbol was used to mark consumer goods in the former Soviet Union. Other popular inscriptions include: 'Brazen'; 'Operates round the clock'; 'Perpetuum Mobile' (in Russian and Latin); 'Take a look at this wonder'; and so on. The act of sexual intercourse itself is very rarely depicted, and is primarily ironic in nature: a wolf copulating with a hare, the Devil, a priest, etc. [See previous note on shaming tattoos.]

See photograph on page 337: 'Hey, girls!'.

Ironic Tattoos

The subject matter of these tattoos varies widely, although salacious and sacrificial subjects are common: devils chasing priests and raping them, etc. (Other canonical themes are virtually nonexistent.) A favourite of ironic tattoos are the cartoon characters of a wolf and a hare (the Russian Tom and Jerry). The wolf often wears a policeman's cap or uniform.

See photograph on page 75: a forearm tattoo of the wolf from a popular cartoon.

Religious Tattoos

Religious tattoos are very common and often carry double meanings (as with the church domes and Orthodox crosses mentioned earlier). The crucifix is the general symbol of thieves. Religious intolerance is not characteristic of the criminal world. Moreover, religious attributes are not necessarily representative of the bearer's beliefs – naked women might well be depicted against the background of a church.

See photograph on page 345, church domes on the chest, depiction of Christ.

1. Madonna and child, Mother of God with the Christ child: 'Prison is my home'; 'A child of prison', on the chest.

See photograph on page 335: a copy of the Sistine Madonna denoting 'Prison is my home'.

2. A crucifix and Mother of God with the Christ child in a typical Orthodox tradition: 'My conscience is clean before my friends'; 'I will not betray', on the chest.

3. An eel wrapped around an anchor: hope for the salvation of the soul (the eel is a fish symbol – a Christian sign, the anchor is a symbol of hope).

4. An eye inside a triangle: the All-Seeing Eye, symbol of God's omniscience.

5. A serpent with an apple: a symbol of temptation.

6. A Star of David: the bearer is Jewish. Also used as a thieves' star in place of a compass rose.

7. A crescent moon and star: a Muslim's religious tattoo.

Political Tattoos

In the criminal world there is a legendary story about one particular political tattoo of the post–Great Patriotic War period. In his autobiography *Walks Around the Barracks* (1997),[4] Igor Guberman relates this fable as it was told to him:

> 'There was a famous tank division general in Nazi Germany – a tank battle theorist and author of books on motorised warfare. His name was Guderian. He had a younger brother named Karl. He was young, but got a high rank for his courage, and like his older brother he commanded a tank division. He was taken prisoner near Stalingrad. Instead of being put in a prisoner of war camp he was mistakenly put in a regular prison camp.
>
> He acclimatised very quickly and even learned fluent Russian. He befriended many thieves, some say he even became a legitimate thief, and was allowed to take part in their meetings. There was just one problem in the eyes of his friends – he didn't have a single tattoo. They told him many times: "Get a tattoo! A monastery or a battle between a Russian and a Tatar, or at least a mermaid on a tank." But he refused. One day an old man passed through the camp's checkpoint proudly carrying a veneer suitcase. He was a famous tattoo artist – the best in the Soviet Union. The thieves nagged Karl again. Don't miss this chance! You think he only tattoos us convicts?

Here, the person who was relating the story raised his finger to the ceiling, demonstrating that *they* also have tattoos. And if they get tattoos, why should we miss the chance to get some beauty on our bodies? This was the argument that made Karl Guderian break down. When he exposed his chest to the old man's needle, he requested only that the artist keep in mind that one day he would return to Germany, so he must not have anything that he would be ashamed of. The old man said he understood. Soon he had tattooed a beautiful tank on Karl's chest with an inscription in Russian that read 'Germany Over All'. On his thighs were two cannons, above these the inscription 'God chastise England'. He was very satisfied with his tattoos. The old man did everything fairly painlessly and very neatly. Then they turned Karl over and began tattooing his back. Murmuring some tune under his breath he worked late into the evening, until eventually they called for the old tattoo artist and he left along with his veneer suitcase, walking as proudly as ever. He told Karl that he had basically finished, and that he shouldn't worry about the fee – his friends had already paid in full.

A few years after the war many prisoners were freed, including Karl Guderian. He became a prominent tank warfare theorist. But no one – not even his closest friends – ever saw him naked. And I'll tell you why: on his back the poor fellow had a large and extremely detailed tattoo of the Soviet plan of attack against the siege of the Nazi forces at Stalingrad.'

Political tattoos are primarily characteristic of the period from the 1950s to the beginning of the 1990s. They are distinguished by a strong anti-communist spirit. Fascist symbols were used as a juxtaposition to those of communism.

See photograph on page 343: an Arian eagle.

1. Portraits of the founding fathers and most prominent followers of Marxism and Leninism. Primarily Lenin and Stalin, they are often depicted with horns, baring their teeth, etc. Sometimes, portraits of Marx and Engels are tattooed, but these are much rarer (on the left and right side of the chest).

2. Portraits of Adolf Hitler ('Tough Ad'); swastikas; SS epaulets; and other fascist paraphernalia: these are worn by hooligans and robbers to give them an air of being harsh and unyielding.

3. A Nazi Iron Cross: 'I don't care about anybody'. A symbol of aggression and insubordination, often on the chest tattooed as if hung on a chain. Also on other parts of the body accompanied by inscriptions in German.

4. Depictions of police officers as devils, wolves, or pigs.

See photograph on page 53, a rare example: a female convict in an *Osoblag* (Special Prison Camp) beats a guard with an assault rifle.

5. Rarely depictions of: Che Guevara; Mussolini; Churchill; Brezhnev; Gorbachev; and other politicians can be found.

Political inscriptions are especially common. The most famous inscription reads: *Rab KPSS* (Slave to the Communist Party). It enjoyed a great deal of popularity from the early 1960s to the early 1990s, probably

appearing under the influence of the dissident movement. This inscription symbolised not only the convict's 'enslavement' to the Party, but also to the prison authorities. The authorities took extreme measures against such expressions of anti-communism, cutting out the skin on the prisoners' foreheads and eyelids and stitching the remains back together. It was not uncommon that after such 'surgery' convicts could not close their eyelids for a long time. Other anti-Soviet tattoos were also removed using this method, or by etching. In the Rostov Region, when large areas of skin had to be cut out, the operations were performed by surgeons at local hospitals. Portraits of Lenin or Stalin were not touched. In his book *Prison Diaries* (1973),[5] Edward Kuznetsov describes this process:

> There's this con who had been operated on three times against his will to remove a tattoo on his forehead. The first time they cut out a strip of skin with a tattoo that said 'Khrushchev's Slave'. The skin was then roughly stitched up. After he was released he tattooed 'Slave of the USSR' on his forehead. Again he was forcibly operated on to remove it. And it happened a third time, he covered his whole forehead with 'Slave of the CPSU'. This tattoo was also cut out and now, after three operations, the skin is so tightly stretched across his forehead that he can no longer close his eyes. We call him 'The Stare'.

Despite the fact that tattoos with national-socialist symbolism and portraits of Hitler are still popular, xenophobia and in particular anti-Semitism were frowned upon in the criminal world. Traditionally, along with 'Daddy' Rostov, 'Mama' Odessa was another capital city of crime. A large portion of the population of Odessa was Jewish. The most influential portion of the criminal world, its 'Kings,' were also Jewish. The Russian criminal world was actively replenished with Jews from the provinces, and the Russian criminal argot enjoyed an influx of words from Yiddish and Hebrew. Terms such as *zhid* (Yid) and *abrashka* (from the name Abraham) are not considered derogatory in the criminal world. Even in the 1920s and 1930s – at the peak of 'social' anti-Semitism, after the Pale of Settlement[6] was abolished and a great number of Jews had moved into big cities – among criminals one could still easily be killed for displaying anti-Jewish sentiments.

A small number of anti-Semitic tattoos emerged in the Gulag after the Great Patriotic War, when UNA (Ukrainian National Army) fighters, (known as *banderovtsy*) and members of the Forest Brothers[7] from the Baltic countries were sent to prison camps in great numbers. Anti-Semitism had been deeply rooted among Ukrainian nationalists for a long time. Many *banderovtsy* took part in pogroms alongside the Nazis. This was also true of the rebels from the Baltic countries, many of whom were in special SS legions and participated in ethnic cleansing against Jews. In prison camps, the two groups were often at odds with the rest of the criminal brotherhood. Ukrainian and Baltic prisioners were not commonly inclined to get tattooed.

Generally, xenophobia and anti-Semitism are frowned upon in the criminal world. The criminal argot does contain words like *natsmen* – from 'national minority'; *churka* – for someone from Asia or the Caucasus; and *khachik* – often a representative of the peoples of Transcaucasia; but they are not derogatory. They are colloquially neutral terms defining various ethnic groups or nationalities.

Today, however, after the break-up of the USSR and the emergence of nationalistic and chauvinistic tendencies in the CIS (Commonwealth of Independent States), and in view of the increasing number of ethnic hate crimes, the escalation of nationalistic tattoos is likely.

[Again the views of Alexander Sidorov differ from those of Danzig Baldaev on this subject. Baldaev's drawings contain evidence of anti-Semitism within the criminal fraternity over many decades, suggesting this is not a recent phenomenon.]

Ring Tattoos

Tattoos that look like rings are chiefly applied at a younger age in juvenile prisons or specialised schools for troubled adolescents. Many convicts regret having such tattoos as they are considered an impediment in life in general, and to their criminal profession in particular. There are hundreds of types of finger-ring tattoos, often they are tattooed at random.
1. A rectangular black ring: 'I served my sentence in full'.
2. A rectangle or rhombus vertically divided into a white and black halves: 'I will not shake hands with police'.
3. A black rectangle divided diagonally with a white stripe: 'A life path through a juvenile prison' (the bearer has been in juvenile prison).
4. A black rectangle with a white cross inside: 'I went through Kresty' (the colloquial name of a prison in St. Petersburg).
5. A rectangle divided diagonally into a light and dark halves, the light half usually has a picture of the sun with rays: 'Shine on the thief, not the public prosecutor'. Also denotes that the bearer was sentenced as a minor.
See photograph on page 369: 'A life path through a juvenile prison', on the left index finger; 'I went through Kresty', on the middle finger of the right hand; 'shine on the thief' sign on the right ring finger.
6. A ring with two black and two white squares inside it. A rising sun over the ring means: the bearer was sentenced twice as a minor. If the white squares contain the letters *S* and *Sh*: the bearer has been to a specialised school for troubled adolescents.
7. A black rhombus: a *patsan*, a prisoner who regularly breaks prison rules.
8. A rhombus separated with stripes making two triangles shaded in black: also a prisoner who regularly breaks prison rules.
See photograph on page 353, an *otritsalovka*: a breach of prison rules, on middle finger; a 'life path through a juvenile prison', on the ring finger.
9. A rectangle with a picture of a spade (from the suit of cards) inside it: a *baklan* (a prisoner sentenced for a misdemeanour).

10. A black cross of any design inside a rectangle: the 'thieves' suit'. Similarly, various rings with black suits (spades and clubs). Often with a picture of a crown, a rising sun, and church domes above the ring.

11. A swastika inside a ring: an inveterate transgressor of prison rules, often on the little finger.

12. A sword entwined by a snake: the bearer was sentenced for murder or assault and battery.

13. A ring with a skull in it: the bearer was sentenced for robbery.

14. A cat, a beetle, an ant, a spider: a pickpocket.

15. A crown of any kind over a ring: an authoritative thief.

In theory there are also 'shaming' rings, but they are never seen in practice as any shaming ring can be shaded into the first example listed: 'I served my sentence in full'. Here are, nevertheless, a few examples of shaming ring tattoos:

16. A small black rhombus inside a rectangle: a *bubnovy*, ('diamonds', or 'buddy suit'); a prisoner who cooperates with prison administration.

17. A rectangle divided diagonally into black and white halves, the black half on top: a *chushok*, an untidy, degraded convict who does all the dirty, shameful work.

18. A black rectangle with a wide diagonal white stripe with three dots inside the stripe: a passive homosexual.

19. Six dots and the number '6' inside a ring: *shesterka* (literally a 'sixer'), an underling or minion.

Inscriptions

Tattooed inscriptions are extremely popular. Sometimes, entire poems from prison folklore are tattooed:

> Do not regret the roses that have shed their petals,
> They will blossom again in the spring.
> But regret your youth,
> For it has gone forever.

'Thieves' prayers' are also tattooed:

> Lord, Save me, a sinner
> From local rules,
> From wicked turnkeys,
> From steel handcuffs,
> From the pickaxe,
> From the earth I have to dig,
> From the horned master,
> From the short-weighed ration...

Quotes from the classics, especially Sergey Yesenin, are also common:

> How few are the roads I have roamed,
> How many are the mistakes I have made...

In many cases the lines are tattooed across each arm: 'Give me my

lucky ticket to youth, I have already paid my fare'; 'I thank my Motherland for my happy childhood'; 'I live in sin. I'll repent when I die'; 'No luck in this life'; 'Father, toll the bell, for your son has done his time'; 'Flowers blossom in gardens, and youth dies in camps'; 'Fortune isn't a penis, you can't grab it'; 'If you haven't been here [in prison], you will – If you have, you'll never forget it.'

See photograph on page 338. Convict (left) on both arms: 'I live in sin. I'll repent when I die.' Convict (centre) below neck: 'Gott mit uns'; on the left arm: 'Hurry up and live'. Convict (right) on upper arm: 'Keep love'; on forearm: *KRAB*: *Klyanus Rezat Aktivistov i Blyadey* (I swear to kill activists and sluts).

See photograph on page 347, bells like this are a substitute for the inscription 'Father, toll the bell, for your son has done his time'.

Tattoos on the face are infrequent. They were most common in the Gulag after the Great Patriotic War, during the conflict between thieves and bitches. The Butterflies clique, for example, tattooed moths on the cheek or forehead, demonstrating an open challenge to their enemies. Whereas some 'honest thieves' hid to survive during the *tryumilovkis* (when bitches looked for legitimate thieves in the prison population and killed them), the 'butterfly drawn to the fire' symbolised reckless courage and devotion to the common thieves' ideals.

As well as the *Rab KPSS* (Slave to the Communist Party) tattoo, other unequivocally insulting inscriptions were also tattooed on the forehead. For example: *BBBK*: *Boytes, blyadi, bashnyu klinit* (Sluts beware, I'm nuts); or *UZh* for *Ustal Zhit* (I'm tired of living). On each eyelid: *Ne budi* (Do not / wake me); or *Oni spyat* (They're / asleep). On the back of the head there are also a great variety of abbreviations, acronyms, or inscriptions, such as *Uznik* (Prisoner), *Omerta* (the code of silence adopted by the Italian mafia), *Zaebali* (Fucking sick of you all), *Vek* (literally 'century' or 'age', but actually an acronym for *Vsemu Est Konets*: Everything comes to an end); etc.

The most common area for tattooing inscriptions is the chest. The inscriptions vary from religious: 'Save me from evil'; to anti-communist: 'Believe in God, not in communism'; and sentimental: 'The Devil carried my happiness away'; to amorous – the most popular being:

Don't be put off by this convict, girl,
I didn't mean to break the law.
I was tried and sentenced and they took away my freedom,
But they didn't take away my feelings.

Aggressive inscriptions are also widespread: 'I hate police'; 'Death to the public prosecutor'; 'Daddy, kill a communist' (akin to the Great Patriotic War poster: 'Daddy, kill a German'); on the arm around the veins: 'Got no blood left – police drank it all'.

Inscriptions on the the upper part of the foot deserve special mention. They are always divided into two parts, one on the right foot the other on the left. The most popular reads: 'They are / tired' or 'They're tired /

walking under escort' ('but they can run away from the police'; 'but they'll still outrun anyone'). Also: 'Wife, wash them / Mother-in-law, wipe them dry'. They can sometimes take the form of a question: 'Where are you going?' and the answer: 'Why the fuck do you care?' (Or: 'To my beloved'.) Variants include: 'I'm like a stallion in a swamp / I walk without leaving traces'; 'Don't hurry to work / Don't miss dinnertime'; 'Stop the world / I'm getting off'; 'Five thousand miles / with no overhaul'; 'We were walking to our bride / and ended up with our master'.

Inscription Tattoos in Foreign Languages

Inscriptions in foreign languages are found quite frequently and may consist of whole phrases or single words, such as *Omerta*, Freedom, Love, *Häftling* ('prisoner' in German), etc. Others include:

In English: 'Battle of life'; 'Help yourself'; 'In God we trust'; 'To be or not to be'; 'Troub the dead befor the cool' (*sic*); 'Wait and see'.

In French: *'La bourse ou la vie'* (Your money or your life); *'Qui ne risque rien, n'a rien'* (Who risks nothing, wins nothing); *'Tous les moyens sont bons'* (All means are good); *'Tout pour moi, rien par moi'* (All for me, nothing from me).

In German: *'Gott mit uns'* (God is with us) – often in a Gothic typeface; *'Jedem das Seine'* (To each his own) as written on the gate of Buchenwald concentration camp; *'Jeder stirbt für sich allein'* (Everybody Dies on His Own) a novel by Hans Fallada; *'Macht geht vor Recht'* (Might is right); *'Lieben und hassen'* (To love and to hate).

In Italian: *'Il fine giustifica i mezzi'* (The end justifies the means); *'La donna è mobile'* (Woman is fickle); *'Sono nato libero, e voglio morire libero!'* (I was born free, and I want to die free).

In Latin, the most popular language of tattooed inscriptions after Russian: *'Cum deo'* (With God); *'Dictum, factum'* (Said and done); *'Dum spiro, spero'* (As long as I breathe, I hope); *'Errare humanum est'* (To err is human); *'Fortes fortuna adjuvat'* (Fortune favours the brave); *'Fortuna non penis'* (Fortune is not a penis); *'Homo homini lupus est'* (Man is wolf to man); *'Homo liber'* (Free man); *'In vino veritas'* (Truth is in wine); *'Memento mori'* (Remember your death); *'Ne cede malis'* (Do not yield to misfortunes); *'Nil inultum remanebit'* (Nothing will remain unavenged); *'Oderint dum metuant'* (Let them hate so long as they fear); *'Qui sine peccato est?'* (Who is without sin?); *'Sic volo'* (I want it this way); *'Suum cuique'* (To each his own); *'Veni, vidi, vici'* (I came, I saw, I conquered); *'Vivere militare est'* (To live is to fight).

See photograph on page 99, inscriptions *'Libro'*; *'Memento mori'* and *'Poka dyshu – nadeyus* (As long as I breathe, I hope).

See photograph on page 5: *'Veni, vidi, vici'*.

Tattooed Abbreviations and Acronyms

Linguistic pastimes are very popular in prison, the number of tattooed abbreviations and acronyms grows by the day.

BARS: (literally 'ounce, snow leopard'), *Bey aktiv, rezh suk* (Beat up activists, kill bitches).

BBBK: *Boytes, blyadi, bashnyu klinit* (Sluts beware, I'm nuts).

BES: (literally 'devil'), *Bey, esli smozhesh* (Hit me if you can).

BLITsS: *Beregi lyubov I tseni svobodu* (Take care of love and value freedom), on the inner wrist of the left hand.

BOG: (literally 'God'), *Byl osuzhden gosudarstvom* (I was sentenced by the government), *Budu opyat grabit* (I will rob again), *Bud ostorozhen, grabitel* (Beware of robbers).

BOSS: (literally 'boss'), *Byl osuzhden sovetskik sudom* (I was convicted by the Soviet court). Found on older convicts.

VINO: (literally 'wine'), *Volkam otdyshka, legavym kryshka* (rest for wolves, death to gun dogs – 'wolves' are convicts and 'gun dogs' police); *Vot ona, lyubov kakaya* (That's what love is) Found in women's prisons.

VOSK: (literally 'wax'), *Vot ona, svoboda kolonista* (Here's what convict's freedom is like).

EVA: (literally 'Eve'), *Ebu vash aktiv* (I fuck your activists).

EVROPA: (literally 'Europe' or 'Europa'), *Esli vor rabotaet, on padshy arestant* (A working thief is a fallen convict).

ZhNSSS: *Zhizn nauchit smeyatsq skvoz zlyezy* (Life will teach to you to laugh through tears).

ZhUK: (literally 'beetle'), *Zhelayu Udachnykh Krazh* (May your theft be a success).

ZEK: (literally 'con[vict]'), *Zdez est konvoy* (There's a police escort here).

ZLO: (literally 'evil'), *Za vse lyagavym otomshchu* (I will take revenge for it all against the police); *Zavet lyubimogo ottsa* ([At the] behest of my dear father).

ZLOBO: *Za vse lyagavym* (or *lyubimoy*) *otomshchu* (will take violent revenge for it all against the police / my beloved).

IRA: *Idu rezat aktiv* (I'm off to kill the activists).

KLEN: (literally 'maple tree'), *Klyanus lyubit eyo / evo navek* (I swear to love her / him forever).

KLOT: *Klyanus lyubit tebya odnu* (I swear to love you alone).

KOT: (literally 'cat'), *Korennoy obitatel tyurmy* (Native prison inhabitant). The question: *Kto ty takoj?* (Who are you?), is answered by reading the acronym backwards: *Teper on kolonist* (Now he's a prison inhabitant).

KREST: (literally 'cross'), *Kak razlyubit, kogda serdtse toskuet* (How can I stop loving you, when my heart is longing for you?)

LEBEDI: (literally 'swans'), *Lyubit eyo / evo budu, dazhe esli izmenit* (I will love her / him, even if she / he betrays me).

LEV: (literally 'lion'), *Lyublyu eyo / evo vechno* (I will love her / him

forever; *Legavykh ebut veselo* (It's fun to fuck the police).

LIMON: (literally 'lemon'), *Lyubit i muchatsya odnoj / odnomu nelegko / nadoelo* (I'm tired / It's hard to love and suffer alone).

LIST: (literally 'leaf'), *Lyublyu i silno toskuyu* (I love and miss you a lot).

LORD: (literally 'lord', as in the noble title), *Legavym Otomstyat Rodnye Deti* (Coppers beware, our children will avenge us).

LOTOS: (literally 'lotus'), *Lyublyu odnu / odnogo tebya ochen silno* (I love only you very much).

LTV: *Lyubi, tovarish, volyu* (Comrade, love freedom!); *Legavy – tvoy vrag* (Police are your enemies); *Lyublyu vorovat tikho* (I prefer to steal with stealth).

MIR: (literally 'peace'), *Menya ispravit rasstrel* (Only execution will rehabilitate me).

NEBO: (literally 'sky'), *Ne grusti, esli budesh odna / odin* (Don't despair if you're alone).

NEBO – ZYaVR: *Ne grusti, esli budesh odna / odin, znay: ya vsegda ryadom* (Don't despair if you're alone – know that I'm always near).

NIKITA: (literally a man's name), *Nenavizhu iud-kommunistov i tvarey-kommunistov* (I hate communist Judases and damned activists).

OMUT: (literally 'whirlpool'), *Ot menya uyti trudno* (It's hard to leave me).

PAPA: (literally 'dad'), *Pizdets aktivistam, privet anarkhistam* (Activists are fucked, hello to anarchists).

PILOT: (literally 'pilot'), *Pomnyu i lyublyu odnu / odnogo tebya* (I love and remember you, and you alone).

PINGVIN: (literally 'penguin'), *Prosti i ne grusti, vinovatogo iskat ne nado* (Forgive me and don't be sad: it's nobody's fault).

POST: (literally 'fast' or 'abstinence'), *Prosti, otets, sudba takaya* (Forgive me, father, it's my fate).

ROKZISM: *Rossiya, oblitaya krovyu zekov i slezami materey* (Russia is drowning in the blood of convicts and the tears of their mothers).

SVAT: (literally 'kin'), *Svoboda vernetsya, a ty?* (My freedom will come back, but will you?)

SLON: (literally 'elephant'), *Smert legavym ot nozha* (Death to police from knives; *Suki lyubyat odno nachalstvo* (Only bitches love the authorities); *Suki lyubyat ostry nozh* (Bitches love a sharp knife); *Serdtse lyubit odnu navek* (My heart is longing for you alone, forever).

SLZhB: *Smert legavym, zhizn bosyakam* (Death to police, long live thieves).

SOS: *Spasayus ot suk* (I'm hiding from bitches); *Suki otnyali svobodu* (Bitches took my freedom away).

SS: *Sokhranil sovest* (My conscience is clean); (Super Sex).

SER: (literally 'sir'), *Svoboda eto ray* (Freedom is heaven).

TIGR: (literally 'tiger'), *Tyurma – igrushka* (Jail is a toy).

TUZ: (literally 'ace', as in cards), *Tyuremny uznik* (prisoner); *Tyurma uchit zakonu* (Prison teaches the law – recently, this tattoo fell out of use

because in prison argot *tuz* now stands for 'prison toilet cleaner' or even refers to the anus).

UTRO: (literally 'morning'), *Ushel tropoy rodimogo ottsa* ([I] followed my father's footsteps).

KhRISTOS: (literally 'Christ'), *Khochesh radosti i bedy tebe otdam, slyshysh?* (Do you want me to give you my joys and my sorrows? Do you?)

TsLIBS: *Tseni lyubov i beregi svobodu* (Value love, take care of freedom).

YuG: (literally 'south'), *Yuny grabitel* (Young robber).

YuDV: *Yuny drug vorov* (Young friend of thieves). A form of parody on the Soviet public organisation, *YuDM*: Young Friend of the Police.

See photograph on page 61, acronyms *NIKITA* and *LOTOS*: on the right hand; acronyms *KOT*, *SVAT*, *LIST*, *VINO*, *PILOT*, and initials of friends on the left hand.

Tattoos in Women's Prisons

Women's tattoos are distinguished primarily by their sentimental nature. They are known as *khalyavkas* from the slang word *khalyava*, meaning 'freebee'[8] and 'woman'. Popular motifs include: naked figures of a man and a woman (sometimes kissing); a woman with a child; a girl wearing a cowboy hat with two handguns (I'm a bandit); kissing doves; angels.

Some tattoos are symbolic: a swan wearing a crown, for example, means 'I was a virgin once'; an apple means 'lost virginity' (often accompanied by the name of the man and date); a child's head commemorates a child left outside the prison or killed by abortion; an infant flying on a skylark is the symbol of a single mother; a snake's head wound around the head of a woman means: 'The grip of cruel fate'; a woman depicted flying like an angel or a woman's head with the clubs suit of cards are marks of thieves; a mermaid is a symbol of luck.

Generally, women's tattoos contain the same motifs as men's tattoos: a heart pierced by an arrow, bars, barbed wire, and so on.

Tattoos of lesbians, however, deserve a special mention. Both passive and active lesbians wear tattoos, as well as *vzaimshchitsy* or *oboyudchitsy* – lesbians who play both the active and passive roles. A woman with a guitar (on the front of the thigh) denotes a lesbian. When tattooed on the buttock, an eye inside of a triangle means a *kobyel* or *kovyryalka*: an active lesbian. An eye on the arm without a triangle, or a naked woman, often with loose hair, also denote an active lesbian. A passive lesbian has the tattoo of a lily blossom (on the shoulder). A rose with thorns on the hip also signifies a passive lesbian.

Female convicts tattoo the names of women on visible parts of the body. The following quote is from V. Eremin,[9] a journalist who has written extensively on womens prisons:

Even on the forehead near the hairline Irina had tattoos. Many women who have been through a juvenile prison have women's names tattooed.

'These are names of lovers,' Irina explains. 'When I was first in the juvenile

prison, I noticed that the girls had strange friendships. They wrote me notes with *TMON* (I like you a lot) on them. I thought it was weird and just tore them up. And then I accepted it.'

Acronyms declaring undying love are most popular:

MAGNIT: (literally 'magnet'), *Myly, a glaza neustanno ishchut tebya* (Sweetheart, my eye will not tire looking for you).

KUBA: (literally 'Cuba'), *Kogda ukhodish, bol adskaya* (When you leave me, I'm in terrible pain).

PIPL: (transliteration of the English 'people'), *Pervaya i poslednyaya lyubov* (My first and last love).

SATURN: *Slyshish, a tebya razlyubit nevozmozhno* (Hey, it's impossible to stop loving you).

OST: *Opyat stanu tvoey* (I'll be yours again).

The following excerpt from an article by O. Koroleva, *That's Their Love*,[10] illustrates the extent of this practice:

'Lena, *YaYL*, you are my *SBP*, *MOPBY,*' says the writing on the wall of a cell in a disciplinary detention cell. In this Rehabilitation Facility for Young Women in the Belgorod Region, everyone knows what these abbreviations mean. They stand for 'I love you', 'My biggest loss', and 'I'm dying without you'.

Large, crooked pink letters run along her whole leg and form the long word 'Brigantine'. This is a complex acronym that stands for: 'There will be good times and bad times, but you won't be with me, and no one can replace you.' The final letter [in the Russian spelling] is unnecessary, but makes the word sound more romantic. Her short skirt allows one to appreciate her legs. They are 'decorated' with scars – tattoos made with a special knife. *FINAL* is written in large dark-brown letters, the colour of cicatrised scars.

'First, I had Lena and I tattooed *PVT* (Why is it like this?) for her,' says Julia. 'Then I fell in love with another girl, Sveta. So then I got *FINAL* (Love turned out to be fake).'

Girls tattoo their most visible parts – the forehead, arms and legs. Why? Often, it is a hysterical challenge to their *stradalkas*, lovers: you denounced me and I have no pity on myself, so I will scar myself. But I will remember you forever. The desire to encrypt with acronyms is also clear: a state of exaltation and infantile sentimentality pushes the girl to demonstrate the strength of her feelings to her lover and keep it secret from others.

Not all the tattooed names are those of *stradalkas* (lovers). Some may be widespread acronyms, such as *EVA* or *IRA* (as mentioned earlier). Others include *NINA*: *Nikogda ne byla i ne budu aktivistkoy* (I never was or will be an activist); *ALYoNKA*: *A lyubit ee nado kak angela* (And you should love her like an angel); *LYuBA*: *Lyubov yunosti byla angelskoy* (A youth's love is like that of an angel); *RITA*: *Rezh i topi aktivistov* (Kill and drown the activists). For the most part, however, women's tattoos are about love, primarily lesbian love.

1. V. Abramkin, M. Kazachkov, M. Rodman, V. Rudnev et al, 'How to Survive in a Soviet Prison. A Guide for Convicts' (*Kak vyzhit v sovetskoy tyurme. V pomoshch uzniku*) (Krasnnoyarsk: Agenstvo 'Vostok', 1992).

2. Mikhail Gernet, 'The History of the Czar Prison' (*Istoriya tsarskoy tyurmy*) (Moscow: Gosudarstvennoe izdatelstvo yuridicheskoy literatury, 1060–1963).

3. Igor Mikhailov, 'Aska' (*Aska. Poema*)
http://lib.ru/POEZIQ/MIHAJLOW_I/aska.txt

4. Igor Guberman, 'Walks Around the Barracks' (*Progulki vikrug baraka*) (Nizhni Novgorod: Dekom, 1997).

5. Edward Kuznetsov. 'Prison Diaries' (*Dnevniki*) (Paris: Les Éditeurs réunis, 1973).

6. The Pale of Settlement was a territory on the border of Western Russia where the permanent settlement of Jews was permitted. First created by Catherine the Great in 1791, it was finally abolished on 20th March 1917, after many Jews had fled into the Russian interior to escape the advancing German army.

7. The Forest Brothers were a group of guerrilla fighters who, in an attempt to resist Soviet rule at the end of the Great Patriotic War, hid in the forests of Estonia, Latvia and Lithuania. Their units varied in size ranging from individuals to large well-organised groups, capable of taking on Soviet forces. Although their active resistance declined in the 1950s and 1960s, individuals continued to evade capture until the 1980s.

8. 'Freebee' is a particularly Soviet notion for getting something that you didn't work for and don't necessarily deserve.

9. Vitaly Eremin, 'Thieves' Medal' (*Vorovskoy orden*) (Simferopol: Tavriada, 1994).

10. O. Koroleva, 'That's Their Love', 'Crime and Punishment' (*Prestuplenie i nakazanie*) magazine, 1992.

Danzig Baldaev 1925 – 2005

Other books in this series:

Russian Criminal Tattoo Encyclopaedia Volume I, Danzig Baldaev and Sergei Vasiliev
ISBN 978-0-9558620-7-6

Russian Criminal Tattoo Encyclopaedia Volume II, Danzig Baldaev and Sergei Vasiliev
ISBN: 978-0-9550061-2-8

Russian Criminal Tattoo Police Files Volume I, Arkday Bronnikov
ISBN: 978-0-9568962-9-2

Drawings from the Gulag, Danzig Baldaev
ISBN: 978-0-9563562-4-6

Soviets, Danzig Baldaev and Sergei Vasiliev
ISBN 978-0-9568962-7-8

Soviet Space Dogs, Olesya Turkina
ISBN: 978-0-9568962-8-5

Notes from Russia, Alexei Plutser-Sarno
ISBN: 978-0-9550061-7-3

Home-Made: Contemporary Russian Folk Artifacts, Vladimir Arkhipov
ISBN: 978-0-9550061-3-5

Home-Made Europe: Contemporary Folk Artifacts, Vladimir Arkhipov
ISBN: 978-0-9568962-3-0

Further information:
fuel-design.com/russian-criminal-tattoo-archive

First published in 2008. Reprinted 2012, 2014

FUEL©
Design & Publishing
33 Fournier Street
London E1 6QE

www.fuel-design.com

Drawings and text © Danzig Baldaev
Photographs © Sergei Vasiliev
Essay © Alexander Sidorov
For this edition © FUEL

Thanks to: Valentina Baldaeva

Distribution by Thames & Hudson / D. A. P.
ISBN 978-0-9550061-9-7
Scans: Happy Retouching
Printed in China